To Meen,
Love & Light

READ&
RIOT

READ & RIOT

A PUSSY RIOT GUIDE TO ACTIVISM

NADYA TOLOKONNIKOVA

HarperOne
An Imprint of HarperCollins*Publishers*

HarperOne

Some names in this book have been changed to protect people's privacy.

Adaptation from *The Simpler Way* on pages 30–31 printed with permission from Samuel Alexander.

Excerpt from "Why? (The King of Love Is Dead)" by Gene Taylor on page 71 reprinted with permission from Sony/ATV Music Publishing.

HarperCollins books may be purchased for educational, business, or sales promotional use. For information, please email the Special Markets Department at SPsales@harpercollins.com.

FIRST EDITION

Designed by Yvonne Chan
Illustrated by Roman Durov

Library of Congress Cataloging-in-Publication Data

Names: Tolokonnikova, Nadezhda, 1989– author.
Title: Read & Riot : a Pussy Riot guide to activism / Nadya Tolokonnikova.
Description: First edition. | San Francisco : HarperOne, 2018.
Identifiers: LCCN 2017059217 | ISBN 9780062741585 (hardcover)
Subjects: LCSH: Pussy Riot (Musical group) | Musicians—Political activity—
 Russia.
Classification: LCC ML421.P88 T67 2018 | DDC 782.42166092/2—dc23
LC record available at https://lccn.loc.gov/2017059217

18 19 20 21 22 LSC 10 9 8 7 6 5 4 3 2 1

CONTENTS

INTRODUCTION

Preliminary Statement

When I was fourteen, I showed up at a local newspaper's office with a piece I had written on pollution and climate change. They told me I was a really nice little girl and not a bad writer, but wouldn't I rather write about the zoo? The piece on catastrophic pollution in my hometown was not published. Oh well.

Many things have happened in my life since then, including my arrest and the two years I spent in prison, but in fact nothing has seriously changed. I keep asking uncomfortable questions. Here, there, and everywhere.

These questions, while not always accompanied by answers, have always led me to action. It seems to me that I have been doing actions all my life. My friends and I began reclaiming public space and engaging in political protest long ago, in 2007, when all of us were a laughable seventeen or eighteen years old. Pussy Riot was founded in October 2011, but it was preceded by five years that were chockablock with formal and substantive research into the genre of actionism—five years of schooling in how to escape from cops, make art without money, hop over a fence, and mix Molotov cocktails.

(!)

I was born a few days before the fall of the Berlin Wall. One might have thought at the time that after the assumed elimination of the Cold War paradigm, we were going to live in peace. Hmm . . . what we've seen, in fact, is a cosmic rise in inequality, the global empowerment of oligarchs, threats to public education and health care, plus a potentially fatal environmental crisis.

When Trump won the US presidential election, people were deeply shocked. **What was in fact blown up on the 8th of November 2016 was the social contract, the paradigm that says you can live comfortably without getting your hands dirty with politics.** The belief that it only takes your one vote every four years (or no vote at all: you're *above* politics) to have your freedoms protected. This belief was torn to pieces. The belief that institutions are here to protect us and take care of us, and we don't need to bother ourselves with *protecting these institutions* from being eroded by corruption, lobbyists, monopolies, corporate and government control over our personal data. We were outsourcing political struggle like we outsourced low-wage labor and wars.

The current systems have failed to provide answers for citizens, and people are looking outside of the mainstream political spectrum. These dissatisfactions are now being used by right-wing, nativist, opportunist, corrupted, cynical political players. The same ones who helped create and stoke all of this now offer salvation. That's their game. It's the same strategy as defunding a program or regulatory agency they want to get rid of, then holding up its resulting ineffectiveness as evidence that it needs to be folded.

If nationalist aggression, closed borders, exceptionalism of any kind really worked for society, North Korea would be the most prosperous country on earth. They have never really worked, but we keep buying it. That's how we got Trump, Brexit, Le Pen, Orbán, etc. In Russia, President Putin is playing these games too: he exploits the complex of rage, pain, and impoverishment of the Russian people caused by the shock economy and the Machiavellian privatization and deregulation that took place in the 1990s.

<div align="center">(!)</div>

I may not be a president or congressman. I don't have a lot of money or power. But I will use my voice to humbly say that looking back on the twentieth century, I find nationalism and exceptionalism really creepy.

Now more than ever we need to take back power from the politicians, oligarchs, and vested interests that have put us in this position. It's about time we quit behaving like we're *supposed* to be the last species on earth.

The future has never promised to be bright, or progressive, or whatever. Things may get worse. They have been getting worse in my country since 2012, the year Pussy Riot was put behind bars and Putin became president for the third time.

<div align="center">(!)</div>

No doubt Pussy Riot was very lucky that we were not forsaken and forgotten when we were silenced by prison walls.

Every single interrogator who talked to us after our arrest recommended we (a) give up, (b) shut up, and (c) admit that we love Vladimir Putin. "Nobody cares about your fate; you'll

die here in prison and no one will even know about it. Don't be stupid—say that you love Putin." However, we insisted that we don't love him. And many supported us in our stubbornness.

I often feel guilty about the amount of support people gave Pussy Riot. *We had too much of it.* There are many political prisoners in our country, and unfortunately, the situation is getting worse. Their cases don't attract the attention they surely deserve. Unfortunately, prison terms for political activists are seen as normal in public consciousness. **When nightmares happen every day, people stop reacting to them.** Apathy and indifference win.

The struggles, the failures, are not a good enough reason for me to stop our activism. Yes, social and political shifts don't work in linear ways. Sometimes you have to work for years for the smallest result. But sometimes, on the contrary, mountains can be turned upside down in a second. You never really know. I prefer to keep trying to achieve progressive changes humbly but persistently.

we Are superpowers

In the United States, there is a lot of talk about Russia nowadays. But not many know what Russia really looks and feels like. What's the difference between a dangerously beautiful country full of mind-blowing, creative, and dedicated people and its kleptocratic government? Many wonder what that's like—to live under the rule of a misogynist authoritarian man with almost absolute power. I can give a little glimpse into that world.

(!)

The Russian-American relationship is a real piece of work. With a strange quasi-masochistic twitch, I enjoy the journey I'm making in the shadows of these two empires. My existence twinkles somewhere between these giant imperialist machines.

(!)

I don't care about borders (though borders do care about me). I know there is power in an intersectional, inclusive, international union of those who care about people more than money or status.

(!)

We're more than atoms, separated and frightened by TV and mutual distrust, hidden in the cells of our houses and iPhones, venting anger and resentment at ourselves and others. We don't want to live in a world where everyone is for sale and nothing is for the public good. We despise this cynical approach, and we're ready to fight back. More than that, we are not just resisting, we're proactive. We live according to our values right now.

(!)

When I try to find words to talk about a more holistic approach to world politics, when I suggest thinking about the future of the whole planet rather than the ambitions and wealth of nations, I inevitably start to sound naive and utopian to many people. I thought for a while that it was because of my poor personal communication skills, and maybe that is part of the problem. But I see this failure of words as a symptom of something larger. **We never developed the language to discuss the well-being of the earth as a whole system.** We identify peo-

ple by where they are from, while never learning how to talk about people as part of a larger human species.

We've survived the Cuban missile crisis, etc., etc. And now, we're happily falling back into the ancient Cold War paradigm. The *Bulletin of the Atomic Scientists* has set the Doomsday Clock to two and a half minutes to midnight. Global threats are the worst they've been since the US Star Wars initiative in the 1980s. We're so excited to be able *again* to blame our counterpart, an external enemy.

(!)

When two people fight for a long time, they end up looking more and more alike. You mirror your opponent, and it's always possible that sooner or later you'll be indistinguishable from her/him. It's an endless game of copycat. It may be good for you when your opponent is a person of great qualities, but when it comes to a relationship between empires, the result is usually rather ugly.

When Putin needs to introduce a shitty new law to Russians, he refers to US practices. When Russian police are allowed to behave violently toward protesters, they say, "Why are you complaining? Look at America. You'd have been killed by a cop already if you protested like that there." When I'm advocating for prison reform in Russia and say that no human being should be tortured and deprived of medication, Russian officials tell me, "Look at Guantánamo, it's even worse!" When Putin pours more money into the military-industrial complex instead of taking care of an infrastructure that's falling apart, he says, "Look, NATO! Look, drones! Look, bombs in Iraq!"

True. Terribly true. My question here, I guess, is, Who made this decision to copycat *the worst*, and when?

When my government hires thugs to beat me and burn my eyes with a caustic green medical liquid, they say (a) you're an anti-Russian bitch, (b) your goal is to destroy Russia, (c) you're getting paid by Hillary, (d) go back to America. And when someone in America challenges power and the official story line in a fundamental way, they're labeled anti-American. As Noam Chomsky says (and he *knows*), "So like in the Soviet Union, 'anti-Sovietism' was considered the gravest of all crimes. . . . As far as I know, the United States is the only free society that has such a concept. . . . 'Americanism' and 'anti-Americanism' and 'un-Americanism' . . . are concepts which go along with 'harmony' and getting rid of those 'outsiders.'"

It's a gloomy show. It makes you think that politics are boring and useless, and you don't need to engage because you'll never change anything. But I say, we can clean it up. **Just use actual human language.** It's simple: health care, education, access to free-of-censorship information. Stop spending our resources on drones, ICBMs, and excessively voyeuristic intelligence services. Pay people who work; we are not slaves. These are rights, not privileges. All this is achievable—change is much more doable than we've been taught to think.

Putin is still in power, but not because everybody loves his governance. We're aware we're getting poorer while Putin and his crew are getting richer and richer. *But* (there's always a "but") what are we gonna do, you and me? We are powerless to change anything. So they say.

If you have to point to an enemy, our greatest enemy is apathy. We'd be able to achieve fantastic results if we were not trapped by the idea that nothing can be changed.

What we lack is confidence that institutions can actually work better and that *we can make them work better*. People don't believe in the enormous power that *they have* but for some reason don't use.

<center>(!)</center>

Václav Havel, a dissident, an artist, and a writer, spent five years in a Soviet prison camp as punishment for his political views, and later, after the fall of the USSR, became the president of Czechoslovakia. Havel wrote a brilliant, inspirational piece called "The Power of the Powerless" (1978). The essay came into my life miraculously.

After I received my two-year prison sentence, I was transported to one of the harshest labor camps in Russia, Mordovia. After only four weeks of highly traumatic labor in the camp (when I still had more than a year and a half of my sentence in front of me), I became lifeless and apathetic. My spirit was broken. I was obedient because of the endless abuse, trauma, and psychological pressure. I thought, What can I do against this totalitarian machine, isolated from all my friends and comrades, hopelessly alone, with no chance of getting out of here anytime soon? I'm in the hands of people who own the prison, who aren't held accountable for the injuries and deaths of prisoners. They literally own us. We're their wordless and lifeless slaves, disposable, somnambulistic shadows—shadows of what's left of human beings.

But I'm a lucky woman.

Because I found "The Power of the Powerless." I read it, hiding it from the prison officers. Then, tears of joy. And the tears brought my confidence back. We're not broken until we allow ourselves to be broken. Tears brought my courage back.

Havel wrote:

> Part of the essence of the post-totalitarian system is that it draws everyone into its sphere of power, not so they may realize themselves as human beings, but so they may surrender their human identity in favor of the identity of the system, that is, so they may become agents of the system's general automatism and servants of its self-determined goals. . . .
>
> And further: so they may learn to be comfortable with their involvement, to identify with it as though it were something natural and inevitable and, ultimately, so they may—with no external urging—come to treat any non-involvement as an abnormality, as arrogance, as an attack on themselves, as a form of dropping out of society. By pulling everyone into its power structure, the post-totalitarian system makes everyone an instrument of a mutual totality, the auto-totality of society.

Words are powerful: Havel's essay had a profound impact in Eastern Europe. Zbigniew Bujak, a Solidarity activist, said:

> This essay reached us in the Ursus factory in 1979 at a point when we felt we were at the end of the road. Inspired by KOR [the Polish Workers' Defense Committee], we had been speaking on the shop floor, talking

to people, participating in public meetings, trying to speak the truth about the factory, the country, and politics. There came a moment when people thought we were crazy. Why were we doing this? Why were we taking such risks? Not seeing any immediate and tangible results, we began to doubt the purposefulness of what we were doing. Shouldn't we be coming up with other methods, other ways?

Then came the essay by Havel. Reading it gave us the theoretical underpinnings for our activity. It maintained our spirits; we did not give up, and a year later—in August 1980—it became clear that the party apparatus and the factory management were afraid of us. We mattered.

When deeds are faltering, we find words to inspire us. So add this to your checklist: remember to turn on your confidence. *You do have power.* Together, as a community or a movement, we can (and will) make miracles.

WOrDS, DeeDS, Heroes

What follows are some rules, tactics, and strategies I have found useful in my own life. You must find your own way, but I hope you'll find something interesting in how I found mine.

I believe in the unity of theory and practice, of words and deeds. In the beginning was the word, but deeds followed closely, as we all know. This applies to my life as well. So I have written pieces about what inspires me, or depresses me, or infuriates me. I also undertake actions according to my beliefs, and each side of the equation—deeds and words—grows and

reinforces and shines a light on the other. Thus, the structure of each rule in the book will look like this:

1. Words
2. Deeds
3. Heroes

Watch out—*magic boxes* may appear from time to time.

Magic, witchcraft, and miracles are crucial in any fight for justice. Major people's movements, like the universe itself, don't work according to simple linear logic (I give you one dollar, you give me one piece of justice). Understanding this will allow you to retain enough openness and the naive ability to keep being amazed, keep wandering, and be thankful for everything you've experienced. That includes prison terms. The nonlinear logic of these social movements requires activists to be attentive, sensitive, grateful, and open-minded creatures. They are pirates and witches. They believe in magic.

RULE № 1

BE A PIRATE

Look for the truth that explodes existing boundaries and definitions. Follow your instincts and you'll get a chance to break prevailing rules so beautifully you may even end up establishing a new norm, a new paradigm. Nothing frozen is perfect.

In my own country I am in a far off land.

I am strong but have no power.

I win all yet remain a loser.

At break of day I say goodnight.

When I lie down I have great fear of falling.

FRANÇOIS VILLON

I don't feel that it is necessary to know exactly what I am. The main interest in life and work is to become someone else that you were not in the beginning.

MICHEL FOUCAULT

Independence is my happiness, and I view things as they are, without regard to place or person; my country is the world, and my religion is to do good.

THOMAS PAINE, *RIGHTS OF MAN*

Words
PIRATE PEOPLE'S REPUBLIC

"I don't feel that it is necessary to know exactly what I am. The main interest in life and work is to become someone else that you were not in the beginning." So says Michel Foucault.

If you are eager to eat your old identity and turn it into fertilizer for somebody else, you're going to burn, and your flesh will be violently and rudely scattered all over the planet, and birds will peck your liver. But it's rewarding. You're going to rise from the ashes, renewed, young, and beautiful—forever.

I want to intensify my life. I want to reach maximum density, live nine lives in one. It's a search for lives, not experiences. As I see it, a search for experiences is a Diet Coke, fat-free version of seeking to have nine lives in one. There's no time when I'm just living by default, just because I was told "it's supposed to be like that." I don't take that as a valid statement.

Punk culture has taught us that being moderate and restrained is often the wrong choice. When your intuition is telling you to leave moderation behind, let it go.

THE INTERNATIONAL WATERS OF PIRACY

I'm suspicious about all kinds of limitations that have been imposed on me. Sex, nationality, race, hair color, the timbre of my voice, the way I fuck or brush my teeth.

If I can be helpful at all, it is by offering the perspective of a human being who's not particularly Russian, or Chinese, or American, who's trying to live and breathe in her own way.

The perspective of a pirate.

As a pirate, I'm a sailor and an adventurer. But as a pirate I know too how crucial it is to have your community, people you

NEVER TRY TO GIVE A DEFINITION OF PUNK

Being a punk is about constantly surprising. It's not about having a mohawk hairstyle and keeping it your whole life. **Being a punk means systematically changing the image of yourself, being elusive, sabotaging cultural and political codes.**

Punk is a method. Bach and Handel are my main punk influences. I don't like the concept of a punk sub-culture, where you are really stuck in the image. The performance artist Alexander Brener criticized a person who wears skinny jeans, tears them, and considers him-self punk as fuck. Punk demands more. On the first day, tear your jeans; on the second, wear stolen Louboutin shoes; on the third, shave your head; and on the fourth, grow butt-length hair somehow. Undermine, transform, exceed expectations. That's what punk means to me.

trust who are committed enough to walk with you on a guerrilla's path, if needed. My home is in my heart and in the hearts of those in my tribe.

Another job of mine is to be an investigator of life and political orders. My art is to sharpen my mind and keep my eyes open and clear. I promised myself to remain critical and, if I have to, be ready to perform coldhearted analysis, dissection, penetration. . . . At the same time I oblige myself to stay loving, open, and connected: sympathy and compassion are the only truly reliable friends for someone who thrills at being finely tuned to the world, who wants to resonate with the time she lives in, who's thirsty to hear the music and harmonies of the universe that are being played on an incomprehensible variety of strings.

"The intellectual as buccaneer—not a bad dream," notes the philosopher Peter Sloterdijk writing about Pasolini's *Pirate Writings*. "We have scarcely ever seen ourselves that way. The buccaneer cannot assume fixed standpoints because he is constantly moving between changing fronts."

It's fascinating to see when somebody is trying to think about reality in the clumsy and constipated terms that empires use. I never got it. I've never understood the empty talk about enemies of the state, external enemies . . . the list is pretty much endless, for example:

Russkies	Mexicans
commies	witches
Uncle Sam	lesbians
Muslims	Pussy Riot
Yankee pigs	

. <–*insert your name here*
. <–*insert your mom's name here*

When you want to see and tell the truth, you're leaving the area of the known (by default), so I can guarantee you'll look ridiculous, sometimes silly, not be well respected at all; and you should let yourself love your failures, because they constitute your path to the sublime. Enter the international waters of the unknown, where the only business is being a pirate.

Nothing frozen is perfect. The queer, liquid world is real; it's nice here. Otherwise you have what? A belief that dog people should marry dog people and cat people should marry cat people?

As a liquid you're free to take any shape and to mix with other liquids too. It's no fun to be ice; I'd rather be water. Seduce and let yourself be seduced into radical questioning.

Deeds
No Borders

I was born in Norilsk, a very industrial and very Siberian city. Siberia is the shape of a giant cock. My hometown is located at the head. Every summer I'd go to my grandma's place, which is right between the balls and a four-hour flight away.

The air in my hometown consists of heavy metals with a little oxygen. Life expectancy is ten years less than in other regions of Russia, the risk of cancer two times higher.

I grew up around persistent, independent, focused adults. My mother is a maximalist and has an incredible work ethic, as does her husband, my stepfather. My mom can point at a dog and tell you it's a cat, and you know, you'll believe her. She has a gift to convince and lead. My father is in charge of all the divine insanity in my life. He's a writer, artist, cynical romantic, stoic, nomad, adventurer . . . and, of course, pirate. "When she was four," my father writes about me, "Nadya absolutely, consciously, strictly, and business-like said to me, 'Papa! Never force me anything.' I don't remember what the occasion was, but I immediately understood it was a declaration of independence. And I have never 'forced her anything.' I have only motivated her. My point of departure was her inner willingness to do something. I cultivated her from within, like a crocus blossom."

My father is not a religious person in any usual fashion, but he understands the importance of culture and a language that

speaks about transcendent experience. We would visit Catholic, Protestant, and Orthodox churches, mosques, synagogues, and even Hare Krishna events when I was a kid. My father imposed no dogmas on me. We would freely, joyfully, playfully discuss our different impressions and write down some of them.

Where am I from? I'm from the most polluted city on the planet. I'm from the Milky Way. I'm from Russian literature and Japanese theater. I'm from every city where I fought or fucked. I'm from jail and I'm from the White House. I'm from punk records and from Bach's compositions, from my obsession with turquoise, coffee, and loud music.

(!)

When your teen crush is Vladimir Mayakovsky, the Russian revolutionary poet, you're fucked. Sooner or later you will end up in politics. I was fourteen years old, and I thought the coolest thing in the universe was doing investigative journalism.

"What do you want to be when you grow up?" my parents' friends would ask me. I don't like the whole idea of the question, that I have to define right now once and for all who I'm going to be. "I want to study philosophy," I'd say.

"But that's insane, who will pay you to be a philosopher? There is no such job as a philosopher." If I'm refusing to define myself anyway, what makes you think I'd want to be labeled for a monetary reason? I didn't feel ready to wrap myself in glittery paper to be sold.

I didn't read leftist books at that time. But our teenage intuitions usually are purely to the left (and we're right about them). I'm aware that I do sound fantastically naive, but I'm

not going to say sorry for that. **Naïveté eventually brought me perhaps the best things in my life.**

"I don't care. I'm going to study philosophy."

"Why?"

"Because philosophy makes me happy?"

I left my Siberian town the second I got my high school diploma. I jumped on a plane to Moscow.

Being a teenage pirate is hard. You're struggling to find out who you are. You're bound by rules and bombarded with instructions and advice. But I wasn't about to be defined by anyone else. That was my job, and I took care of it.

Heroes
Diogenes

Diogenes of Sinope (aka Diogenes the Cynic or Diogenes the Dog) was a Greek philosopher born in the fifth century BCE, about 2,400 years ago. Living a life of poverty and simplicity, speaking truth to power and not giving a shit about what anyone thought of him, he has plenty to teach us today. He would walk around in daylight using a lantern to help him find an "honest man."

One account says Diogenes was inspired by a mouse that runs here and there, not driven by looking for shelter or fancy food but simply *being a mouse*. Diogenes slept in his cloak wherever he wanted, talked to anyone, and lived in a giant wine jar. He was a "dog philosopher," a Cynic, which comes from the Greek word κυνικός—*kynikos*, or "dog-like."

Diogenes didn't like Plato, a contemporary of his. The biographer Diogenes Laërtius shows Diogenes criticizing Plato for being too full of himself and interrupting Diogenes's lectures

to make a point. Plato's crime was turning philosophy into pure theory, while for Socrates and Diogenes philosophy was a combination of theory and practice. It was real life. The father of philosophy, Socrates never wrote a line in his life. Like Diogenes, Socrates liked walking around drinking and chatting. Plato and Aristotle are responsible for our modern idea of philosophy as something written on a piece of paper. But there was an alternative branch of philosophy, practical philosophy, when a philosopher taught by example, by his way of life. Deeds, not words.

(!)

When I was eighteen, I tried to convince my professors on the philosophical faculty of Moscow State University to let me pass exams by doing actions instead of writing a paper. We reached a compromise and I wrote a paper on action philosophy.

(!)

Diogenes is credited by the playwright Lucian with the first known use of the phrase "citizen of the world." Diogenes is asked where he is from and he says, "Everywhere . . . a citizen of the world." Ever the subversive, Diogenes was saying that he belonged to the world of ideas and not to any artificial political entity. Diogenes was a man with no stable social identity, the exile and outcast par excellence.

He was even unimpressed by Alexander the Great, the legendary conqueror. According to Plutarch, Greek statesmen and other celebrity philosophers had fawned over Alexander when he announced a military campaign against Persia. But not Diogenes. Alexander went to look for Diogenes and found him sunbathing. Alexander asked Diogenes if he wanted anything,

and Diogenes said yes, stop blocking my sun. Fortunately, Alexander wasn't offended. Another time, Alexander the Great said that if he didn't have to be Alexander, he'd be Diogenes.

Diogenes urinated on people who insulted him, defecated in the theater, and masturbated in public. On the indecency of this act he said, "If only it were as easy to banish hunger by rubbing my belly."

Diogenes was quite happy to be called a dog. After all, he said (as quoted by Diogenes Laërtius), like a hound, "I fawn on those who give me anything, I yelp at those who refuse, and I set my teeth in rascals."

We followers of Diogenes behave like dogs too: we eat and make love in public, go barefoot, and sleep in tubs and at crossroads.

He had no interest in money or status, and he thought that spending life seeking artificial pleasures only made you miserable. But it's possible to find pleasure in the actual act of rejecting pleasure. So Diogenes asked statues for money to get used to being turned down. He rolled in hot sand in the summer and hugged frozen statues in winter to toughen himself up. When he did allow himself to relax, it was the simplest, most natural pleasures he looked for.

Diogenes Laërtius says of Diogenes, "Being asked what was the most beautiful thing in the world, he replied, 'Freedom of speech.'"

Diogenes died like a pirate too, on his own terms. Nearing ninety, he killed himself by holding his breath. (Either that or he ate bad octopus or died from a dog bite, which is too ironic for Diogenes the Dog.) It is said he died on the very same day as Alexander the Great.

DO IT YOURSELF

If you want to change something, you need to know how things work. An activist should know this. You're learning about how things work by practicing them. Who wants to be that alienated (wo)man from the ivory tower? Try. Win. Fail. Put on different roles, masks, personas. Don't wait until you're told what you're supposed to do. Choose by yourself. And do it yourself.

The whole punk ethic was do-it-yourself, and I've always been very literal, especially as a kid. When they said that anybody can do this, I was like, "OK, that's me."

MICHAEL STIPE

To be GOVERNED is to be watched, inspected, spied upon, directed, law-driven, numbered, regulated, enrolled, indoctrinated, preached at, controlled, checked, estimated, valued, censured, commanded, by creatures who have neither the right nor the wisdom nor the virtue to do so.

PIERRE-JOSEPH PROUDHON, *GENERAL IDEA OF THE REVOLUTION IN THE NINETEENTH CENTURY*

Anarchy is law and freedom without force.

Despotism is law and force without freedom.

Barbarism is force without freedom and law.

Republicanism is force with freedom and law.

IMMANUEL KANT, *ANTHROPOLOGY FROM A PRAGMATIC POINT OF VIEW*

Words
THE DIY ETHOS

The do-it-yourself ethos teaches you that it's good to use your own brain and hands. The DIY ethos keeps you sane: it saves you from alienation. The DIY ethos says that it's not fun to sleepwalk through your life. It opens up endless possibilities, including the pleasure of self-education. The DIY ethos tells you that each (wo)man is an artist. The DIY ethos makes you happy.

Alienation happens when you have no idea about the bigger picture, when you have no idea how the whole system works, but you mechanically perform your duties. The DIY ethos encourages you to explore. There is nothing in this world that's beyond your ability to comprehend. The DIY principle does not tell you that you never need experts. Sometimes you need someone who has knowledge in a particular area, but the DIY principle tells you that not *only* experts can deal with problems.

Your lifelong hassle has been about getting control over your day-to-day life and therefore having freedom. The DIY ethos reminds us that the most beautiful and life-changing things do not follow the logic of big institutions. Love, thunder, sunrise, birth, and death, for example. The DIY ethos is the decorporat-

ization of the way you perceive reality. If you learn that you're the owner and manager of your every second, you'll become a pretty dangerous anarchist-hijacker.

(!)

We made Pussy Riot because we were inspired by riot grrrl punk zines.

How did a twenty-year-old Russian girl who lived under Putin in 2010 happen to feel so deeply connected with the American riot grrrl movement from the 1990s? Who knows, but that's what happened with me. It's a pure manifestation of the power and mystery of art.

Art creates connections and bonds that are not based on blood, nation, or territory.

JUNK POLITICS

People think that junk is just about food, but there is junk music, junk movies, and yes, junk politics.

Junk culture convinced us to think that shit that kills us is somehow entertaining and amusing. **Cola that is produced from highly acidic and poisonous gray dust and Trump, who's made from cheap bigotry and pure hatred, work according to the same logic.** Following this logic, millions of impoverished workers in America keep voting for the most dangerous organization in human history, the Republican Party.

Minimizing junk, maximizing joy and understanding are a question of honor to me. At a certain point you say, fuck this shit, we can do better by ourselves. The DIY principle might help here: it makes you analyze, question, come up with alternatives. Start from scratch.

(!)

Bernie Sanders writes in *Our Revolution* about an experience he had in South Carolina. He was talking with a young black man who was working at McDonald's: "He informed me that, to him and his friends, politics was totally irrelevant to their lives. It was not something they cared about or even talked about." Like most Republican states, South Carolina had rejected the Medicaid expansion provided by the Affordable Care Act. People survive or die without access to health care, but they still refuse to see how their participation in politics is directly connected with their lives (and deaths). And then Bernie writes (it's simple and genius): "Frankly, this lack of political consciousness is exactly what the ruling class of this country wants. The Koch brothers spend hundreds of millions to elect candidates who represent the rich and the powerful. They understand the importance of politics." The Koch brothers and Putin's mob don't want you to check on what's going on with the money they use their political influence to steal from us, the taxpayers, in government subsidies and other concessions. It's understandable.

The quality of political discussion has turned into junk. It's all very comforting for the Koch brothers and Putin's friends, who can keep doing their shady deals while we're distracted with idiocy.

(!)

Across the globe, the same political trends are spreading like a sexually transmitted disease.

In Russia there is no real politics. My country is a territory run by thugs, and they do whatever they please. They're not

interested in public debates or real public opinion; they know that convenient public opinion can be easily manufactured. It's easy to make an opinion poll in Russia: the administration picks numbers they like and announces them through state-controlled media. So we can't really expect to have high-quality debates in Russia. We can't expect it, but that doesn't mean we're not trying to re-create Russian political discourse by ourselves.

I remember thinking that in other countries, where unfake elections are going on, everything must be so different from what I've seen in my country and much more complicated, and I will never be able to understand it. I was nervous when I talked about politics in front of, say, American students. Everything changed (for America and me) when Trump showed up. He dumbed down American political discourse. He did it bigly.

I used to pay more attention to details and facts in the United States, but after Trump, I lost any wish to do so. I became lazy in a way. I don't feel that I even have to read the news in Russia every day, because everything is clear: we have selfish thugs in power who want to make our country authoritarian again, and they are doing that in order to extract as much profit as they can for their own pockets.

The Trump phenomenon criminally simplifies political conversation. I was ruined by the level of the presidential debates. Keep your words close to your deeds, be clear and coherent, don't try to bullshit me (I'm not an idiot though I may look like one), serve the people, be transparent—or fuck off. You're public property when you're an elected representative; if you don't like it, fuck off again and don't go into politics. Or, as Noam

Chomsky puts it, "That is what I have always understood to be the essence of anarchism: the conviction that the burden of proof has to be placed on authority, and that it should be dismantled if that burden cannot be met."

Isn't it both funny and desperate when punks end up being those who require a work ethic and professionalism from politicians?

We surely need more of the DIY ethos in politics. The DIY ethos in politics means more direct democracy. There are certain issues that citizens can and should decide by themselves.

REBEL'S GUIDE

At some point I was holding master classes on shoplifting in Moscow.

It is more convenient to work in pairs in supermarkets. You put the groceries in a cart, find a safe place in the store, and put them in your bag. Expensive and compact items like meat and cheese are easier to pack on your back or stomach, cinching them tight with your belt. Then you grab a loaf of bread or box of oatmeal from the shelf and head for the checkout counters. You pay for the bread or the oatmeal.

When you exit the supermarket and turn the corner, put the stolen items in your camping backpack. Your shoulder bag should be ready for the next store; always keep it empty. You must not go into the next store with items taken from the previous store. If you are found and detained, the list of stolen goods will include what you brought in with you.

LaDY SIMPLICITY: POOr ArT

I have a lust for simplicity, purity, and minimalism of form in art. I like to consider this approach to art as the art of simple living.

Art is being overproduced, overpolished. The market overproduces pieces of art because of its own fears. The fears of the market are simple: What if not enough products are sold?

It breaks my heart when young artists who are not really involved in the market are working hard to overproduce. They are castrating themselves, diluting their own works of art. They're forced by the market-driven art world to start down their artistic paths with money hanging over their heads. They have to think about where they can suck up more money by producing more art instead of thinking about the art itself— the shadows, the sounds, the colors.

These kids spend tens of thousands of dollars on equipment they don't even need. I understand why Sony or Time Warner needs a RED camera and professional lighting. The entertainment industry *is an industry.* It's a factory, fast-food art, mass produced. To make a shitty hamburger for McDonald's you need to have a factory, and you need giant, expensive facilities to produce a piece of shitty art. So I understand why Sony needs CGI, but I don't really understand why I and other artists who are not connected with corporations need to reproduce corporate aesthetics.

Nevertheless, I see more and more outsiders who, instead of developing their own radically new path, are copying deadly mechanical and overproduced aesthetics. If you think you need thousands of dollars to make a video, it means you were fooled. It's the idea, vision, feeling, and integrity that counts. With or without money.

It's all about the idea, or skill, or passion, or courage, or radical honesty without any glitter or special effects. With zero unnecessary gestures or expensive equipment. Art requires hellish amounts of concentration and self-discipline, and you're totally in charge—there's nobody around to tell you what to do. There are no safety belts. No insurance or guarantee. But that's where the edge is.

MONEY ACTION!

1. **Vote with your money.** Every time we spend our money on something, we vote for this thing to exist in our world. Purchasing something sends a message to the marketplace, affirming the product, its ecological impact, its process of manufacture. Money is power, and with this power comes responsibility. If we spend our money differently, we can change the world.

2. **Live beneath your means.** It provides a sense of security to live on less than you earn. It also proves that you are not an insatiable consumer.

3. **Avoid debt.** Beware of credit cards. Banks are generally very eager to offer us credit, because it's a good way to chain us to them. Beware of debt.

4. **The 30-day money experiment.** Spend a month taking note of everything you purchase. At the end of the month, categorize your expenses into rent, food, electricity, wine, coffees, lunches, etc., then multiply those categories by twelve to get a rough idea of the yearly cost of each of the categories. Small things add up to significant sums over a year.

This means that small changes in spending habits can produce significant savings.

5. **Rethink your spending.** Perhaps by spending less or more carefully you will be able to work less? Consider reducing your working hours. Many people are locked into forty-hour-per-week jobs even though they'd prefer to work shorter hours and receive less money. This locks people into over-consuming lifestyles. In Holland there is a law that allows employees to reduce their working hours simply by asking their employer. The employer is required to accept this request unless there is a sufficiently good business reason to deny it (which happens in less than 5 percent of cases). By protecting part-time employment, Holland has produced the highest ratio of part-time workers in the world.

(Adapted from *The Simpler Way: A Practical Action Plan for Living More on Less* by Samuel Alexander, Ted Trainer, and Simon Ussher.)

Deeds
KILL THE SEXIST

We created Pussy Riot out of confusion. My friend Kat and I had been invited to give a lecture. We told the organizers the topic would be "Punk Feminism in Russia." We started preparing for the lecture the night before and suddenly discovered that Russian punk feminism did not exist. There was feminism, and there was punk, but there was no punk feminism. The lecture

was less than a day away. **There was only one solution: invent punk feminism so we would have something to talk about.**

Our first song was "Kill the Sexist" (October 2011).

KILL THE SEXIST

You're tired of rancid socks,
Your daddy's rancid socks.
Your husband will wear rancid socks,
His whole life he'll be wearing rancid socks.
Your mom is up to her neck in dirty dishes,
In dirty dishes and rancid grub.
She washes the floors like an overfried chicken.
Your mom lives in a prison.
In prison, she washes potties like shit.
There is never freedom in prison.
A hellish life, male domination:
Hit the streets and free women!
Sniff your socks yourself,
And don't forget to scratch your ass.
Burp, barf, binge, shit,
And we'll happily be lesbians!
Go on, suckers, envy the penis yourselves.
Even your beer buddy's long penis,
And the long penis on the boob tube
Until the shit hits the ceiling.
Become a feminist, be a feminist.
Peace to the world, and an end to men.
Be a feminist, destroy the sexist.
Kill the sexist, wash away his blood!
Be a feminist, destroy the sexist.
Kill the sexist, wash away his blood!

We didn't have any musical instruments. We snipped a sample from an English Oi! punk song and duplicated it. To record the vocals, we took a Dictaphone and locked ourselves in the bathroom. But Kat's dad kicked us out. Then we went outside to record. It was autumn, three in the morning, and raining. We took refuge in a playhouse on the playground, our heads butting against the ceiling. A bunch of druggies were sitting on a nearby bench.

"You're sick of rancid socks. . . . And we'll happily be lesbians," rang forth from the playhouse.

A few of the druggies poked their noses in the window.

"Girls, what have you been smoking? We dosed up too, but it didn't get us as high as you are. Maybe you could share with us?"

"Leave us alone, we're busy."

Pussy Riot began rehearsing in a basement belonging to a Moscow church. It was the autumn of 2011. Construction work was going on. We would be recording songs, and workers with jackhammers were walking around us.

We rehearsed a number thoroughly and for a long time. Unlike punk groups who perform in clubs, we had to get the musical part down, but we also had to unpack and pack the equipment as quickly as possible. We not only sang during rehearsals but also tried to learn how to continue playing and singing when guards or police were grabbing our legs and trying to drag us away.

Time passed, and the renovation of the church basement was finished. The church decided to rent it to a store, and we wound up on the street. We went to rehearse in a pedestrian underpass from which we were constantly kicked out.

But after a couple of months, the harsh winter was setting in, and it was impossible to rehearse outside. We set up shop in an abandoned tire plant. We went there every day during the New Year's holidays. We started work on January ·1, 2012, as the country was sleeping in after the big party and MPs were sunbathing in Miami. The guards at the entrance to the plant always asked us the same thing: "Can't sit still at home, girls?"

"Why should we stay at home?" Kat would ask, surprised.

"To make pies and cook soup."

After hearing a full lecture on the history of the feminist movement a couple of times in response to their questions, the guards elected not to talk to us anymore and would just let us in without saying a word. That is just what we wanted.

Journalists were slightly intimidated by us at that time. Moscow News wrote, "Finding Pussy Riot is not easy. The soloists do not give out their telephone numbers, and they constantly change the place where they rehearse. I managed to contact them through the internet. We agreed to meet near a subway station. At the appointed time, a tall young man came up to me. He did not wish to reveal his name and silently led me off. We soon turned down an alley and descended into a dilapidated basement. A single lamp lit the room, and beneath it sat two young women in masks, bright tights, and short dresses."

(!)

How much does it cost to put on a Pussy Riot concert? Nothing. The equipment—microphone, cables, amp, guitar—is borrowed from our punk friend; the dresses, tights, and hats, from our girlfriends who like colorful things. We ask video and photo

journalist friends to shoot the concerts. To edit the videos, we download a pirated program and do the work ourselves. Food expenses amount to a loaf of bread and a bottle of water. You should always take this ration with you to a concert in case you are locked up at a police station overnight.

For a pittance we got hold of some decently powerful car speakers. We picked up some aluminum trim at the market and built cabinets for the speakers.

We powered our DIY speakers with a car battery. Once, on my way to a concert, I noticed something was running down my back and that something was burning. It turned out my backpack was leaking. The rubberized bottom was liquefying: acid flowing from the battery was eating through it. There was nothing I could do: I couldn't throw the battery away! So I kept going, feeling the contents of my backpack slowly dripping into my panties.

Early on, I discovered that when I'm wearing a mask I feel a little bit like a superhero and maybe feel more power. I feel really brave, I believe that I can do anything and everything, and I believe that I can change the situation. We played at being superheroes, Batwoman or Spider-Woman, who arrive to save our country from the villain, but we were choking on laughter looking at ourselves: a fur hat pissed on by a cat with narrow slits for eyes, a nonworking guitar, and for the audio system a homemade battery that leaks acid.

When I put on the balaclava—that fantastic sensation when I did my first performance—I understood that happiness could be this, among other things. When you enter that certain moment, you really appreciate it.

CREATING A POLITICAL FEMINIST PUNK BAND: THE BASICS

An artist, just like a philosopher, is a junkie for critical thinking. And he knows (allegedly) how to turn the results of his analytical activity into cultural forms.

Some people are inspired by exactly the same things in Pussy Riot that irritate others: directness, frankness, and shameless dilettantism. You say we're making shitty music? That's right. We consciously stick to the concept of bad music, bad texts, and bad rhymes. Not all of us have studied music, and the quality of performance has never been a priority. The essence of punk is an explosion. It is the maximal discharge of creative energy, which does not require any particular technique.

But why the bright colors? It was a really dumb reason: we just didn't want to be taken for terrorists in black balaclavas. **We didn't want to scare people; we wanted to bring some fun, so we decided to look like clowns.**

Heroes
D. A. PRIGOV

I refer to D. A. Prigov as Pussy Riot's godfather. Or, possibly, fairy godmother. D. A. Prigov didn't care about definitions. The opposite is true too: he enjoyed definitions, but he liked to juggle with them.

When somebody called D. A. Prigov a painter, he would say, "Oh no, no, no, I'm actually a poet!" When he was called a poet, his reaction would be, "You may have misunderstood something. I'm a sculptor!" And if somebody referred to D. A. Prigov as a sculptor, he'd claim to be a musician. He actually

started to play in a music band at some point in order to escape the earlier definitions. They created a fake contemporary art band called Central Russian Upland (when Pussy Riot started to do illegal street performances, we borrowed a microphone from this band—it was a big blessing). D. A. Prigov was also a performance artist, fiction and nonfiction writer, and political columnist, and he worked with video art too. He took part in movies as an actor.

D. A. Prigov created himself as a conceptual art project. He was thoughtful and original about every role he took. His whole life was his project. A DIY project in a way. It requires a lot of self-reflection and outstanding self-control to build your whole life as an art project. D. A. Prigov did it. DIY is not about being easy on yourself—quite the opposite: it means that you're demanding as fuck of yourself. Always follow your own axioms, as D. A. Prigov says.

At the beginning of the 1990s, he decided to write 24,000 poems by the year 2000. Twenty-four thousand because he wanted to produce one poem for each month of the next two thousand years. Prigov calculated how many poems he needed to write in a day and religiously followed his plan. He never skipped a day. And what do you think, he killed it! Always follow your own axioms.

Nobody refers to Dmitri Aleksandrovich Prigov just by his first and last names. He always wanted people to use his middle name, Aleksandrovich, with his first name. He treated his whole life as a work of art: his project was Dmitri Aleksandrovich Prigov.

D. A. Prigov came to my little hometown to give a lecture when I was fourteen.

I went to the festival where he would be lecturing and saw his artworks that were exhibited. There was a video where he talked to a cat, trying to make the animal say "RUS-SIA." If you'd like to hear my interpretation, this is a brilliant commentary on all-consuming Russian exceptionalism and imperialism. Russia's "domestic kitchen nationalism" as we call it here—Russian exceptionalism—is huuuge.

Another video of D. A. Prigov's was exhibited, "A Cop and the People Are Molding the Face of New Russia." In it, a cop and a half-naked man were kneading dough. This was during the first presidential term of Vladimir Putin, when he was trying to figure out how he should handle all the power he'd suddenly received. Putin and his circle tried different faces for his new Russia—and the easiest one surely was to return to neo-Soviet/Cold War/police state imperialism.

In his lecture, D. A. Prigov started to read a poem by Pushkin. Because Pushkin was unhappy to be used by an oppressive state ideological apparatus on a regular basis, he was praised as a shining light, the actual sun, of Russian poetry in Soviet times and in Putin's Russia. Understandably, when you hear something like that about the sun and stuff, especially if you're a kid who had to learn tons of this sun's poetry in school—you want to throw up immediately. So D. A. Prigov started to read Pushkin's poem, but it was hard to recognize the sweet poet: he read this piece of poetry in the manner of a Buddhist mantra, in Chinese, Muslim, Orthodox Christian styles; he would sing and scream like an odd magic creature. It was a whole new Pushkin.

I met D. A. Prigov a few years later, when he was sixty-four and I was seventeen. It was a big deal. I wanted to be

his apprentice, wash his floors—just be around him. I asked him for advice. He told me, "Don't live within the lie." Later, when I was reading literature on dissent in prison, I found out that these were not D. A. Prigov's own words—they were the words of Václav Havel. But I did not know all of that when I was seventeen. I was just so happy to hear "Don't live within the lie" from Prigov that I got drunk right away and ended up reading the book of Revelation out loud till I fell down, sleeping in the snow.

Six months later, we agreed to do an action together. My colleagues—performance artists—and I had a plan to carry D. A. Prigov, who would be sitting inside a cabinet reading his poetry, up to the twentieth floor of a building. We had to do it with our own hands, climbing the stairs. DIY in action. Our point was that an artist should not lie around on a sofa—the artist should work harder than anyone, not excluding hard manual labor. D. A. Prigov wrote a fantastic prophetic text about a new generation of artists carrying him back to heaven. And then he died. He died on the way to our performance. It was a heart attack.

TAKE BACK THE JOY

Smile as an act of resistance. Smile and say fuck you at the same time. Laugh in the face of your wardens. Seduce your hangman into your beliefs. Make prison wardens your friends. Win the hearts of those who support the villain. Convince the police that they should be on your side. When the army refuses to shoot into the crowd of protestors, the revolution wins.

We shall live with Love and Laughter
We, who now are little worth
And we'll not regret the price we have to pay

RALPH CHAPLIN, "COMMONWEALTH OF TOIL," 1918
(FOR THE WOBBLIES, INDUSTRIAL WORKERS OF THE WORLD)

Nothing is worth more than laughter. It is strength to laugh and to abandon oneself, to be light. Tragedy is the most ridiculous thing.

FRIDA KAHLO

Words
WE SHALL LIVE IN LOVE AND LAUGHTER

Here is a chapter dedicated to all sorts of pleasure that you can find, both earthly and otherworldly pleasure. Joy is my ultimate capital, but it resides in me and not in a bank. I find joy in my art, which is barbaric and primitive political cabaret. It might not look joyful, but I get joy out of it. I even found joy in prison, briefly and secretly.

(!)

Your tormentors are easy to spot when you are in prison. Less so when you live a comfortable enough life in the free world. But there are tormenters out there all the same. They are the ones who preside over a system that dumps trillions in debt on students and gives tax breaks to billionaires. They sell off public land and drill nature reserves. They make sure the 1 percent gets rich and the 99 percent stays poor, relatively. They start wars and turn cities into no-go areas. You know, the politics.

Call out someone in power and rejoice when they are taken down. Resist and smile with meaning.

There is a popular misconception: people keep thinking that political struggle is boring. That it's something you have to do with a sad face and for five minutes a week, and then you walk away from it, as far as possible. It's like brushing your teeth in the early morning—you have to do it, but it's not a super pleasurable thing.

They think you do a political action like you go to your boring office, and then you rest, then your real life starts. In fact, the truth is completely opposite. You just need to find a way to recognize it, this ultimate joy of uniting efforts. I actually start

to worry about myself sometimes, because I may be addicted to this feeling of being involved. I'm an activist junkie.

DaDa

Dada is how absurd political melancholy manifests itself in a joyful manner. "The absurd has no terrors for me," said Tristan Tzara, philosopher of Dada, in his 1922 "Lecture on Dada," "for from a more exalted point of view everything in life seems absurd to me."

Dadaists lived in an awkward period: the time between two world wars. Since the Industrial Revolution, the West had been seriously obsessed with the idea of progress. Progress had replaced God. But during and after World War I, it all started to look pretty confusing. People were working sixteen hours a day, kids were toiling in poisonous factories and losing their eyes and hands, often to produce more weapons for people to kill each other. This surely was not pleasing, and it left a number of people feeling fooled.

The artists who would go on to form the Dada movement were really upset about philistinism and the idolization of mechanics and progress. It was a turbulent, dangerous, nonlinear time, the time after World War I and before the rise of Hitler in Germany. They were on to something.

Real art is that obscure dream you're too confused to talk about even to your psychoanalyst. In its collages, ready-mades, and performance pieces, Dada made a salad of public consciousness.

It's all more than just politics. It's always more than merely politics. Especially when it comes to art. Dada was also about new nonlinear physics. It was a reaction to the total failure of the Newtonian model of the world.

Newton came up with a couple of idealizations to describe the world, but it looked like they couldn't solve a growing number of questions about the nature of reality. In particular, he wondered if light is a particle or a wave. People were confused. It turned out that light can be *both* a particle and a wave. *What?* The new revelation that the atom is not really the ultimate building block of the universe, not the simplest thing in the world, stepped onto the stage. Later all of this business in physics gave birth to quantum mechanics and string theory and so on.

Dadaists rejected the reality and logic of the uber-modernist society. Life was falling apart right in front of their eyes. They ran into the arms of nonsense, absurdism, making playful collages, sound art, sculptures, and the like.

It was said that Lenin visited the Cabaret Voltaire in Zurich. (Cabaret Voltaire was the artists' nightclub where Dada began.) Lenin was making his revolutionary plans for Russia in a nearby apartment and allegedly would stop by the club to play chess.

What's exciting about Dada? Artistic courage, freedom, introducing new techniques of not just making art but possibly thinking about the world itself. There was a lot of hype about postmodernist technique in literature, hypertext, and Roland Barthes's "death of the author" idea some years ago, but I feel that dadaists had proclaimed this method for a long time, as early conceptual artists.

Dadaists used scissors and glue rather than brushes and paints to express their views of modern life through images presented by the media. Dada collage technique is beautiful to me, subversive, playful, flirty, coquettish. It's based on collecting ready-made objects, and it can claim that it *simply reflects reality*. Though as usually happens with any process of making a collec-

tion or classification, metadata (a set of data that describes and gives information about other data) gives you much more information about intentions and moods than the data itself does.

Artistic classifications of reality are my all-time favorite, because through their absurdity and insanity they reveal the simple fact that any process of putting things in order is biased from the very beginning. Collage as an artistic attempt at a random classifying of information helps us not normalize and take for granted other types of classifications—stupid ones like "male behavior" and "female behavior," "free world" and "non-free world," "educated" and "uneducated."

Cut-ups are like collages but with words rather than pictures. Pussy Riot uses this technique extensively. When we decided to start a band, we hated the idea of writing poetry (we were suspicious about poetry because we came from a conceptual art background), but we still had to create lyrics for our songs. We ended up composing our lyrics from quotes of our favorite philosophers and media headlines.

Tristan Tzara describes this cut-up technique in the *Dada Manifesto on Feeble Love and Bitter Love* (1920):

To Make a Dadaist Poem

Take a newspaper.

Take some scissors.

Choose from this paper an article of the length you want to make your poem.

Cut out the article.

Next carefully cut out each of the words that makes up this article and put them all in a bag.

Shake gently.

Next take out each cutting one after the other.
Copy conscientiously in the order in which they left the bag.
The poem will resemble you.
And there you are—an infinitely original author of charming
 sensibility, even though unappreciated by the vulgar herd.

When life was broken apart, these cutups were one response to that displacement and hopelessness. Hugo Ball wrote in a manifesto in 1916: "How can one get rid of everything that smacks of journalism, worms, everything nice and right, blinkered, moralistic, Europeanized, enervated? By saying Dada."

Deeds

What's up with Pussy Riot? Why are we constantly changing our methods and mediums? Illegal concerts, articles and books, speeches, drawings, posters, music videos . . . what else? It's nothing but a *diversification* of art protest in action. The artist doesn't constantly hit the same spot but is listening all the time. I'm ready to explore new mediums and will inevitably fail in that, be an amateur, be a fake artist, fake musician, fake actor.

"We share the same label of anti-state artists," artist and activist Ai Weiwei told me.

"And another one: 'fake artists,'" I added.

"Yes!" He got excited. "Anti-state and fake ones."

Pussy Riot are conceptual artists, that's why we may feel more free about music than most musicians. There is a popular idea among musicians that it is important to stick with some particular genre of music. I don't feel like I have to. When I meet new people with whom I am about to record a song, they

ask me, "What do you want to do?" I tell them that I want to do something I've never done before. Today we could do a Chordettes-influenced song, tomorrow we could do hard rock, and then the next day we could do a classical piano ballad. Every song should be so different that people won't believe it's the same artist. That's the kind of freedom conceptual art gives you, when you don't really care about craft. "Can I do it or not?" This question just doesn't exist for you. If you want to do it, you can do it, and there is joy in this absolute freedom.

IF THE KIDS ARE UNITED

But there's no bigger joy than seeing how your voices and powers are amplifying and growing into something bigger. There's this weird, fantastic, nonlinear mathematics of people's movements: 1 voice + 1 voice + 1 voice may equal 3 voices, but 1 voice + 1 voice + 1 voice may also equal a whole new social and cultural paradigm. It happened in the 1960s; it happened with the Occupy Wall Street movement.

I find myself in activist depression from time to time. What helps get me out of my hurricane of self-doubt is good solid action. You're turning from a frog into a beautiful prince, from a jellyfish into a fighter. When you're climbing onto a roof loaded down with musical equipment to perform the song "Putin Has Pissed Himself," you don't have time to fuck with your brain anymore. You think about the audience, your guitar, and trying to understand how many minutes you have until the cops will come. This feeling is joyful and priceless. It's a pure divine orgasm and a moment of supernatural clarity, maybe even clairvoyance.

What I've learned from people who were going through genuinely difficult situations in their lives—prison, disease,

poverty—is that they often learn better and faster about the currency of joy than those who lead "prosperous" lives. Life has an end point, so why don't I take back from sorrow and sadness those minutes and hours that I have? For me, I remember that this works perfectly in prison.

Friends ask me now, "Hey you, you are a helpless, crying baby, you can't make a phone call without bitching about your phone phobia. How did you survive prison?" It's pretty easy. You simply don't have the option to be helpless in prison. The danger is real: you fight for your life. You fight for your life with a smile. You grab your happiness back or you die. You may die physically or you may be buried in your own apathy. You formulate it to be crystal clear: my government wants me to lose all these years, okay, so what can I do? Human life is pretty short, and I understood early—at fourteen or so—that I have no desire to merely survive, I want to live. In Erich Fromm's words, I want to be rather than have.

So I stayed committed to living a full life in prison. It was my full-time job, though not an easy one. I gained even more from my prison years than I would have gained from those years had I been free. Learn more, feel more, act more. Make the bigger difference. It's your decision—if you want to intensify your life, flood it with passions and beautiful details, or not.

It wouldn't be a lie if I said that I probably got the most important revelations about my consciousness, modern culture, human relationships, and power hierarchies while I was sitting in the cell during my pretrial detention. I learned more about my body too, doing lots and lots of push-ups and stretching. I didn't know what would happen to me tomorrow. I was facing seven years in a prison camp. I lived every day as if it was the

last one. I felt every minute of my life. Every meal, every bowl of porridge, every piece of bread. I was conscious of processes that were going on in my mind and in my body, I was working on balancing myself. I vowed to stay a happy warrior.

I learned what it means to care and be attentive. I was able to see green leaves for about thirty minutes the whole summer. I was able to catch sunlight through the prison bars for ten minutes several times a week. I did it religiously every time I had a chance to see the sun. I caught rare raindrops and cried happy tears because of the shining beauty of the rain.

The white-blue penitentiary light is always *on* in the cell. At night they have the light turned on: guards have to see the prisoners, and prisoners should always remember that they are being watched. Once a week a female guard who was friendly had her shift, and she'd secretly turn off the light in our cell. It was a glimpse of surprise solidarity, one you're truly grateful for. We looked out our window and saw the whole prison filled with light—we were the only ones who had the luxury of darkness. I've never been happier in my life than at those moments. It was a privilege higher than the highest of earthly privileges. And I was just sitting in a cell with no lights on, greeting the sunset without the stark white prison lamps, embracing the pale light of the Moscow evening summer sky. We'd sit still, *afraid to even say a word.* We did not want to interfere in this breathtaking magic—we would drink the evening, its subtle semitones.

Any given system of power is built on an assumption (which of course is trying to portray itself as an axiom) that to receive joy you need to pay or obey. The ultimate act of subversion is thus finding joy in a refusal to pay and obey, in an act of living by radically different values. It's not an act of deprivation or

austerity, it's not a vow, it's an act that reveals joy that transcends given boundaries. And that's the way to go, the way to attract people to what we're doing. Who can possibly be excited about the politics of austerity anyway?

Bring joy back into the act of resistance. For some weird reason political action and fun have been basically separated for decades. It comes from the professionalization of politics. I believe we've lost the connection between our existence, something that personally touches us, and politics. Look back at what was going on in the 1960s: we used to know how to combine the very core of our human existence and politics. Perhaps that's why radical politics changed so many things in the political structure back then: those amazing, brave, and beautiful beings knew how to live passionately, how to treat political action as the most exciting and pleasurable love affair in their lives.

Nothing will change if we prefer to sit around and complain that politics is boring and because it is boring we don't want to take part in it. It's up to us to reshape what politics is. Take it back. Bring it back to streets, clubs, bars, parks. Our party isn't over.

Heroes
1968

Can a period of history be heroic? I absolutely think so. There was something in the air in 1968 that made people use their imaginations to find new ways to revolt. Thinking about that year gives me chills. People knew how to dream about social justice, peace, and equal opportunities. There were labor unions, the civil rights movements in Russia, France, Japan,

Egypt, Czechoslovakia, America. Words and deeds came together in new and inventive ways.

The world today is heavily influenced by events that happened in 1968.

MAY 1968, PARIS

It was a year when everybody realized that it was time to rebel against the conservative archaic world. They felt that the ruling aesthetics, political regime, and official cultural codes did not represent them anymore.

Charles de Gaulle was president of France in 1968. He was one of those paternalistic, patriarchal leaders. Women were not allowed to wear pants to work. Married ladies had to get a husband's permission to open a bank account. Abortions were illegal. Homosexuality was considered a crime. Workers did not have rights, and unsatisfied ones could simply be fired. The education system was rigid and conservative. There was just one TV channel in France, and all information was subject to government censorship.

For young people from the baby boomer generation, it was not enough to believe in utopia, that another world is possible. They were keen to experience utopia, to live in it.

It began as a series of protests and occupations by students. The agenda was a polyhedral constellation of anticonsumerism, anarchism, pro-imagination. . . . Students occupied the Sorbonne and said it was now the "people's university."

Students were joined by striking workers who staged wildcat strikes throughout the French economy. Up to 11 million workers took part—a huge number that represented about a quarter of the population of France at the time. The strike

was the largest in French history and lasted for two weeks.

In a wildcat strike, workers walk off the job with no warning and often without authorization or support from the union. In this sense they are "unofficial." (By the way, "wildcat strike action" is the best name ever, isn't it?) Wildcat strikes have been considered illegal in the United States since 1935 (of course). In 1968, they were the main tactic of the protesting workers.

The workers' demands were serious and structural. They wanted to see a change in how things worked, how things were governed. It was a radical agenda—not better wages and conditions but a plan to kick out the government and President de Gaulle and to have the ability to run their own factories. When the trade union leadership negotiated a one-third increase in minimum wages, the workers occupying their factories refused to return to work. It wasn't enough. It was a sellout. After union leaders made the deal, workers started to treat their own leaders as traitors and collaborationists.

"The largest general strike that ever stopped the economy of an advanced industrial country, and the first *wildcat general strike* in history; revolutionary occupations and the beginnings of direct democracy; the increasingly complete collapse of state power for nearly two weeks . . . —this is what the French May 1968 movement was essentially, and this in itself *already* constitutes its essential victory," proclaims an article titled "The Beginning of an Era" (*Internationale Situationniste* 12 [September 1969]). The piece goes on to say that 1968 brought all the criticisms of existing ideologies and the old way of doing things into a single holistic unity. This was a new world—there was no need for the concept of property when everyone had a home everywhere. In the free, open spaces where the participants of

1968 met, there was genuine dialogue, completely free expression, a real community in the common struggle.

(!)

Take a look at the slogans on pages 54 and 55. They appeared as graffiti, chants, and posters during revolutionary events in Paris 1968. To me they seem to be a perfect manifestation of rebellious collective consciousness, precisely the kind of group action that makes regimes uncomfortable.

When I'm trying to formulate what would be perfect poetry to me, I think about these words.

They are (a) a result of collective effort, (b) eclectic, made using a collage technique, and (c) anonymous. They are highly ambitious and question the very basis of existing society, but they're not about anybody's personal ambitions. You would never suspect that these words were spoken with an intention *to only appear to be radical* and to push, say, T-shirt sales (like today). They smell like a revolution, with all its insanity and unknowability. This spirit cannot be sold, because it cannot be quantified.

Another thing that strikes me when I read these slogans is their wholeness and coherence. Created by different authors, together they look like a solid, powerful piece of art. Everybody knows how hard it is to write something with anyone else, especially a big collective. Collective writing is liable to destroy the artistic soul of each author. Take a look at the lifeless monsters created by the entertainment industry. **The slogans of 1968 teach us that there is another, miraculous form of collective writing: when all your thoughts are genuinely focused on achieving progressive and poetic changes in your culture, crowds start to write communal street poetry.**

Find three slogans that don't belong to Paris 1968:

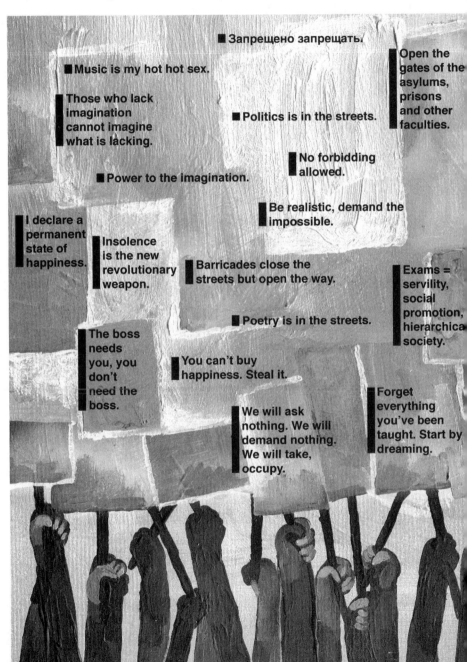

Запрещено запрещать.

Music is my hot hot sex.

Those who lack imagination cannot imagine what is lacking.

Politics is in the streets.

Open the gates of the asylums, prisons and other faculties.

No forbidding allowed.

Power to the imagination.

Be realistic, demand the impossible.

I declare a permanent state of happiness.

Insolence is the new revolutionary weapon.

Barricades close the streets but open the way.

Exams = servility, social promotion, hierarchical society.

Poetry is in the streets.

The boss needs you, you don't need the boss.

You can't buy happiness. Steal it.

We will ask nothing. We will demand nothing. We will take, occupy.

Forget everything you've been taught. Start by dreaming.

For the answers go to page 238.

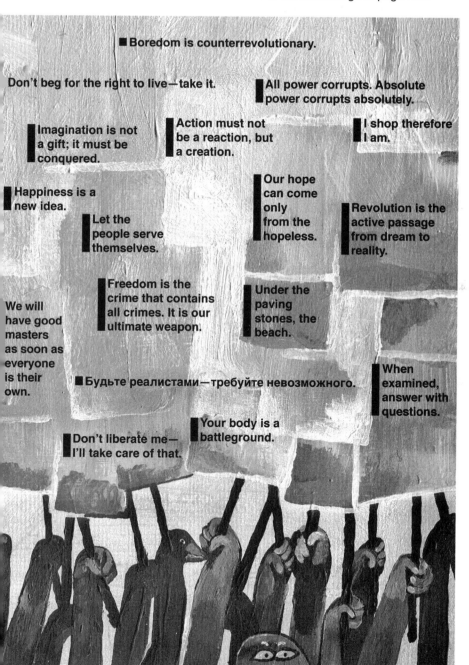

Boredom is counterrevolutionary.

Don't beg for the right to live—take it.

All power corrupts. Absolute power corrupts absolutely.

Imagination is not a gift; it must be conquered.

Action must not be a reaction, but a creation.

I shop therefore I am.

Happiness is a new idea.

Let the people serve themselves.

Our hope can come only from the hopeless.

Revolution is the active passage from dream to reality.

We will have good masters as soon as everyone is their own.

Freedom is the crime that contains all crimes. It is our ultimate weapon.

Under the paving stones, the beach.

Будьте реалистами—требуйте невозможного.

When examined, answer with questions.

Your body is a battleground.

Don't liberate me— I'll take care of that.

For all the hope that 1968 brought, there have been many events in the following years that beat back progressive causes around the world. Just to look at a few of the changes in government . . . Nixon was elected that same year and again in 1972. There was the overthrow and death of President Allende in Chile in 1973, the right-wing coup in Argentina in 1976, the election of Margaret Thatcher in 1979. Reagan (1980, 1984); the Bushes (1988; 2000 and 2004) and of course Putin (2000 and 2012) and Trump (2016).

Okay, Chris Hedges says in this same book that you are holding or reading on your phone that Nixon was the last liberal president of the United States (page 181.) Chris's point is that nothing ever changes without people exerting pressure. Emmeline Pankhurst makes the very same point in this book (page 136). It's a universal fact. Ask Cesar Chavez and Dolores Huerta, or Dr. Martin Luther King Jr., or W. E. B. DuBois, or Margaret Sanger.

The pressure has to be maintained, because the opposing powers are massive and they're not used to losing. Even if society has changed for the better—thanks to 1968 in many cases (racism is illegal, voting rights are protected, free speech is enshrined in law)—the movement to return society to what it was around 1868 gathers momentum. (Actually to 1862, just before the Emancipation Proclamation.)

This is why we have to remember 1968 fifty years later. No gain is secure.

The lasting impact of what was gained in '68 was the belief around the world that if the government wouldn't listen, you had the right and obligation to make yourself heard. It happened in Paris; it happened in Czechoslovakia in

the Prague Spring, when people took to the streets to support their government's reforms and were met with a full-scale Soviet invasion. It happened on American university campuses with protests against the Vietnam War and in Chicago when police and the National Guard were sent to deal with demonstrators at the Democratic National Convention. It happened in Tokyo and Berlin and Mexico City. The circumstances may change, but there is still latent potential in the world like there was in 1968. It just needs to be ignited . . .

MAKE YOUR GOVERNMENT SHIT ITS PANTS

Those who have power need to live in fear. In fear of the people. Meet the main characters of this chapter: power, courage, laughter, joy, belief, and risk. The main characters may well also be inspiration, fairness, struggle, heretics, witches, dignity, faith, masks, and mischief.

Think back 120 years ago, when workers in this country were forced to work seven days a week, fourteen hours a day. . . . Think about the children—ten, eleven years of age, losing fingers in factories, and what the working people of this country said. Sorry, we are human beings, we are not beasts of burden. We are going to form trade unions and negotiate contracts.

BERNIE SANDERS, SPEECH IN CARSON, CALIFORNIA,
MAY 17, 2016

This is why it is important to remember that the New Deal did not come only from kindly elites handing it down from on high, but also because those elites *were under massive popular pressure from below.*

NAOMI KLEIN, QUOTED IN *HUFFINGTON POST*, DECEMBER 3, 2008

Words
QUESTION THE STATUS QUO

Your job is to ask annoying questions.

Socrates did it. He was a bizarre bearded creature who'd approach people on the street to ask them, "What is life, dignity, and love?" These were fair questions, but the government didn't feel like letting Socrates do his thing. **The government rarely approves of the sort of dangerous, subversive activity that's called thinking.** The government always feels suspicious when someone behaves like a free person. And Socrates ended up being sentenced to death and forced to drink poison.

There is power in asking simple questions. Dear Mr. President, if you're so powerful, rich, and smart, why are your people living in poverty? Why is the snow in my hometown black? Did journalists who report on pollution deserve to be beaten to death?

Their goal is to make you believe that it's in your best interests to maintain the status quo. Your goal is to make them scared. Force them to share with you what they have—power, capital, and control over natural resources.

Elites don't enjoy resistance, and they respond by getting angry and taking revenge. By not accepting their rules, we cause them greater damage than their revenge causes us, because it starts to dawn on everyone in your vicinity that the emperor really has no clothes.

We must reclaim language and ideals that the government has stolen from us. Those in government claim to be "the real patriots," but they lie, cheat, and steal. They claim to care about religion, but they break every commandment. They say they represent the people, but they care only about their own wealth. They judge, condemn, and kill. "It is important for people to consider that authoritarianism, though it claims all the national symbols, is not patriotism," notes the historian and Yale professor Timothy Snyder.

Pussy Riot started doing political punk because our state system was rigid, closed, and dominated by castes. In Russia, current policy is dictated by the narrow corporate interests of a handful of officials to such a degree that the air itself hurts us, making us feel as if we had been skinned.

What we were looking for was real sincerity and simplicity, and we found them in our punk performances. Passion, candor, and naïveté are superior to hypocrisy, deceit, and feigned modesty. Take childish, anarchic freedom with you wherever life carries you. Take it with you to the streets, take it to dusty prison cells. Humor, buffoonery, and irreverence can be used to reach the truth. The truth is many sided, and many different people lay claim to it. **Challenge your government's version of the truth, tell your own, and if you can, damn the consequences.**

Deeds
DON'T TALK BABY TALK

We looked around us and did not see a willingness to sacrifice, to be humble, to be aggressive and fight, that combination of extreme and dissimilar states of being in whose absence humans would differ little from tapeworms. We examined the art world, where I had expected to see madness and the search for the absolute. We found hundreds of people leading a comfortable existence, people who knew how to do nothing except play at being bohemians without being real bohemians (if the authenticity of bohemians is measured by the degree of their internal dissent, their anguish, and the sharpness with which they perceive reality).

So if it didn't exist, we sought to create something that can have at least the tiniest resemblance to what we were looking for in the art world.

Here are a few of the earliest actions.

THE STORMING OF THE WHITE HOUSE, NOVEMBER 7, 2008
LOCATION: RUSSIAN WHITE HOUSE
SIZE OF THE SKULL PROJECTED ON THE RUSSIAN WHITE HOUSE: 60 × 40 METERS

We have our own Russian White House. It stands on the banks of the Moscow River. In 2008, Putin, who was then the Russian prime minister, controlled the White House, the seat of the Russian government. We set ourselves a goal. On Revolution Day, November 7, we would project a gigantic Jolly Roger, sixty by forty meters, on the White House with a laser cannon, and then a team of us would storm the White House by climbing over the six-meter-high fence surrounding it.

We taught ourselves to evade the police by rolling under a car in three seconds. We could jump into Dumpsters while on the run and cover ourselves with garbage at one fell swoop. We were ready for the eventuality that when we climbed the government's six-meter-high fence, we would be zapped with a high-voltage charge.

About eight hours before the practice run, we realized that most of the participants had wimped out. One person had diarrhea; another was having her period. Someone was found drunk. We had to find people to replace the wimps. We split into groups and began combing the city.

I asked students at a contemporary art school, the Rodchenko School of Photography and Multimedia. It was my first time there. I approached a group of students sipping tea on the stairs.

"Who is going with us to storm the White House today?"

"What would we need to do?"

"We are going to go to the White House, project a skull and crossbones on it, then climb over the fence onto the grounds."

"Has this been cleared with the administration?" a female student asked me.

"Of course not. That's the whole point."

The students remained silent and continued to suck on their tea. I threw on my coat and headed for the door.

"I'll go with you. When and where do we meet?" said one of them, suddenly approaching me. His springy gait, like that of a wild animal, gave him away as someone who had physical training and stamina.

"Come with me now."

We left the Rodchenko School together. I traveled to the White House with this guy, whose name was Roma. That evening we gave him a new name, Bomber. He was one of three people who managed to get over the six-meter-high fence that night and, after dashing across the grounds of the Government House, successfully disappeared amid Moscow's courtyards and squares.

At four in the morning, the dark canvas of the Russian White House was flooded with green rays from the roof of the Hotel Ukraina, opposite the White House on the other side of the Moscow River, and the Jolly Roger was traced on the building. The group of shock troops ran across the porch of the Government House and, after jumping from a height of six meters, fled the scene.

Several minutes later, burly government security guards appeared on the grounds of the White House, scouring everything in the vicinity with long-range searchlights looking like dozens of pillars of light bustling around the building.

CLOSING OF THE FASCIST RESTAURANT OPRICHNIK, DECEMBER 2008
LOCATION: THE MOSCOW RESTAURANT OPRICHNIK, OWNED BY PRO-PUTIN, ULTRACONSERVATIVE JOURNALIST MIKHAIL LEONTYEV

The restaurant Oprichnik opened in Moscow. We immediately set ourselves the goal of closing it by welding a metal plate to the front door. Why?

In the sixteenth century, Ivan the Terrible used the *oprichnina* to advance his policies in Russia. To wit, he stabbed, hacked, hanged, and poured boiling water on his enemies. Ivan and his *oprichniks* used red-hot frying pans, ovens, tongs, and

ropes. This reign of terror was called the *oprichnina*. In Russia, calling a restaurant Oprichnik is like naming a nightclub Auschwitz in Germany.

We practiced welding doors in the tank-strewn back alleys of Victory Park in Moscow. Day by day, a handful of people learned how to weld in the freezing December weather amid garages and snowdrifts.

Our activist collective had split into two parts.

The first was the industrial workers. We were in charge of the physical work—finding a huge pile of metal and welding it to the door of our restaurant. We had a wide range of engaged citizens: anarchists, social democrats, feminists, advocates for transgender rights, and those who simply shared our general irritation with Vladimir Putin. Weirdly enough, years afterward I found out that one of those anti-Putin activists was secretly super-conservative, and the nature of his disapproval of Putin was that Putin was not tough enough. Well, shit happens.

The second half of our group was a distraction group. Their role was to enter the restaurant and play a drunken crowd to attract the attention of security workers. The action was to happen at the end of December, close to New Year's eve, so the distracters were dressed as bunnies, kitties, and Santa Clauses. We rehearsed a song that our crew would start to sing when welding started. They had to sing super loud, otherwise security would hear the welding and prevent the action.

Finally, one more activist, a prominent organizer of LGBTQ prides in Moscow, had to stand on the street corner, close to the restaurant, to hand passersby stickers on LGBTQ issues. His

mission was to distract potential secret or not-so-secret police officers.

And you know, we did it, we did it successfully—we closed that shameful restaurant. We came back there after the action, at night, after a few hours had passed, to take a look at them trying to tear our welded sheet of metal from their door and open it.

Now the restaurant is completely gone. Sometimes I walk down that street and wonder whether that's connected with our action or not.

ART IN ACTION

The urban environment is highly underrated as a venue for exhibiting artworks. The subway, trolleybuses, store counters, Red Square. Who else has such colorful and spectacular stages?

We debuted with a tour of public transport. We discovered that the best times for performing on public transport are during the morning and evening rush hours. We performed under the arches of the Soviet underground and atop trolleybuses. With all our equipment (guitars, microphone stands, amps) in tow, we clambered atop scaffolds that had been erected to change lightbulbs in the middle of subway stations.

In the middle of a song, I would rip open a pillow, and feathers would rain down on the subway station, then be wafted upward again and again by the currents of air that accompany the trains in the underground tunnels. I would pull a large firecracker filled with multicolored confetti from my panties (Where else can you store it if you need to pull it out quickly

during a performance without stopping the show to rummage through your backpack?) and set it off. A layer of colored foil and paper covered stunned passengers, who pressed the "record" button on their phones and pointed them at us.

Nearly every performance ended with our being detained after we descended the scaffolding.

We looked really strange at police stations, wearing torn bright pantyhose and white lace-up Doc Martens and lugging huge hiking backpacks with bundles of cables poking out of them. Bored cops would come out of their offices to gawk at us.

Once, while we were rehearsing "Putin Has Pissed Himself," the speakers started to burn and smoke. This apparently was a sign from above that he really had pissed himself.

PUTIN HAS PISSED HIMSELF
A column of rebels heads to the Kremlin
Windows explode in FSB offices
Behind red walls the sons of bitches piss themselves
Riot proclaims, All systems abort!
Dissatisfaction with male hysteria culture
Savage leaderism ravages people's brains
The Orthodox religion of the stiff penis
The patients are asked to swallow conformity
Hit the streets
Live on Red Square
Show the freedom of
Civic rage

SEXISTS ARE FUCKED

In November and December 2011 we undertook an antiglamour concert tour: Sexists Are Fucked, Fucking Conformists Are Fucked. We performed at places where rich Putinists and conformists gather, e.g., on top of Jaguar automobiles, on tables in bars, in shops selling expensive clothing and furs, at fashion shows, cocktail receptions. We performed only one song, because you have time for only one song before you're arrested. The song was called "Kropotkin Vodka," and it featured calls to carry out a coup d'état in Russia. "Kropotkin Vodka sloshes in stomachs, / You're fine, but the Kremlin bastards / Face an uprising of outhouses, the poisoning is deadly," we sang.

Whereas during the previous concert series we ripped up old feather pillows, this time around we decided to work with flour. Our plan was to riff on new bits of everyday life in our performances, things women encounter every day. We went to a fashion show armed with flour. It was not easy to get in. The show was invitation only, and members of the conservative pro-Putin artistic elite were among the audience.

"We are from BBC Radio," we muttered to the guard. We waltzed into the room, our faces tense. Skinny, long-legged young women, curtains wrapped round their beautiful bodies, were pounding up and down the catwalk.

We climbed onstage and launched the performance.

"Sexists are fucked, fucking Putinists are fucked!" we screamed.

The models huddled in the corner. We grabbed a bag of flour and tossed its contents into the air. The white flour fanned out over the stage. Suddenly, something burst and there was machine-gun fire. A bunch of balloons noisily popped. We

were enveloped in a pillar of fire. Our balaclavas smoldered and smoked. It was hot. We could not drop everything and run, because another chance to perform at a fashion show might not present itself.

It was only later that we realized a fire had started because flour suspended in air is quite flammable. The catwalk at the fashion show had been ringed with candles, and when we threw the flour in the air, it caught fire. But we could have cared less why the flour caught fire, because we were already on our way to our next performance.

"DEATH TO PRISON, FREEDOM TO PROTESTS!," DECEMBER 14, 2011
LOCATION: MOSCOW DETENTION CENTER № 1

When the police arrested 1,300 of our fellow activists after mass anti-Putin protests, we were incredibly pissed. Our relatives, friends, comrades were locked up. Being angry is a good thing sometimes—it motivates you. We wrote a song in a day and hastily rehearsed it. The next day, we went to the detention center.

We showed up on the rooftop of the prison to perform "Death to Prison, Freedom to Protests!"—a concert for political prisoners.

When we showed up at the venue, we saw that a riot police bus, a traffic police car, and a car containing plainclothes police officers had surrounded the detention center. Nevertheless, we decided to go through with the performance. The concert at the detention center marked the debut of Pussy Riot's new soloist, Serafima, a militant feminist.

"Cops or no cops, we're going to perform," she said right away.

We took out our banner ("FREEDOM TO PROTESTS!") and deployed it right on the barbed wire encircling the detention center. We climbed up to the roof of the facility. The heads of astonished staff poked out from the windows. There had never been a music concert there before, apparently. A policeman approached us from behind, from the yard, and demanded we get down. Several plainclothes officers came from the same direction and recorded the proceedings on camera.

> The gay science of seizing squares
> Everyone's will to power, without fucking leaders
> Direct action is humanity's future
> LGBT, feminists, defend the fatherland!

As we chanted, "Death to prison, freedom to protests! Free the political prisoners," the prisoners peeked out of the windows of their cells. They quickly picked up our slogans, and the detention center was shaken by their yells. The bars shook: the prisoners were trying to rattle them loose with their bare hands. When we got to the lines, "Force the cops to serve freedom. . . . Confiscate all the cops' machine guns," two policemen went back into the building, nervously shutting the door behind them.

Toward the end of our performance, we chanted, "Turn Putin into soap!" and "The people united will never be defeated!" Then we calmly climbed down from the roof on our magical folding ladder and disappeared into the nearby streets. The

officers with the video cameras had gone, apparently to buy doughnuts at the nearest store, and we quietly left.

Heroes
Dr. Martin Luther King Jr.

Making your government shit its pants does not require force. Dr. Martin Luther King Jr. led the civil rights movement starting with the bus boycott in Montgomery, Alabama, in 1955 that led to the Supreme Court ruling that racial segregation on public transport was unconstitutional, and he continued to fight peacefully for change until his assassination in 1968.

Nina Simone sang after Dr. King was killed:

Once upon this planet earth
Lived a man of humble birth
Preaching love and freedom for his fellow men
. .
He was for equality
For all people you and me
Full of love and good will, hate was not his way

He was not a violent man
Tell me folks if you can
Just why, why was he shot down the other day?

Dr. King's own leadership credo was detailed in his "Letter from a Birmingham Jail," written in 1963 when he was incarcerated for protesting in an Alabama city where segregation was brutally enforced. King was responding to white clergy

who criticized his actions. He was here, he wrote, because injustice was here. "I cannot sit idly by in Atlanta and not be concerned about what happens in Birmingham. Injustice anywhere is a threat to justice everywhere. We are caught in an inescapable network of mutuality, tied in a single garment of destiny. Whatever affects one directly, affects all indirectly."

The Reverend Dr. King was a man of God who actually followed what is written in the Bible. "Whoever oppresses the poor shows contempt for their Maker, but whoever is kind to the needy honors God," says Proverbs 14:31. How many people go to church looking to make themselves feel better for doing well? To King, the worst enemy was not the KKK but white moderates who preferred order to justice. The southern church had failed to support his cause, he wrote, and sanctioned the way things were. Members of the early church had been prepared to sacrifice themselves, but he saw few around him who were prepared to support his cause.

Campaigning for a guaranteed basic income in 1968, Dr. King named racism, poverty, militarism, and materialism as our main enemies, and argued that "reconstruction of society itself is the real issue to be faced."

In the jail letter, Dr. King described why he insisted on non-violent direct action—it's how you create the tension that forces the other side to negotiate. "It is a historical fact that privileged groups seldom give up their privileges voluntarily," he wrote. Making them do it nonviolently was a statement of strength, not of weakness. Dr. King was clearly tired of waiting, tired of lynchings, of hate-filled police killing black brothers and sisters, tired of 20 million African Americans living in poverty and sleeping in cars because motels wouldn't take them.

Dr. King was called an extremist. Was not Paul an extremist, said King in response, and Amos, and John Bunyan and Abraham Lincoln and Thomas Jefferson? Even Jesus Christ was "an extremist for love, truth and goodness."

From 1963, King and his Southern Christian Leadership Conference participated in a whirlwind of action and success. That year, the March on Washington included Dr. King's "I Have a Dream" speech. The Civil Rights Act was passed in 1964, the Voting Rights Act in 1965—could they have been passed without Dr. King? Then he attacked the Vietnam War and took on the cause of economic justice, until he was gunned down at the age of thirty-nine.

Who knows what he might have achieved had he lived. A broad-based movement for racial, social, and economic justice led by Dr. King would have shifted mountains. Stop, wait a second. He *did* shift mountains. He keeps doing it after his death. Through his followers all over the earth.

COMMIT AN ART CRIME

The magic of art is that it elevates your voice and amplifies it. Sometimes it happens literally, with a microphone and speakers. Art is a miracle-making machine. Art opens up alternative realities, and that's extremely helpful when we have a crisis and multiple failures of the political imagination.

New meditations have proved to me that things should move ahead with the artists in the lead, followed by the scientists, and the industrialists should come after these two classes.

HENRI DE SAINT-SIMON, *LETTRES DE H. DE SAINT-SIMON À MESSIEURS LES JURES*

All innovative work is theatrical.

ALEKSANDRA KOLLONTAI

We have to create ourselves as a work of art.

MICHEL FOUCAULT, *ETHICS: SUBJECTIVITY AND TRUTH*

Words

It usually stays behind the scenes when somebody is talking about Pussy Riot, but first of all we are art nerds. Moscow conceptualism and Russian actionism of the 1980s and 1990s were important influences for us.

One of our favorite artists from the 1990s was the wildest one, Oleg Kulik, who is known for running around Moscow naked, barking and biting people like a dog. He said incredibly warm words at the time of our trial in 2012. It was very important for us to be supported by our family of Russian conceptual artists, where we basically came from.

Kulik said righteous things about the importance of the mutual double penetration of art and politics. Kulik described how Pussy Riot resonated because they belonged to a great tradition of Russian political artists. As comparisons he mentioned Varvara Stepanova (1894–1958), a photographer, graphic designer, artist, and stage designer associated with the Constructivist movement, the great painter Kazimir Malevich (1879–1935), and the revolutionary architect Vladimir Tatlin (1885–1953). Pussy Riot themselves referenced the artists of the 1990s when asked what they were doing, Kulik said, but art will always be art even if politics is always changing.

Art may be an important reason Pussy Riot's case attracted such miraculous support. Art goes beyond existing boundaries and talks about the inexplicable. You don't need to know any Russians or details about Russian politics to understand what our punk prayer is about and to feel sympathy for some girls who live on the opposite part of the globe. Art unites. I can smell it: art, protest art in particular, can become an important driving and unifying force for the global activist movement, the human movement.

THe Human as a Political and Artistic Animal

Is what Pussy Riot does art or politics? For us it's one and the same—art and politics are inseparable. We try to make art political and at the same time enrich politics with developments from art.

Try to solve any problem through art first, then with all other means at your disposal. Art is the best medicine, both for you personally and for society.

Antigovernment punks may not have much craft. Even when our music technically sucks, we still have an insane purity of impulse. Any living being can smell it, and therefore, they will trust a punk gesture, be inspired and motivated by it. **So if you're thinking about creating a punk band or an art collective, never allow yourself to be stopped by the imperfection of your craft.** Impulse, energy, drive are what's priceless.

(!)

They ask Pussy Riot, "When and why did you decide to combine art and politics for the first time?" But when and why did *they* decide to separate art and politics? Art and activism?

"It seems that art as art expresses a truth, an experience, a necessity which, although not in the domain of radical praxis, are nevertheless essential components of revolution." *The Aesthetic Dimension* (1978) by Herbert Marcuse is a theoretical poem on the radical transformative nature of art. How can we break through the alienation of social existence, inauthenticity, and the treatment of a human being as a thing among things? How can we create a radical response to reification and oppressive social circumstances, which militate against the possibility of human self-realization?

Art helps to create a radical subjectivity, the key element in any political transformation. Art is a realm that helps us fight forces which try to mechanize people, forces which see humans as things that need user instructions and should be placed on the shelf of a store in a shopping mall.

I've never seen the point of separating art and political engagement. Perhaps because I've always been in love with the avant-garde. I'm a girl from the beginning of the twentieth century, a time when politics and art were organically connected.

At that time, artists were looking for primordial, pre-Christian, pagan, organic, simple forms and means of expression, and new methods were intended not just to change dramatically the art field, they were meant to create an explosion in a social space. It was an epoch of major shifts in collective consciousness, and artists were willing to be in the avant-garde of these changes. It was not an exception, but a norm at that time: an artist who is a revolutionary rather than a decorator. **"Philosophers have only interpreted the world, in various ways; the point is, to change it."** As Marx said.

"We were all revolutionists," said Sergey Diaghilev, whose *Russian Seasons*, an explosive and exotic Russian ballet, was conquering the world in the first decades of the twentieth century. "It was only by a small chance that I escaped becoming a revolutionist with other things than color or music."

If Russia is to collude with the world, it should be done by means of art, not with nuclear power, tanks, or financing Trump and Le Pen. **And I believe that Kazimir Malevich's *Black Square*, not Putin, should be the symbol of Russia.**

(!)

By making and experiencing art, we get our chance to revisit that feeling of raw freedom, bare courage, and naïveté that allows us to dare, along with the unrefined creativity and mischievous investigation that we used to have when we were kids. The tired, irritated, and lonely police officer gets his chance to go back to this magic playground through art. A woman who struggles, working two waitress jobs to pay her bills, gets her chance. A prisoner who's about to serve twelve more years, who's abandoned by relatives and friends, who's being treated like she's already dead—she finds her joy and hope in making art from toilet paper and bread.

Art is that magic stick we've been looking for, which could help you transcend languages, borders, nations, genders, social positions, ideologies.

Art elevates us by giving us the most valuable capital in the world: the right and the confidence to ask disturbing questions about the very core of our animal, political, social existence.

Surprise is freedom, accident is freedom. Thus, art is freedom.

Art allows a creature who's involved in it to be unique, but the nature of art requires us to stay strongly connected with the world, catching ideas, symbols, emotions, tendencies, archetypes. We're standing together, but we're not part of a faceless crowd.

I've seen that art is capable of giving hope and meaning to those who are desperate. I played in a Siberian prison rock band, and I know how precious those moments are, when art brings you back to life, art steals you from a world of apathy and obedience. "He who has a why to live can bear almost any how," Nietzsche said.

HOW TO COMBINE ART AND POLITICS

A million protest actions are possible:

kiss-in: A form of protest in which people in same-sex or queer relationships kiss in a public place to demonstrate their sexual preferences.

die-in: A form of protest in which participants pretend that they're dead. This method was used by animal rights activists, antiwar activists, human rights activists, gun control activists, environmental activists, and many more.

bed-in: A protest in bed. The most famous one was done by Yoko Ono and John Lennon in 1969 in Amsterdam, where they campaigned against the Vietnam War from their bed.

car/motorcycle caravans: A group of cars/bikes move through the city with lots of symbols, posters, and noise. Used, for example, by the Blue Buckets movement in Russia to protest the unnecessarily frequent use of flashing lights and roadblocks by motorcades and vehicles carrying top officials.

repainting: In 1991, Czech sculptor David Černý painted a Soviet IS-2 tank pink.

replacing: Swapping "normal" mannequins in shop windows with "abnormal" mannequins.

shopdropping: Covertly placing your own items in stores.

refusing to accept management's absurd orders and laughing in response to them

laughing in response to abuse by police or guards

laughing to protest a trial

(Ridiculing power is one of the best means of democratization; we call it methods of laughter.)

. .

. .

. .

(add your own items to the list)

To spark people's lives with meaning, art should not exist only in the form of an art market, as it mostly does now. A market—by definition—creates exclusive, not inclusive, experiences. Art belongs to everybody. We should be able to create more art in the street, in public spaces. We should have free communal art centers, where anybody who'd like to can create an artwork. You say that it's a utopia, I say look at Sweden in the 1980s and '90s. They had communal cultural hubs, where every person who walked in could learn how to, let's say, play the guitar.

Destroy The (Fourth) Wall

How can I break the fourth wall that separates the artist from the audience?

Breaking the fourth wall is a good and healthy thing to do. It's a sign of real hospitality, an invitation to think and create together. **Trust your audience, treat them as equals, involve every guest in a journey, an investigation, and a conversation.** They are part of the work of art too.

"What strikes me is the fact that in our society, art has become something which is related only to objects and not to individuals, or to life," writes Michel Foucault. "That art is something which is specialized or which is done by experts who are artists. But couldn't everyone's life become a work of art? Why should the lamp or the house be an art object, but not our life?"

You share your artistic responsibility with the audience. It's political theater—it's a theater of cruelty where nobody is just an observer. **You're breaking the society of the spectacle by turning a spectacle into society.** The audience will be thankful to you. They're also tired of being force-fed junk by the enter-

tainment industry. They want to share responsibility. Freedom grows through pressure, so give them pressure. They want to be in your mob.

We feel disconnected from reality. How can my little action possibly make any difference? If I could unite five or ten people through art, if I could make them believe in *their* power, that's my prize and that's my victory.

<div align="center">(!)</div>

Guy Debord, Jean-Luc Godard, and Bertolt Brecht were seeking a form of art that could break down the wall between the actor and the audience. According to them, the elimination of this wall would make it possible to involve an audience in action and critical analysis.

"Bourgeois dramatic art rests on a pure quantification of effects: a whole circuit of computable appearances establishes a quantitative equality between the cost of a ticket and the tears of an actor or the luxuriousness of a set," writes Roland Barthes in *Mythologies* (1957). This kind of art is not going to ask the audience inconvenient questions. The audience has paid to feel comfortably numb.

"Art is not a mirror to reflect the world, but a hammer with which to shape it." That's Bertolt Brecht.

I have no interest in art that does not disturb. Being radically honest, I would not even call it art. The goal of art is not to protect the status quo. Art is development and investigation. **By definition, as an act of creation, art is change, change that affects artist and audience alike.**

Making political art or music videos is not really that different from making any other type of art. The slight differences are:

1. You're aware that intelligence services are closely following your every move.

2. You act according to the knowledge that intelligence services are following you.

3. As an honest (wo)man, you have to be sure that you warn every single person who's involved in a production at the very first meeting: you have to be ready to (a) be fired from your job, (b) be beaten, and (c) be sentenced to several years in prison.

4. After you've released the piece of art, you casually check the news feed just to see if a criminal case has been opened or not.

5. You have to be ready to help those who are in danger because they participated in your political artistic enterprise.

That's it, I think.

A Prayer

If the theory of superstrings is right and we all consist of strings that vibrate, it explains why music can touch us so deeply. Because we do not consist of solid things, as we used to think. If we are just strings of energy—and quantum physics says that we are—we would resonate. If you could feel it, you could project ideas and feelings and perceptions of reality. Music is a prayer.

Music brings you closer to your animal state. The heartbeat of rhythm organizes your thoughts and visions, organizes effortlessly and elegantly, making them more impactful and mesmerizing. We cannot fake a spell, we must let a spell invade us,

and then a spell is ready to be cast and may work very well. That's what shamanism looks like. Music has always been—and will always remain—a prayer at its core.

(!)

"As a little girl," Einstein's second wife, Elsa, once remarked, "I fell in love with Albert because he played Mozart so beautifully on the violin. He also plays the piano. Music helps him when he is thinking about his theories. He goes to his study, comes back, strikes a few chords on the piano, jots something down, returns to his study."

Deeds
PUSSY RIOT CHURCH

You might think that on the day you committed a crime that resulted in two years of prison, you should feel something special. In fact, on my day, I felt ridiculous and stubborn. Honestly, I feel this way every day anyway, so nothing seemed special for me on the 21st of February 2012.

When we arrived at the Cathedral of Christ the Savior, it didn't feel as if we were doing anything wrong. Later, we were told by the court, the investigators, our president, the patriarch of the Russian Orthodox Church, and various outlets of Russian propaganda that what we did in the cathedral was blasphemy, a felony, an attempt to destroy Russia . . . that we in fact had declared war on Russian values, traditions, morality. We crucified Christ a second time; we sold our homeland to America and let NATO tear it apart. That's what they told us.

WHERE TO STAGE AN UNSANCTIONED CONCERT

Wall Street

Physical structures (construction scaffolding, lampposts, roofs)

In the air (balloon, tightrope, helicopter)

In flames (either by belching flames or dancing amid them)

Government buildings (police stations, city administrations)

A blocked-off street; you can block it with trash bins

Military installations (e.g., the musical *Hair*)

The woods

Boat (e.g., Sex Pistols on the River Thames, 1977)

Prisons

Psychiatric institutions (Nina Hagen plays a lot of concerts there these days)

Interrupting a lecture in a college

The Pentagon

FSB HQ

Red Square

On public transport

On a tank, in front of a tank

On a military submarine

Interrupting an official event

During protests

We didn't foresee any of that when we came to the cathedral. It wasn't as if we were planning to overturn the entire state. It was a windy winter day—there's really nothing good I could say about the weather. But everything besides the weather felt just fine. I felt confident. I had heard from my gov-

ernment officials that I was living in a free country, so I could come to any public space and communicate to those in power whatever I'd like. Right?

That morning, we met at the Kropotkinskaya subway station (named after the Russian anarchist Kropotkin). Five women in colorful tights and colored hats.

For three weeks, we had been rehearsing quickly laying out the footlights and connecting them to a portable battery while simultaneously setting up the microphone stand and getting the guitar out of its case. However much we rehearsed, it took us fifteen seconds to set up the performance, which was way too long, of course.

"Careful planning of joint actions by the accomplices of the criminal group, attentive planning of each stage of the crime, and use of the necessary props made it possible to successfully complete all stages of the planned action and commence with its final stage," read the verdict of Moscow's Khamovniki District Court, August 17, 2012.

I had never thought that a concert could lead to a prison term, but you know, never say never—never stop wondering, life is truly full of unknowns. We entered the church and "began devilishly jerking [our] bodies, jumping, hopping, kicking [our] legs high, and wagging [our] heads," as it says in our criminal case.

"After Nadya had crossed herself while kneeling, a guard came up to her and tried to grab her, and she very nimbly and girlishly slipped from his arms and ran off like a rabbit," says my father, who was with us in the cathedral.

The performance lasted forty seconds. After the action, we picked up our belongings and left.

The next day, Putin and the patriarch get on the phone. The

presidential administration called the right people. The main question in the Pussy Riot case was, Who was more offended by the Punk Prayer, Vladimir Putin or the patriarch? Putin knows that church and state are constitutionally separate in Russia, but he believes that they are one and the same. As quoted on inoSMI (November 7, 2017), he said: "How many European countries have deviated from their roots, including Christian values, that lie in the very core of the Western civilization? They deny moral principles and everything traditional on the national, cultural, and even sexual level. . . . The West quickly goes backward and down to the chaotic darkness, to the primitive state."

"Through their actions they demonstratively and pointedly attempted to devalue ecclesiastical traditions and dogmas cherished and revered for centuries," said the judge at my trial.

"I have vouchsafed God's revelation and that the Lord condemns what Pussy Riot has done. I am convinced this sin will be punished both in this life and the hereafter," said archpriest Vsevolod Chaplin, head of the Russian Orthodox Church's press service (RBK Group, June 25, 2012). God's law, the most important law, had been violated by this action, by this sin. "For the wages of sin is death," the Bible says, meaning eternal damnation in hell.

I feel that the action in the Cathedral of Christ the Savior was horrible on the whole. We didn't accomplish most of what we intended—we didn't even get to the refrain of the song. We did not have enough footage to make a good music video. We were extremely disappointed. **Oddly enough, we were sent to prison for the worst Pussy Riot action we'd done.** Apparently, Putin simply didn't like it. He thought, *Damn—what a load of shit! Put them in jail!*

A PUNK PRAYER: MOTHER OF GOD, DRIVE PUTIN AWAY

Virgin Mary, Mother of God
Drive Putin away
Drive Putin away
Drive Putin away
Black cassock, golden epaulettes
Parishioners all crawling to pay their respects
The phantom of liberty in heaven
Gay pride dispatched to Siberia in shackles
The KGB boss, their principal saint
Escorts protesters to jail
So as not to insult His Holiness
Women must have babies and sex
Shit, shit, shit, holy shit
Shit, shit, shit, holy shit
Virgin Mary, Mother of God
Become a feminist
Become a feminist
Become a feminist
The Church praises rotten leaders
A sacred procession of black limousines
A preacher is coming to school today
Go to class and bring him money!
Patriarch Gundyayev believes in Putin
The bitch had better believe in God
The Virgin's Belt is no substitute for rallies
The Virgin Mary is with us at protests!

It was just a prayer. A very special prayer. "The most important dictator, Putin, is really afraid of people," as Pussy Riot

member Squirrel says. "More specifically, he's afraid of Pussy Riot. Afraid of a bunch of young, positive, optimistic women unafraid to speak their minds."

We exposed the brutal and cruel side of the government, but we didn't do anything illegal. **It's not illegal to sing and say what you think.**

People don't call it the Cathedral of Christ the Savior anymore, but rather the Pussy Riot church or, alternatively, the trade center of Christ the Savior. You can rent a holy conference hall and a press center and a concert hall with a VIP green room. Restaurants, a laundry, and a VIP car-washing service are located under the altar in the basement. It also houses a company that sells seafood. Tourists are sold Fabergé eggs at 150,000 rubles a pop, and the cathedral does a brisk trade in souvenirs. And since no one supervises or taxes them, the Russian Orthodox Church has decided to dabble in cheap Arabian gold. "If you want to be sure that your venture will go well, do it with us." That's what I read on the website of the "holy place."

The Orthodox Church's patriarch, Kirill, renowned for his tobacco business and his alleged fortune of $4 billion, spoke out often before the elections against political activism on the part of the rank and file. "Orthodox people are unable to go to demonstrations. These people do not go to demonstrations. Their voices are not heard. They pray in the quiet of their monasteries, their monastic cells, and their homes," said His Holiness.

The patriarch had been unashamedly campaigning for Putin, referring to him as president of Russia before the presidential elections took place and saying that Putin had allegedly

"fixed history's crookedness." If Putin has fixed anything, it would be the pockets of his minions—for example, the pockets of His Holiness Kirill.

So Pussy Riot's only crime was that we did not rent a room at Christ the Savior Cathedral. The church's website features a price list for room rentals. Any wealthy official or businessman could afford to hold a banquet at the church, because he is a man, has money, and is not opposed to Putin. These are the three secrets to success in Russia. Someone in a crowd once asked Saint Francis of Assisi if he ever thought about getting married. "Yes, a fairer bride than any of you have ever seen," he answered.

Christ comes to church, throws out the merchants, and overturns moneylenders' tables. Christ doesn't sell jewelry in the church. Or operate a car wash. The church we have is fucked up, has sold out, and is corrupted. If you have eyes, you'll see it.

Heroes
THE YES MEN

If there are superstars of the place where art and politics collide with irony and subversion, then the Yes Men are those stars. The Yes Men skewer their victims by making perfectly believable public pronouncements that only reveal their devastating satire when you sit down and think about it for a second.

I met the Yes Men at a gala event in Berlin. It was that kind of charitable dinner where they invite celebrities, etc., etc. Pussy Riot was expected to give a speech. We were sitting with our purses full of drugs next to the minister of interior affairs of Germany and overall felt a bit weird.

If Christ were resurrected now in Russia and went around preaching what he had preached before, he would be

1. registered as a "foreign agent";
2. sent to jail for thirty days for violating the law on rallies;
3. sentenced to six months in jail for insulting the feelings of religious believers;
4. sentenced to a prison without parole under Article 282 of the Russian Criminal Code ("Incitement of hatred or enmity, as well as abasement of dignity of a person or a group of persons on the basis of sex, race, ethnicity, language, origin, attitude to religion, as well as affiliation to any social group, if these acts have been committed in public or with the use of mass media");
5. sentenced to four and half years in prison for involvement in rioting;
6. sentenced to fifteen years in prison for extremism;
7. whacked upside the head with a pipe.

Our acquaintance started when I ran into a giant polar bear backstage. The bear was having trouble with the authorities, and guards were trying to throw the bear out. A man named Igor Vamos was standing behind the bear—arguing with the guards. There were two naked people covered in sweat inside of the bear's fur. Their plan was to get on the stage, get out of the bear, and talk about climate change, about melting ice caps. Why naked? Animals are naked—why aren't we?

We did not think twice; of course we took the bear under

our protection. We spoke to Bianca Jagger, and Bianca also became a strong bear supporter. She was saying that the bear is right and we need to care about climate change. Don't we?

It did not work out, though, in that instance. The guards were unbeatable and the bear did not make it to the stage. But Pussy Riot met the Yes Men.

Every time you think about actions, about pranks, remember how many of them were rehearsed and carefully planned but simply prevented by authorities. In my experience this covers about 40 percent of actions. It can be rather frustrating, but that's the rules of the game. Perhaps I should make a whole catalog describing our art protest actions that were prevented by police or FSB.

The Yes Men are Jacques Servin, Igor Vamos (the man with the bear), and lots of friends and supporters, other activists who prefer to stay unknown. The Yes Men have been doing actions for twenty years. They have made excellent movies: *The Yes Men* (2003), *The Yes Men Fix the World* (2009), and *The Yes Men Are Revolting* (2014). They promoted a supposed Halliburton product called a "SurvivaBall," which protected against climate change–related natural disasters. They produced their own fake edition of the *New York Times*, dated July 4, 2009—80,000 copies of which were given to people on the streets of New York and Los Angeles. The paper imagined an alternative future that had already arrived, with headlines like "Iraq War Ends" and "Nation Sets Its Sights on Building Sane Economy." "All the News We Hope to Print," said the tagline on the front page. There were stories about establishing universal health care, a maximum wage for CEOs, as well as an article in which George W. Bush accuses himself of treason for his actions during his years as president.

In 2004 Servin, in character as a Dow Chemical spokesman, went on the BBC and said Dow was going to give $12 billion to the untold thousands of victims of the Bhopal chemical plant disaster in India in 1984. Which is what Dow Chemical should have done. The financial market's reaction was to tank Dow stock to the tune of billions. Oh no! Money for deserving victims?

Jacques Servin is a professor at the Parsons School of Design in New York, and Igor Vamos, an associate professor of media arts at Rensselaer Polytechnic Institute. In 2014, students at Reed College invited Vamos, an alum, to give the commencement address. During the address and backed by a press release, Vamos announced that Reed was divesting its $500 million from fossil fuels. It wasn't, but students had been pushing the trustees to do so.

SPOT AN ABUSE OF POWER

(We can identify specific abuses of power and bring them to everyone's attention.)

First there was Greek civilization. Then there was the
Renaissance. Now we're entering the Age of the Ass.
JEAN-LUC GODARD'S *PIERROT LE FOU*

President? My big toe would make a better president.
SWEET SMELL OF SUCCESS

Words
LIE, CHEAT, STEAL (EVERYBODY'S DOIN' IT); OR, WHO IS MR. PUTIN AND WHAT DOES IT HAVE TO DO WITH MR. TRUMP?

If we measure the success of a politician by his/her ability to
reflect the main tendencies of her/his time, then Trump and

Putin are triumphant. They both manage to reflect the worst impulses that the times have brought us—they are greedy, ethics-free, uncaring.

"Oligarchic elites, while they may disagree on just about everything else, are firmly united in their desire to defend their wealth," German economic sociologist Wolfgang Streeck says in the book *How Will Capitalism End?*

If you ask me what I would like to say to President Putin, I'd tell you that I don't feel like talking to him. To my mind he is a waste of space.

Putin, the man who has co-opted the ideology of Russia today, doesn't even have a coherent set of beliefs. "I cannot imagine my country being isolated from Europe," said Putin in an interview with the BBC in March 2000. He didn't mind Russia being a part of NATO, either. Today, antagonism with Europe, America, and NATO seems to be Putin's favorite game in his playground.

Stealing money from the Russian people may be Putin's only enduring idea. As a former KGB agent, Putin simply doesn't believe in beliefs. Anyone who "believes" could be bribed or intimidated and is therefore vulnerable. And you can't arm yourself with a belief. Money, prison, or a gun can neutralize any "conviction."

Putin remains an ordinary KGB agent, and—paradoxically—that's the secret of his success. Putin came into his enormous power by pure accident. He was appointed by the oligarchs in 2000, with the oligarchs believing that Putin would be their puppet. They believed it because Putin is a truly unexceptional human being.

Putin is petty, uncaring, spiteful, incapable of love and

forgiveness, and incredibly insecure. He's nervous, especially when he tries to hide his tremor under a hypermasculine bravado. Trust, compassion, and empathy are second-rate emotions in Putin's world—that is, in a KGB agent's world.

(!)

Somebody told me an anecdote about the KGB. I believe this story might be true.

Candidates come to the KGB to apply for a job. They have passed the basic exams, and now they are told they have to take one last test, and everyone who passes it will be hired.

Each is shown a room in which he sees his wife. The examiner says, "Here is a gun. Go in and shoot your wife for the sake of the Motherland, and you're hired."

Everyone refuses except for one man. Shots are heard from the room, then shouts, scuffling, and sounds of a struggle.

The candidate emerges from the room and brushes himself off.

"The rounds turned out to be blanks, so I had to smother her," he says.

(!)

Putin will never allow himself to be creatively or intellectually open. He is a well-trained agent. Anything that may make him emotionally vulnerable is harmful. Thus, having a heart is harmful.

He is a professional at corrupting people's souls with material goods, opportunities, and if needed, fear. Good intentions and honesty don't exist in reality, Putin thinks. A pragmatic, smart, effective player could not let sentimentality decrease his

productivity. Remember the main hero of Bertolucci's *The Conformist*? He embodies the banality of evil. He is a pale, insignificant opportunist who nevertheless has enough power to crush beautiful, sophisticated worlds. If he finds a flower in his hands, he'll destroy it: its beauty is alien and intimidating to him.

Putin claims to be a religious person. He's not. The same with most of the Republicans in the United States, who are killing freedom and rights in the name of God. If they opened the New Testament and actually read it, it would become clear to them that Christ would throw up if he saw what they are doing.

Putin condemned Pussy Riot for dancing in a church and protecting women's rights, saying that he'll save Christianity from devilish witches like us. **It seems that Putin has no clue about early Christianity; otherwise he would know that Christ and his followers were rebels and not Caesars.** Putin is not able to conceive of the virtues that constitute the heart of every pure religion: the readiness to give yourself away, willingness to sacrifice, an unconditional lust for truth and justice. Putin understands only the safe, comfortable, bureaucratic type of institutional religion that confirms the status quo.

Religion is a useful facade, a masquerade for Putin. Maybe that's why he doesn't seem to remember that he came from the KGB, which has prosecuted, arrested, and killed hundreds of thousands of Soviet people just because they dared to believe in God. Now Putin has changed face: now he's friends with the deeply corrupt and infected institution of the Russian Orthodox Church. Obviously, facades are interchangeable. There is no person who is irreplaceable, as Stalin liked to say. Or: there is no person I cannot fire to save my petty ass, right?

"The Party seeks power entirely for its own sake. We are not interested in the good of others," George Orwell writes in *1984*. "We are interested solely in power, pure power. The object of persecution is persecution. The object of torture is torture. The object of power is power." **And power that exists for its own sake is by definition an abuse.**

When I'm going through Putin's qualities and can't find anything of worth, I unwittingly start to think about another petty person I know. Trump is his name.

Putin and Trump share a bunch of qualities (besides business and political connections and being dangerously corrupt and crooked). They share a belief that people are motivated only by self-interest. They are distrustful of human sincerity or integrity, selfishly and callously calculating the profit from every social transaction. They believe that all connections have to be profitable transactions. And they believe this religiously. Trump is maniacally obsessed with "winning." He was able to simplify the whole wide world to the degrading alternative of win or lose. And the KGB agent Putin also knows that you have just two options: you eat someone or you'll be eaten. **In Trump and Putin's world, we don't really care about human dignity; we care about human capital.** Dignity is not profitable.

"In general it is possible to divide mankind into two categories," wrote Vladimir Bukovsky, a dissident who spent twelve years in psychiatric prison hospitals, labor camps, and prisons within the USSR, "those you could share a cell with and those you couldn't." I don't think I could share a cell with someone for whom a human is just a number, a pawn that can be manipulated for their personal gain.

There is one set of laws and regulations for the 1 percent, and another for the 99 percent. It leads to the relentless exploitation of both "human capital" and the environment for short-term profits. It leads to kleptocracy, to private profiteers sucking money out of education and health care, assaults on women's rights, imperial adventurism, and the demonization of the other.

Nobel Prize–winning economist Joseph Stiglitz wrote in an article titled "Of the 1%, by the 1%, for the 1%" (*Vanity Fair*, May 2011):

1 percent of the people take nearly a quarter of the nation's income—an inequality even the wealthy will come to regret. . . . In terms of wealth rather than income, the top 1 percent control 40 percent. Twenty-five years ago, the corresponding figures were 12 percent and 33 percent. Among our closest counterparts are Russia with its oligarchs [see?] and Iran. Governments would compete in providing economic security, low taxes on ordinary wage earners, good education, and a clean environment—things workers care about. But the top 1 percent don't need to care.

As Bernie Sanders puts the main principle of our political era, "When you see a social problem, you financialize, you privatize and you militarize."

The wealthy have their own version of political struggle. This struggle manifests itself in their stinky, shady financial schemes, which ruin the lives of opponents, killing them sometimes. Finding sneaky ways to not follow their own laws or simply creating new ones (a favorite trick of Putin's).

"In this world laws are written for the lofty aim of 'the common good' and then acted out in life on the basis of the common greed," Saul Alinsky wrote in *Rules for Radicals*. And the wealthy are fantastically well organized. Again, if we need to pick up what elites all around the world know very well how to do, it is how to protect their own wealth. *Everybody has a right to be my servant,* they think. **If we, the left (or "the up" or "the high," as my friends who don't like binary oppositions call it), progressive activists, want to oppose them somehow, we have to learn how to be fantastically organized too.**

There is no friendship or comradeship in the world when only power and profit are worshipped. No trust, love, or inspiration. There are business and political alliances based on a recognition of each other's power and influence, i.e., deeply based in mutual fear and mistrust. It's scary to lose power in such a toxic environment. Once you lose protection, your fall toward the abyss starts. **Those who licked your ass yesterday will be happy to use your skull as an ashtray today.**

ALT-RIGHT FASCISTS

"Fascism was right since it derived from a healthy national-patriotic sensibility, without which a people can neither lay claim to its existence nor create a unique culture."

This is a quote from Ivan Ilyin, Putin's favorite philosopher.

"It is not Russia that lies between the East and West. It is the East and West that lie to the left and right of Russia," says Putin (*Komsomolskaya Pravda*, December 5, 2013). **Any imperialist exceptionalism is about as unexceptional in my eyes as it gets.**

When Noam Chomsky was asked by the *Nation* (June 2,

2017) what's the story with Brexit, Trump, Le Pen, Hindu nationalism . . . nationalism everywhere, he said yes, it's a real world phenomenon. "It's very clear, and it was predictable. . . . When you impose socioeconomic policies that lead to stagnation or decline for the majority of the population, undermine democracy, remove decision-making out of popular hands, you're going to get anger, discontent, fear [that takes] all kinds of forms. . . . People are very angry, they're losing control of their lives. The economic policies are mostly harming them, and the result is anger, disillusion."

It's a simple plan. First, create inequality and structural violence. Second, scapegoat the "others" as an explanation of what's wrong. Third, offer nativism and more privileges for the privileged as a solution. That's how we got Trump, Brexit, Le Pen, Orbán, etc.

Putin's playing these games too: he plays on the complex of rage, pain, and impoverishment of the Russian people caused by the Machiavellian privatization and deregulation that happened in the 1990s. "Do you want to go back to the '90s?" It's his main trick. The same old story: using fear to get the power and the money.

(!)

We are all victims of a strange misunderstanding that politics and our everyday lives are somehow disconnected. I meet people here and there, in different countries, who say that they don't care about political issues because the issues don't have any significant influence on their lives. Interesting.

The professionalization and elitism of politics went much too far. The atomization of the people went too far. These

are two sides of one coin, and you know for sure that the coin doesn't belong to us either. The situation is predictably getting worse, because the less we participate in collective actions, the less we believe that we have any power as individuals who can join forces and fight back. **Sometimes it feels like "united" is just an airline that asks you to pay money for your backpacks and leg space.**

Margaret Thatcher said, "There is no society, only individuals." Noam Chomsky reveals that she was paraphrasing Marx, who in his condemnation of repression in France said, "The repression is turning society into a sack of potatoes, just individuals, an amorphous mass can't act together." That was a condemnation. For Thatcher, it's an ideal. There is no society, only atomized consumers.

When we believe it's up to professionals to decide how to run our countries, we start to think that even political revolution or radical change can be effected by another professional instead of us. A professional revolutionary, I guess. It makes us think that we can delegate somebody to clean up our shit in politics, like we pay someone to clean our place after a huge messy party, while we're dying in bed devouring Advil.

Wrong. **We can outsource ugly factories, but we cannot outsource political action.** Lack of involvement and engagement brought us to the point we are at right now, a moment of political desperation and social alienation, a situation where "equal opportunity" sounds like a joke. We cannot hand over responsibility, even to Bernie Sanders or the ACLU. It simply will not work. Bernie, the ACLU, or Bikini Kill will do their best, but we'd all need to become Bernie ourselves if we wanted to get a real new deal.

(!)

It may be calming to think there is somebody wise and powerful who will take care of us. I'm Russian, and we have an insanely strong traditional desire for paternalism. There has to be someone who'll come and make the world a better place. But more often, they will not come. And if they do, there is a very good chance they will be assholes. **Absolute power turns everybody into an absolute shit.**

Some more advice from one of the most brilliant of political organizers, Saul Alinsky. "It is not enough just to elect your candidates. You must keep the pressure on." "The separation of the people from the routine daily functions of citizenship is heartbreak in a democracy." I tend to trust these words.

Putin and Trump, these men devoid of convictions or beliefs, happen to be perfect figures for the twenty-four-hour hyped news cycle, where we are ping-ponged back and forth between indifference and hysteria.

The media universe fills us with a feeling of total helplessness, total defeat. We don't know what is truth and what is a lie, especially when we are fed lies labeled as truth and vice versa. We're constantly being fed shocking stories that leave us feeling hopeless, isolated, and powerless. Pure despair. All-inclusive blackouts. No surprise that we have anxiety attacks.

When I turn on the TV, I feel miserable. The universe is falling apart, and I don't know how to keep it together. It's against our nature to be overwhelmed with bad news and to not have the power to fix it. It leads to frustration, rage, desperation. **What every human being needs is to have a set of tools to overcome the horror. Our aim should be to create this set of tools.**

What makes me hopeful is that I experienced something in my life that tells me this separation could be overcome.

I will never forget the atmosphere at the giant protests against Putin in Moscow in 2011. We were grateful to each other for coming out of our houses and creating a new, incredible, clever political animal and force for good that filled the streets and squares. We were in love with each other and with the feeling that suffuses everyone involved in major emancipatory social movements.

"We had grasped the great truth that it was not rifles, not tanks, and not atom bombs that created power, nor upon them that power rested," says Vladimir Bukovsky, a Soviet dissident. "Power depended upon public obedience, upon a willingness to submit."

There are cultures of eating, film viewing, and book reading, and there is the culture of revolt, the ability to pose awkward questions, cast doubt on things, and change them. Feed the latter. Even the best, most perfect president will serve you fuck-all on a silver platter. It's self-service in these parts.

"It is not simply a question of making the 'other' change; the painful truth is that we, too, will have to change," writes Paul Verhaeghe, a Belgian professor of clinical psychology and psychoanalysis and author of *What About Me? The Struggle for Identity in a Market-Based Society* (2012). "Instead of being merely consumers, we must once again become citizens—not just in the voting booth, but above all in the way in which we lead our lives. . . . If we want politics to be governed by the public interest—and that is more necessary than ever—we ourselves must promote that public interest, rather than private concerns."

Verhaeghe points out a paradox of the (post)modern individual, "a strange type of dissociation, a new form of split personality": we are hostile to the system and at the same time feel powerless to change it. On top of that, "we act in a way that reinforces and even extends it. Every decision we make—what to eat and drink, what to wear, how to get about, where to go on holiday—demonstrates this. We are the system that we complain about."

Erich Fromm distinguished two ways of living: being and having. The "having" mode of existence is a product of consumerist culture, when someone believes that a human being is an empty vessel to be filled with different commodities. If it's not filled, then anxiety, crisis, psychological blackout happens.

If you read Fromm, many things about oligarchy, celebrity fascism, Trump, and Putin become clear. Fromm points out how the development of the industrial economic system radically shifted the values of our civilization. With industrialization, he says, came the idolization of growth and profit. We're not longing to be anymore, but to have, to have the maximum pleasure and fulfillment of every desire (radical hedonism), which results in the egotism, selfishness, and greed of people.

In 1956 Fromm wrote *The Art of Loving*, where he fairly states, "Modern man has transformed himself into a commodity; he experiences his life energy as an investment with which he should make the highest profit, considering his position and the situation on the personality market. He is alienated from himself, from his fellow men and from nature. His main aim is profitable exchange of his skills, knowledge, and of him-

self. . . . Life has no goal except the one to move, no principle except the one of fair exchange, no satisfaction except the one to consume."

I'm concerned with the idolization of economic growth. Why did we even start to think that we have to grow endlessly in the first place? We aren't inflatable ducks or unicorns. "The truth is that, for developed nations, continued economic growth as conventionally measured is incompatible with climate stability," writes Samuel Alexander, a researcher at Melbourne Sustainable Society Institute. "A safe climate requires that we now need a phase of planned economic contraction, or 'degrowth.' This does not simply mean producing and consuming more efficiently and shifting to renewable energy, necessary though these changes are. It also requires that we produce and consume less—a conclusion that few dare to utter." What we need to do is to find a way to make a shift to a stable, postgrowth economy.

We need a shift in values, we need a change of paradigm. **Happiness is bigger than growth and profit—on the scale of the planet, on the scale of history.** I'm sure that if something may be changed at this point, it would never come from the government, it'd never come from the top 1 percent. It will be something requested by mass movements of the people.

Aleksandr Solzhenitsyn wrote, "Thus, the word is more essential than cement. Thus, the word is not a small nothing. In this manner, noble people begin to grow, and their words will break cement." When I am weak, then I am strong. Just like Solzhenitsyn, I believe that in the end the word will break cement.

But if we are to do so, we also need more democracy, and when I say "democracy" I mean "direct democracy." **It's ridiculous and hysterically unfunny that with the internet spread all around, we do not have in our hands more effective methods to directly participate in everyday political decisions.** Our political systems are still structured in a way that pretends the internet does not exist. The authorities cannot guarantee the security of the electoral process. And in fact, many Republicans are more interested in disenfranchising voters than ensuring free and fair elections. We elect representatives once every four or six years and then they are free to do whatever the fuck they want, to take bribes from lobbyists, destroy the public infrastructure, and most importantly, wreck our planet. Don't expect that these rights to participate in direct democracy will be handed over to you, though. The Koch brothers and Putin's buddies, oligarchs like the Rotenbergs, will make sure that we won't get them. We need to gnaw out these rights.

In his final lectures, Michel Foucault spoke of the need for *parrhesia*, the courage to speak out (one of Diogenes's favorite ideas). "We tend to interpret this lazily, for instance by sniping at the Catholic Church, or venting our opinions (bristling with exclamation marks) on internet forums," writes Paul Verhaeghe.

Some would say that we should just rearrange our private lives and it'll be fine. I say that's like making the bed in your cabin on the *Titanic* when the ship is already underwater.

The future is not going to be bright if the driver's seat is occupied by petty assholes. We have to call to account those who are abusing power in our name. We need to grab the power back.

The old Communist cult of personality is still alive in North Korea. If you wish to mention former leader Kim Jong-il in print, one of his many titles and a special typeface must be used. Either something large and out of place (**Brilliant Leader Kim Jong-il** blah blah blah) or something in a different and incongruous font (**FATHER OF THE PEOPLE KIM JONG-IL** blah blah blah).

Although all the names listed below are used to refer to Kim Jong-il, they are equally applicable to any paternalistic fantasy of an almighty figure about to come and save us. If we want to be saved, we may consider undertaking our own action and doing it ourselves. "Nothing will work unless you do," as Maya Angelou said.

A list of people we don't need:

Superior Person

Dear Leader

Respected Leader

Wise Leader

Brilliant Leader

Unique Leader

Dear Leader, who is a perfect incarnation of the appearance that a leader should have

Father of the People

Guiding Sun Ray

Leader of the Revolutionary Armed Forces

Guarantee of the Fatherland's Unification

Fate of the Nation

Beloved Father

Leader of the Party, the Country, and the Army

Ever-Victorious, Iron-Willed Commander

Great Sun of the Nation

World Leader of the 21st Century
Peerless Leader
Bright Sun of the 21st Century
Amazing Politician
Great Man, Who Descended from Heaven
Glorious General, Who Descended from Heaven
Invincible and Triumphant General
Guiding Star of the 21st Century
Great Man, Who Is a Man of Deeds
Savior
Mastermind of the Revolution
Highest Incarnation of the Revolutionary
 Comradeship

Deeds
Bite Off Your Tongue

Let me tell you what happens as the result of an abuse of power. Politically motivated arrests, for example.

"What should I say if I am beaten during interrogation?"

"You should say it is bad to beat people," advises a lawyer, "and put up with it."

"That's it?" I asked.

It's 2012, one week before our arrest. Coffee shop in Moscow. Pussy Riot's activists are here with overstuffed backpacks, our eyes red after a sleepless night. We already know the Russian state has decided to arrest Pussy Riot and prosecute us for a crime punishable by up to seven years in prison. The criminal case has been opened, and we're on the lam. I'm trying to get

used to the idea that I'll end up in prison soon. I eat one cake after another.

"As long as they are beating you, you should say you will bite off your tongue, but you will not testify."

"That I will bite off . . . what? My tongue?"

"Yes, that you will bite off your tongue."

"But I'm not going to bite off my tongue!"

"Well, at least say it convincingly."

Everyone looks at the table.

"Let's try hitting each other in the face with a bottle and find out whether it hurts," my friend suggests.

"No, let's not do it now. We'll scare people."

"Let's step outside then. What, you think you'll have a lot more time to prepare for interrogations?"

The next day we escape from the police to the countryside and find ourselves in a quiet place where the white snow crunches underfoot. If you walk down the hill, atop which the house stands, to a narrow stream, you smell smoke from the Russian stoves, and you hear watchdogs barking from behind old wooden fences.

We go into the apartment and plop down on the floor. We stare straight ahead.

"We need to get some sleep."

"Yes."

The five of us curl up together on a double bed and, huddled together like dogs in the cold, we fall asleep.

We spent two days in the countryside. In the mornings, I descended the hill to jog along the river. When I was warming up, I shadowboxed and shadowkicked the air opposite shattered old brick buildings that had been factories sometime in

the distant Soviet past. I greedily breathed in the rural air, and it made me dizzy. I responded by jumping and flogging the empty space more energetically with my fists.

Despite the cold, the thin stream at the foot of the hill did not freeze over because of the toxic industrial waste dumped into it. I halted on a bridge over the river and listened. I was aware of wooden houses, spruce trees, barking dogs, the smell of woodstoves, the sun, the blinding snow, and water running over stones.

And what if, I thought, swinging my leg, *I don't see this sun and this river again for several years? I need to muster my strength and soak up the sun's warmth while I can.*

I froze, like a dandelion that turns to face the sun. *If I am, nevertheless, imprisoned, I will definitely come back here, to this bridge, because it is my river and my air and my world, and no louse can take them away from me.*

This was what I thought as I stood on the bridge, waiting for my arrest.

<p style="text-align:center">(!)</p>

When the state decided to arrest us, we were not professional politicians, revolutionaries, or members of an underground cell. We were activists and artists, a bit naive and straightforward, as is common among artists.

When we were arrested, we were more like cartoon characters than characters from *Salt* or *Tomb Raider*. We laughed at our pursuers more than we feared them. We would burst out laughing thinking about the pettiness of the circumstances. A huge team of well-trained and well-paid state investigators was tracking down a group of pranksters and freaks with ridiculous bright hats pulled over their faces.

We, the five women who performed the Punk Prayer, sat glued to our rucksacks drinking coffee, gradually getting used to the idea that every sip of coffee could be the last sip we took on the outside.

A few days later, about one hour before my arrest, I painted my fingernails and toenails red, did my hair, and put on a white-and-blue polka-dot ribbon. I left the house to buy a gift for my daughter, Gera, whose birthday was the following day, March 4. Her father, Peter, and I had already bought a set of tiny toy badgers, a whole family (mom, dad, daughter, and son), for her. We had to find furniture and a kitchen for them, and a family of hedgehogs to be their friends.

"Freeze! Hands on the wall!"

Ten men in plain clothes jumped Peter and me near the glass doors of a subway station.

Peter was hurled against the wall.

"Over here, you louse!"

They dragged me away.

They shoved us into a community police office. The men in plain clothes flashed badges from the Moscow CID. Dressed in Adidas sneakers and tracksuits, they were around six feet tall.

I ripped the page from my notebook containing the password for Pussy Riot's mailbox. I crumpled and swallowed it. The paper stuck in my throat.

"Could I get some water?" I asked.

"You don't deserve good treatment, whore!" a CID officer replied.

I reacted by pulling my hood over my head and lying down on the bench in the police office. The thought of chatting with

these guys from Moscow CID did not thrill me. I had a long road ahead of me. I had to gather my strength.

"Get used to sitting up, bitch!"

Another officer, also dressed in a tracksuit, grabbed me and jerked me up.

I took out a book.

Peter managed to make a five-second call to a lawyer with his phone. The cops, enraged because they hadn't been keeping track of him, confiscated the phone and dismantled it.

One of the Moscow CID officers nodded at me, maliciously grinning.

"She's fucking pretending to read."

"I *am reading.*"

I smiled and straightened my polka-dot ribbon.

In all psychologically damaging situations, I read. It helps, I've never had a panic attack in my life. So far. When Trump won the election in America, I read for two months. I was *seriously* overwhelmed.

Take Back the Streets

Streets are our veins. Walls—skin. Roofs, windows—eyes. Trees are lungs. Benches are our butts. Traffic is a burp. We're becoming the town we're living in. We're quite alienated from making decisions about how the city we live in will look. It's ridiculous. How can someone possibly decide how my city will look just because he or she has money and I don't?

If you're living in the city, the quality of your life depends on the quality of public spaces much more than on your furniture. I love cities with lots of graffiti. They have vitality, sexual animal energy, those towns. Every city is a dragon of a million

faces, and we should be able to see it on the streets. If we see only the footprints of billionaires and corporations, it means that the dragon is sick, and it needs an anarchist angel doctor. I don't understand cities that have been completely taken over by commerce. They look like shopping malls where only zombies can stay alive. I don't like it when I can't sit on the ground.

"It looks like you're hanging out here," guards tell me. Yes, I am. That's what I call life, hanging out here and there, leaving traces. Take back the streets, make them beautiful, different, controversial, strange. The streets are an open ongoing conversation. The streets are open relationships too.

Occupy Wall Street is one of the most inspirational things that has happened so far in the twenty-first century. I could not believe my ears when I heard about it for the first time. The 1 percent understood the power of this movement too, and they did their best to shut down this magic situation of reclaiming streets.

It was May 6, 2014, and we were about to have a meeting at the US Senate in Washington when we learned about Cecily McMillan's case, one of the most brutal decisions against Occupy protesters. Cecily McMillan was convicted of felony second-degree assault after she was arrested and assaulted by a New York City police officer. She said that her breast was grabbed and twisted by someone behind her, and she responded by reflexively elbowing her attacker in the face. The police officer disputed Cecily's version of events, and the jury sided with him. As a result, she was facing seven years in jail. Pussy Riot faced seven years for our protests too.

At the Senate we were supposed to be raising awareness about human rights abuses in Russia, but we were so shocked

by Cecily's case—we considered her an American political prisoner—we decided to go broader and speak about her as well, in the Senate and then at our a press conference on Capitol Hill.

Instead of calling Capitol Hill "Capitol Hill," we happened to call it "Capital Hell."

On May 9, a few days after our hearing in the Senate, I met Cecily McMillan in the Rose M. Singer Center on Rikers Island, New York City's offshore complex of ten jails that can house up to 15,000 prisoners. Cecily has an amazing political charisma, a trait not every social or political activist can successfully cultivate. Cecily's efforts are aimed at undoing social indifference: her ideals are volunteering, solidarity, and mutual consideration of other people's struggles, but her ideals were nowhere to be found in that court.

The judge who presided over the case, Ronald Zweibel, seemed to be siding with the prosecutors from the beginning—time and time again he forbade the defense from presenting evidence to show the jury that Cecily's physical action of using her elbows against the police was not without just cause. The cops' use of force to disperse Occupy activists was not an isolated event, and Cecily was adamant that she was personally reacting against sexual harassment. The judge limited the jury's access to information during the trial. On May 5, Cecily was found guilty.

Despite the fact that nine of the twelve jurors wrote a letter to the judge asking that she not be incarcerated, Cecily could have been sentenced to seven years in prison. On the day Cecily was sentenced, the jurors were not aware of the article used to accuse Cecily, nor were they aware that the article stipulated imprisonment. The jury's change of heart calls to mind a quote

from Luke 23:34: "They know not what they do." The fate of Cecily McMillan is a perfect example of why her efforts as an activist are needed: the inability of the jury to accept Cecily's problems as their own and to take the time and consideration during her trial to seek justice resulted in her imprisonment.

Me and my Pussy Riot colleagues Masha and Peter went to visit Cecily on Rikers Island. She might be the happiest prisoner we ever met.

Cecily told us with great pride that her ability to talk to people of different social categories and groups is one of her most valued traits. Her ultimate goal is to find points of contact between closed social clusters and create a platform for shared, collective action. At various times in her life, Cecily has found herself in completely different strata of American society, switching from one layer of language and experience to another. This is the heart of Cecily's interest—to master these "other tongues"; to understand social circles outside of that in which she was born, raised, and made her career; and to understand other people's experiences.

Cecily wants to gradually recover the lost social dialogue between the 1 percent, who basically own everything, and the 99 percent, who have to live in their shadow. She also opposes the policies of Wisconsin governor Scott Walker, who, in an effort to further restrict trade union rights, gave the green light to arrest hundreds of people whose only fault was singing in the State Capitol. (I spent two years in prison for singing a song about Putin. I can't understand how anyone could be arrested for singing.) If it is Walker's goal to weed out undesirable voices, then it is Cecily's goal to return those voices to the people who have been deprived of them.

Cecily McMillan's case reflects global politics. Judge Zweibel's verdict marked a dangerous new direction in the United States and countries indirectly impacted by US domestic policies.

"May Judge Zweibel avoid becoming a link to these practices and, like a true patriot, may he admit his fault and rescind such a shameful judicial precedent?" I asked myself after visiting Cecily in jail.

P.S. After three months in Rikers, Cecily was released; she got five years of probation.

(!)

Step into the streets and take back what's ours. Streets, squares, corners, yards, shores, and rivers—they are public; education, health care, transport, and natural resources are public too. We just have to remember that.

We have more than enough signs that changes are ready to be made, that people are willing to share their time, energy, brains, and hearts to reach their dreams. The massive support for progressive forces all around the globe is obvious to anyone who breathes—for Jeremy Corbyn, who won the votes of the young generation in Britain, Bernie Sanders in the United States, the Podemos party in Spain. And Russia too, where there have been huge protests against Putin and his fellow oligarchs, a mind-blowing grassroots campaign for an alternative future for our country.

"All over the world, people are rising up against austerity and massive levels of income and wealth inequality," Bernie Sanders said at the People's Summit in Chicago right after Corbyn's Labour Party's stunning result in the UK election in June 2017.

"People in the UK, the US and elsewhere want governments that represent all the people, not just the 1 percent."

Heroes
THE Berrigan Brothers

As an activist, I am often asked, What are you fighting for? Why should we organize?

We have solid answers that are reasonable enough: we need real democracy, a better quality of life for the 99 percent, free independent media, broader opportunities, access to medication and health care, environmental responsibility. But there are times when you're exhausted as an activist, as a human being. Sometimes you're just tired.

Then you find your source of inspiration in muses who are walking through life so elegantly, meaningfully, bravely, fighting beautifully and politely and without compromise. They're not mythological figures or the product of fairy tales or miracles. They're real. Look around you. Shake off pain from your shoulders, let it fall to the floor, and go march with your muses. Make an effort to speak in "the unlikeliest and rarest of tongues: the truth," as Daniel Berrigan put it. People like the Berrigan brothers, Daniel and Philip, are muses for an activist.

Philip Berrigan served in the US Army in World War II, then became a priest in 1955. Daniel Berrigan, the intellectual and theologian, was ordained in 1952.

Daniel Berrigan gives us one of the best possible reasons to keep being motivated to spot abuses of power. "But how shall we educate men to goodness, to a sense of one another, to a love of the truth? And more urgently, how shall we do this

in a bad time?" (as quoted on the cover of *Time*, January 25, 1971). "After a given time, we cannot so much as imagine any alternative human arrangement than the one we are enslaved to—whether educational, legal, medical, political, religious, familial. The social contract narrows, the socialization becomes a simple brainwash. Alternative ways, methods, styles are ignored, or never created," he writes in *The Nightmare of God: The Book of Revelation*. As an antiwar activist and the first-ever priest on the FBI's "most wanted list," Philip and Daniel collaborated with Howard Zinn and Martin Luther King Jr., led antiwar demonstrations, and resisted American military imperialism in the turbulent times of the Vietnam War. In his lifetime, Philip Berrigan served eleven years in jail for his protest actions.

In 1967 Philip Berrigan and his comrades (the "Baltimore Four"—two Catholics and two Protestants, one of whom was an artist and two ex-military, including Berrigan, a former infantry lieutenant) occupied the Selective Service Board, a military building in Baltimore where the draft was organized. The men poured human and chicken blood over records in a sacrificial act meant to protest "the pitiful waste of American and Vietnamese blood in Indochina." Philip Berrigan and others were arrested for this action. Their trial took place at the same time as the assassination of Martin Luther King Jr. and the subsequent riots in Baltimore and other American cities. Berrigan was sentenced to six years in federal prison. Their nonviolent action laid the foundation for more radical antiwar demonstrations.

"I think that [the] word [of the church], on the modern scene, is one of liberation from death. We are learning something of the price of that word, in repeated trials and jailings," writes Daniel Berrigan.

In 1968, Philip Berrigan was released on bail. Of course, the brothers did not stop. Philip and Daniel, joined by seven other activists (the group became known as the "Catonsville Nine") walked into the offices of a draft board in Catonsville, Maryland, removed six hundred draft records, doused them in homemade napalm, and burned them in front of the building.

"We confront the Roman Catholic Church, other Christian bodies, and the synagogues of America with their silence and cowardice in the face of our country's crimes. We are convinced that the religious bureaucracy in this country is racist, is an accomplice in this war, and is hostile to the poor," they said.

The brothers were convicted of conspiracy and destruction of government property. They were sentenced to three years in prison. They went into hiding but were caught and forced to serve the sentence.

Our courageous priests' story is far from its conclusion at this point, but I'll shut up and let you explore it by yourself. Do it during the tough times when you feel like you have way too many troubles as an activist. What if you don't?

One of the biggest challenges in resisting abusive power is that you constantly have to look for more inspiration and motivation. They beat you, and you don't just bear it, but you find in yourself enough courage and mischievous energy to laugh. **The key is consistency. Power is abusive pretty consistently. We should be consistent in spotting it and building alternative futures.**

DON'T GIVE UP EASY. RESIST. ORGANIZE.

When you say that the emperor is naked, you may end up being punched in the face by the emperor's people. You'll be labeled demented and insane; a crazy, perverted, dangerous idiot. But you're the happiest sort of idiot—an idiot who knows the divine joy of telling the truth.

Art and liberty, like the fire of Prometheus, are things one must steal, to be used against the established order.

PABLO PICASSO

Prison can be ecstasy. . . . They say even in DC Jail, you can't go lower than we've gone. We're in deadlock: 24-hour lockup, two in a cell hardly large enough for one, sharing space with mice, rats, flies and assorted uninvited fauna. Food shoved in the door, filth, degradation.

And I wouldn't choose to be anywhere else on the
planet. I think we've landed on turf where the breakthrough
occurs. I think it's occurred already.

<div style="text-align: right">DANIEL BERRIGAN, THE NIGHTMARE OF GOD</div>

A man possessed of inner freedom, memory, and a sense
of fear is the blade of grass or wood chip that can alter the
course of the swift-flowing stream.

<div style="text-align: right">NADEZHDA MANDELSTAM, HOPE ABANDONED</div>

Words

What makes us act out? I for one am really angry because Russia's principal political institutions are law enforcement, the army, intelligence agencies, and prisons. Run by a lone insane quasi-superhero, riding horseback half-naked, a man who is not afraid of anyone (except gays). A man so generous that he has handed half the country over to his closest friends, all of them oligarchs. What kind of act is this?

By working together, we can build institutions different from these.

We don't want to be passive squares, boring phonies, or conformists seduced by comfort, trapped in a repetitive, endless ritual of consuming, who keep buying shit that's thrown to us as a bone, who forget how to ask honest and important questions, who are *just trying to make it through the day*.

Take Your Beatings as a Badge of Honor

They will try to shut you up and shut you down.

It's useful to have the ability to transform obstacles and trag-

edy into strength and faith. If you can get it, do it. I'm not sure where they sell it, but if you come across this thing, no matter what it costs, you must pay, and then pay some more. It's worth every penny.

Me and the other Pussy Riot members acquired this superpower during our arrest, trial, and jail time. **Ironically, by locking us up we found an almost sublime liberation.** Despite the fact that we were physically imprisoned, we were freer than anyone sitting across from us on the side of the prosecution. We could say anything we wanted, and we said everything we wanted. The prosecution could only say what the political censors permitted them to say.

Their mouths are sewn shut. They are puppets.

Stagnation and the search for truth are always opposites. In this case, and in the case of every political trial, we see on the one side people who are attempting to find the truth, and on the other side people who are trying to fetter the truth seekers.

It was our search for truth that led us to the Cathedral of Christ the Savior. We were persecuted in the name of Christianity. But I think Christianity, as I understood it while studying the Old Testament and, especially, the New Testament, supports the search for truth and a constant overcoming of oneself, the overcoming of what you were before.

But I did not see evidence of forgiveness at our trial.

It would serve us well to remember that a human being is a creature who is always in error, never perfect. She strives for wisdom but cannot possess it. This is why philosophy was born. This is ultimately what forces the philosopher to act, think, and live, and most importantly, maintain a sense of poetry in their outlook on the world.

In poetry and political trials, there are no winners and losers. Together, we can be philosophers, seeking wisdom instead of stigmatizing people and labeling them.

(!)

The price of participation in the creation of history is immeasurably great for the individual. But the essence of human existence lies precisely in this participation. To be a beggar, and yet to enrich others. To have nothing, but to possess all.

Do you remember what young Fyodor Dostoevsky was sentenced to death for? His guilt rested on the fact that he was fascinated by socialist theories, and during meetings of freethinkers and friends, on Fridays in the apartment of Mikhail Petrashevsky, he discussed the writings of Charles Fourier and George Sand. On one of the last Fridays, he read aloud Vissarion Belinsky's letter to Nikolai Gogol, a letter that, according to the court that tried Dostoevsky, was filled "with impudent statements against the Orthodox Church and the supreme authorities." Dostoevsky was taken to a parade ground to be executed, but after "ten agonizing, infinitely terrifying minutes awaiting death," it was announced that the sentence had been commuted to four years of hard labor in Siberia followed by military service. The same day Dostoevsky wrote his brother, "Life is everywhere, life in ourselves, not in what is outside us."

Socrates was accused of corrupting youth with his philosophical discussions and refusing to accept the Athenian gods. He had a living connection with the divine voice, and he was not, as he insisted many times, by any account an enemy of the gods. But what did that matter when Socrates irritated the influential citizens of his city with his critical, dialectical thought,

free of prejudice? Socrates was sentenced to death, and having refused to escape Athens (as his students proposed), he courageously drank a cup of hemlock and died.

Injustice in the name of religion. Labeling truth seekers as crazy. Even Christ himself, characterized as "demon-possessed and raving mad" (John 10:20), was sentenced to death for crimes against the church: "It is not for good works that we are going to stone you but for blasphemy" (John 10:33).

If the authorities, tsars, presidents, prime ministers, and judges understood the meaning of "I desire mercy, not sacrifice" (Matthew 9:13), they would not put the innocent on trial. Authorities, however, are still in a hurry to condemn, but in no way to reprieve.

If you let someone define what is the center for you, you're already playing somebody else's game. But if you try to live your life right, you can look any (wo)man in the face and tell her/him to go to hell.

TERMS ALL MEMBERS OF THE RESISTANCE SHOULD KNOW

GREED. An emotion that tells you money and fame are the most important things. If you don't fight it actively, it's easy to get caught up in greed. It sneaks up on you, and then you find yourself doing shit you never would have dreamed of as a kid. When greed has crept in, you lose a clear vision of things. You become a proud member of the league of bastards. But pigs cannot fly, even if they are genetically altered.

IMPEACHMENT. Something you should demand if your president is a dangerous, uncontrollable asshole, every day getting more backward than he was to begin with.

CELEBRITY FASCISM. A disease that should be eradicated by any means. An ultracorrupted state of mind in which someone believes that money and status will always let you get away with being an asshole and committing crimes. "And when you're a star, they let you do it. You can do anything. Grab 'em by the pussy."

CLITORIS. A very important part of the human body that has been extensively repressed by patriarchal culture. It's something that is either ignored by phallocentric society or destroyed through barbaric procedures of mutilation.

OBSTRUCTION OF JUSTICE. One of the main methods of handling the country and managing law enforcement agencies' job, according to Putin. Trump shares Putin's views on that.

FREE TUITION. Something we should all have.

ORGANIZATION. A must for activists. The only way to go. Occupy streets and squares, and do not leave until your requirements are fulfilled. Plot, demand, persist. There is a monster inside all of us, and the monster wants honesty.

PUSSY. Something that you're not going to get without a riot. No riot, no pussy.

PUTIN. A tiny malicious KGB agent, whose main goal in life is to steal more and more money from the Russian people and who would love to see a patriarchal, ethics-free oligarchy spread all around the globe.

Deeds
Freedom is the Crime That Contains All Crimes

Arrest is an almost religious experience. **The moment you are arrested, you are abruptly purged of the self-centered confidence that you can control the world.** You find yourself alone and faced with a vast ocean of uncertainty. Only high spirits, a smile, and calm confidence can help you sail across this ocean.

We are not told what we have been arrested for, and I don't ask. Goes without saying. Keys, telephones, notebook, and passport are all confiscated.

After all the necessary formalities have been observed, we are sitting with the political police case officer in the hallway of the police station. "By the way, you hid very well. We knocked ourselves out looking for you. Way to go."

My first interrogation is at 4:07 a.m. I refuse to testify. An hour later, I am taken to the Temporary Detention Center at Petrovka, 38. Prisoners move around stiffly in handcuffs, escorted by guards. The next confiscation steals my shoelaces, scarf, boots, bra, and polka-dot ribbon.

A blond female cop orders me to strip, spread my legs, and bend down, and she pulls my butt cheeks apart with my hands.

"And hurry, hurry, you're not in kindergarten!" says the blonde's partner, a brunette.

I write an official announcement that I am going on indefinite hunger strike.

I am already hungry as hell.

My mind is swimming as I scribble my thoughts. It's what I was thinking at that time, but I didn't have to write it down to remember it all my life:

"There are so many things I haven't managed to do. I had so many ideas. I have done so little for my age. If I had only known I would be thrown in jail when I was twenty-two. . . . Are headache tablets permitted in jail? I need them. I take them every day. And . . . and there is a text I still haven't finished writing. Tomorrow is my daughter Gera's birthday. We never finished buying her presents. What will she think? How is she doing without me? When will I be able to come back? Will I be able to? Where am I? What happens when a person is imprisoned? It's like she is dead to other people, right?"

Your first jail cell is a relief. Finally, cops and investigators no longer surround you. There are no more questions. It is just you and the wall opposite you.

I turn on the radio. "Members of the controversial group Pussy Riot, who disturbed the peace in Christ the Savior Cathedral, have been detained and placed in a temporary detention facility. They are under investigation," reports Radio Russia.

"Thanks, goddamnit, for the news. We didn't need you to tell us," I say to the radio as I shiver on my bunk.

Three days after our arrest we are brought to the court that—surprise!—decided to keep us locked up during the investigation (the investigation of a highly dangerous criminal activity—girls jumping around for forty seconds).

This is what was written in my criminal case, case no. 17780: "Pretrial restrictions not involving detention cannot guarantee the accused will honor the obligations imposed on her by the Criminal Procedure Code and will permit Tolokonnikova to escape, obstruct the investigation, and continue to engage in the activity that has led to the filing of these criminal charges."

That's what law enforcement people normally say in situations when they need to hold someone for a long time. And it's not like what they said was untrue: no doubt if I stayed out of prison, I would indeed "continue to engage in the activity that has led to the filing of these criminal charges." No doubt about that at all.

<div align="center">(!)</div>

Women's Pretrial Detention Facility No. 6 is a place of magical, malicious beauty. The old, fortresslike brick building is constructed in the shape of a rectangle. It contains a huge yard where, in a concrete structure divided into sectors, suspects, defendants, and convicts are walked.

It's a clammy brick castle pervaded by the never-fading stench of rotting garbage. And by the chimes coming from a nearby church on Sundays.

Some jail cells contain fifty-four people, even though they have only forty-one beds. Girls sleep under benches, come out from under the table in the morning. A pregnant girl sleeps on a broken cot. The cells are full of yelling and shouting.

New arrivals are led into a gloomy room with dark-green walls and old, dusty lights. In its depths sits a woman who is either very young or going on forty. It's hard to say, because the expression of indifference and hopeless fatigue imprinted on her face would age even an eighteen-year-old woman. She issues you a mattress.

Hugging the mattress and swaying after ten days without food, you climb to the third floor. A semicircular brick wall patterned with narrow windows made of thick, opaque glass frames the staircase.

With each passing day of the hunger strike, your blood pressure falls. Headaches have become so bad it is hard to get out of bed. For the first time in your life you can feel your own kidneys (because they are sick too), and your skin is dry, and your lips are cracked.

Finally, you chew a piece of prison bread, washing it down with the local tea, a sweet, light-brown, lukewarm liquid. After your hunger strike, you respect the prison bread from that day on.

(!)

I've learned some things in jail. I used to never be able to do push-ups, touching my breasts to the floor. In prison, I can pump them out. During strolls, I wear myself out by doing hundreds of exercises.

(!)

Six months after our arrest, the court bailiffs' dog, which had sat next to our cage for three hours with a sad, tormented expression on its mug, suddenly stiffened, its body twisted in a light convulsion, and spewed a puddle of vomit on the courtroom's parquet floor.

The bailiffs glanced at the dog reproachfully, and the judge paused for a moment, but the trial went on without a hitch. The people in the gallery laughed. We watched the dog sympathetically for the rest of the court day. Who knows why, but the puddle was not cleaned up for another three hours.

"Hold still! No sudden movements!"

In the basement of the lockup at the court building, we are under attack by another dog and its master, a sullen, wiry man

resembling both the anti-intellectual hero of a Hollywood action movie and a porn actor playing the role of a rough, simple man. The dog barks its head off and tries to attack us. The guy digs his sinewy legs into the floor and uses his whole weight to try and pull the dog away. The dog continues to yowl.

"Excuse me, but why is your dog so agitated?" I ask.

"She has been trained to react to jail smell."

Great. Now even dogs will treat me as an inferior because I am in jail.

(!)

A lot of strange things happened while we stayed in pretrial detention.

I was locked in a cell with a former police investigator. She was one of those people who had followed her heart and joined the police after watching a TV series about good cops in her childhood. During the 1990s she investigated crimes, saving citizens from malevolent cops, and she was happy. In 2003 she resigned, because she lost interest. Nobody needed crimes solved. Instead, total submission and unconditional loyalty were all that were required, even the willingness to break the law. Her ex-husband, also a cop, put her in jail for a crime she did not commit. She was accused of being a fraud. But in fact her ex-husband openly told her that her criminal case was bullshit, and if she'd give him a flat she owned, he'd make this case disappear and she'd be free. She refused to give him the flat. So she was in jail.

One day during the Pussy Riot trial, she had a revelation that what John the Evangelist had written about would come to pass, purging Russia of the Putinist abomination.

Meanwhile, a priest who wanted to apologize to Pussy Riot was banned from the ministry by the church.

A man who claimed to be a supporter of Pussy Riot tried to kill with an ax the judge who had given permission to arrest us.

Orthodox activists were walking around the court chanting, "All power is from God! Send the witches to the bonfire." People dressed like Cossacks attempted to light a fire for the witches.

PENITENTIARY NEW YEAR RECIPES

OLIVIER SALAD

Instant noodles (substitute for potatoes because boiling potatoes is restricted)
Pickled cucumbers
Canned peas
Onion
Mayonnaise (a lot)
Canned fish/beef (instead of popular Doktorskaya sausage)

NEW YEAR'S EVE CAKE

Cookies
Butter
Condensed milk (a lot)

Put the ingredients in the mayo container (there are no other bowls anyway) and combine.

Enjoy your meal! Happy New Year!

The court was surrounded by people who supported us. And by some who hated us—Orthodox Christian activists who were asking for ten years of prison for us and were walking around in "Orthodox Christianity or death" T-shirts.

Our judge complained that she was being publicly shamed for fulfilling her duties. Indeed, activists who saw her walking the corridors of court would start to scream, "Shame on you! Shame on you!" The day before the verdict in the Pussy Riot trial was announced, our judge was assigned a personal government security detail.

The cells are located in the court basement, where you wait until guards bring you to the courtroom. These cells are always outstandingly dirty, dark, and small. So you're sitting there chewing your crackers, reading notes that have been left for you by other prisoners: "Russia will be free," "Sun shines for thieves, sun does not shine for cops," "ACAB," prison love poetry (the whole genre).

You sit on a dirty bench. Guards are shooting idiotic comments at you and you're swallowing it. You're trying not to lose a sense of self-respect, though. You'll be brought to your friends, relatives, all your supporters who wait outside. You don't want to show them how humiliating and discouraging your whole experience in jail is. You're smiling and your smile is an act of resistance. It's a matter of principle, if you wish. It's tough and gloomy here in jail, but you don't give those who put you here joy in observing your sufferings. Fuck you, dear government. **My smile is my ultimate weapon.**

It's awkward to hear your own sentence being read out. I'd only seen things like that in movies before. You're expected not to sleep the night before your sentence. I resisted this tra-

dition in my own fashion and slept like a baby. If you're about to be transported to a prison camp where you'll have to work as a slave, you'd better get some good sleep while you have the chance.

When they read your sentence, you have to be handcuffed. For four hours you stand, handcuffed, listening to the bullshit that your judge did not even write herself. This kind of decision comes from the administration of the president. You're listening to your sentence and know already—from your interrogators, from prosecutors, from Putin's comments on your case, and from TV propaganda—that you won't get out of prison soon.

"Defendants' behavior cannot be corrected without isolation from society," says the judge, and you know what this formula means. You're going to a labor camp. And then she adds, "Two years." It sounds like forever. Every day in prison lasts forever.

We were transported back to the detention center surrounded by five police cars and a couple of police buses. They literally blocked roads to transport us to the facility, because they were scared that protesters would try to free us. I was thinking about my future life in a penal colony and trying to convince myself that it was an exciting challenge to me as an activist.

Heroes
Emmeline Pankhurst

The fight for women's suffrage—the right of women to vote in elections—has been long and hard. The white male oligarchs

who hold power have been reluctant to give the vote to anyone other than themselves—even today, look how hard they are working to take the vote away from poor and minority voters in the United States. So at the turn of the twentieth century, when women came together to demand rights similar to men, it was clear: the struggle was going to be difficult.

One of the great pioneers of the women's vote was Emmeline Pankhurst. I learned about Pankhurst when I was a schoolgirl. There was an English language lesson and I had to pick an influential historical figure to talk about. My affair with Emmeline started from me misspelling her surname: I was sure for a while that it was "Punkhurst," which sounded super dope to my Russian ear, more like "Punk Thirst." As a result, I believed that Pankhurst was the mother of English punk.

Emmeline Goulden was born in Manchester, England, in 1858. The man she married, Richard Pankhurst, was a lawyer who supported voting rights for women and drafted a suffrage bill in the 1860s. With her husband's support, Emmeline founded the Women's Franchise League and won the right to vote in local elections. After his death, she founded the Women's Social and Political Union, which included her daughters Christabel and Sylvia. The organization worked for social reforms, in particular the vote. Give us the right to vote, the women said, and we will fulfill our obligation as citizens.

Frustrated by an immobile government, the women got "militant"—which is what men say when women misbehave. Emmeline was arrested often, and when she went on hunger strikes in prison, she was force-fed. **When my prison doctors approached me on my eighth day of hunger strike to say I was about to be force-fed, I thought about Emmeline.**

Christabel organized a group of women arsonists. Women all over the world began doing organized radical actions. They poured acid in mailboxes, broke windows, and chained themselves to railings. In the most dramatic action, a woman named Emily Davison went out on the racecourse during the biggest horse race in England, the Derby, and was trampled to death.

Although male onlookers were horrified by such unladylike actions, the suffragists were absolutely fearless. The British government decided it didn't look good to stick feeding tubes down the throats of ladies in prison to stop them from starving themselves to death, so they passed the "Cat and Mouse Act." Women who went on hunger strike were released and re-arrested when they regained some strength. Emmeline was let out of prison and arrested twelve times in a year under this act.

Emmeline described herself as a "soldier." She was clear on what had to be done to get women to be treated as human beings. The government was going to have to either kill women or give them the vote.

In 1913, she made a speech to supporters in Hartford, Connecticut. (Women suffragists were jailed and force-fed in the United States too, of course.) "You have two babies very hungry and wanting to be fed," she said. "One baby is a patient baby, and waits indefinitely until its mother is ready to feed it. The other baby is an impatient baby and cries lustily, screams and kicks and makes everybody unpleasant until it is fed. Well, we know perfectly well which baby is attended to first. That is the whole history of politics."

Then came World War I. It was hard for even the most reactionary government to deny the contribution made by women to the war, and women in the United States and Britain got

the vote shortly after, but only those over thirty in the United Kingdom (along with millions of men over twenty-one with no "property"). In 1928, the year Emmeline Pankhurst died, the women's voting age was brought into line with the men's.

Like a lot of rights unwillingly granted by states, the right to vote is fragile. Women only got the right to vote in Swiss national elections in 1971. Don't even ask about Saudi Arabia. A woman's right to choose is being taken on nationally and locally. Seven US states have only one legal clinic licensed to perform abortions. How secure is gay marriage? Or Medicare and Medicaid? Rights hard won by women like Emmeline Pankhurst aren't won forever. We have to not only work for new rights but protect the ones we already have. Like hungry babies, we must kick and scream and raise hell to be fed.

BREAK OUT FROM PRISON

The modern prison system, in the form in which it exists in Russia, the United States, China, Brazil, India, and many, many other countries—as an island of legalized torture—should be destroyed. That's it.

The degree of civilization in a society can be judged by entering its prisons.

FYODOR DOSTOEVSKY, *THE HOUSE OF THE DEAD*

I'm suggesting that we abolish the social function of prisons.

ANGELA DAVIS

While there is a lower class, I am in it, and while there is a criminal element, I am of it, and while there is a soul in prison, I am not free.

EUGENE V. DEBS, STATEMENT TO THE COURT UPON BEING CONVICTED OF VIOLATING THE SEDITION ACT, SEPTEMBER 18, 1918

Have not prisons—which kill all will and force of character in man, which enclose within their walls more vices than are met with on any other spot of the globe—always been universities of crime?

PYOTR KROPOTKIN, *ANARCHISM: ITS PHILOSOPHY AND IDEAL*

Oh bondage! Up yours!

X-RAY SPEX, "OH BONDAGE UP YOURS!"

Words
THE PRISON-INDUSTRIAL COMPLEX

It's a well-known fact: when you extract profits and then label yourself a savior, you're the worst sort of douche—you're a hypocritical douche. People like this use desperation and poverty, discrimination and racism to build one of the most profitable of all global enterprises, the prison-industrial complex. It's been said that prisons are here to help us, but this is not so—we don't get much help from them. We're silenced, enslaved, and used. They say that it's about "rehabilitation," but often prisoners don't even have the freedom to read books, talk to relatives, or go to church—they are too busy working, making profits for the penitentiary owners.

Hopelessness partnered with cynicism and cruelty is what I've seen in the eyes of those who have to go through the prison system as it exists in modern Russia and in modern America. During the two years I spent in Russian prisons, I dreamed of another, alternative prison system that would give prisoners a chance to explore their inner worlds, get educated, read, create art. I literally had dreams about it: dreams about a penal colony

where inmates would learn about other cultures—Chinese, Indian, Iranian, Japanese cultures. A strange thing happened: I woke up with the English word "REVIVAL" pulsing in my head. In my dream, it was written on a chalkboard in a prison class. I had no idea what this word meant at that time, but I wrote it down. I explored its meaning later.

In reality, the nightmare of prison couldn't have been more different from what I witnessed in my dreams. It was dehumanizing, barbaric. "The prison . . . is not only anti-social, but anti-human, and at best is bad enough to reflect the ignorance, stupidity and inhumanity of the society it serves." That's from Eugene V. Debs (from his book *Walls and Bars*, published in 1927, after Debs's death), a political organizer and labor union leader who ran for president from prison, where he spent six months as the result of his socialist activity.

"It must surely be a tribute to the resilience of the human spirit that even a small number of those men and women in the hell of the prison system survive it and hold on to their humanity," writes Howard Zinn in *You Can't Be Neutral on a Moving Train*.

The prison system I know can produce only two things: first, profits for bureaucrats or corporations; and second, masses of people who *hate* the government, who will never trust anybody from an official institution. If your goal is to increase crime, that's the way to do it. I know my time spent in Russian prisons made me anything but apologetic, anything but obedient to the system.

Since my Pussy Riot colleague Masha and I got out of prison, we have visited many prisons all around the world, spoken with prisoners and ex-prisoners, with activists and organizations

whose goal is to create real resocialization for ex-prisoners. We have been amazed by how closely the Russian and US prison systems resemble each other. The Cold War made our countries similar in a lot of ways, not just in aggressive imperialism, militarism, and huge inequality, but in the attitude of our governments to those people who have no power, who are behind bars.

We studied how Baltic countries, which used to be under Soviet rule, are exploring other ways of dealing with prisoners rather than those popular in the gulag, how the old type of prison is being replaced with new ones, which want to help a human being rather than destroy his or her will.

We visited a former Stasi (East German security service) prison in Berlin and witnessed how they're working with their past, remembering the torture and murder. There is a female prison in Berlin too with a very respectful attitude to inmates (good conditions, legal same-sex partnerships in prison, no obligatory jobs).

We've seen Scandinavian prisons and their rehab centers, shelters for ex-prisoners, and social workers who help them find a job. We know it's possible: a situation where an inmate sees a social worker not as an enemy but as someone who's there to help. It's not the case in a Russian prison. Or an American prison.

The United States leads the world in a lot of areas. It has the largest economy, the top-rated universities, the most Olympic gold medalists. But it also leads the world in putting people in prison. The United States has not quite 5 percent of the world's population but more than 20 percent of its prisoners. **One in five of all people in prison in the world are locked up in the United States.**

One reason for this is the disastrous "war on drugs" that began in the 1970s. In 1980, the federal and state prison population was about 320,000. In 2015, according to the Bureau of Justice Statistics, there were 1,526,800 people in federal and state prisons (a *decrease* of 2 percent from 2014), plus more than 700,000 in local jails (up from 182,000 in 1980), hundreds of thousands of them locked up for nonviolent drug offenses. Sentences for marijuana possession were often harsh and remain so in states like South Dakota and Indiana. Now that scientists are indicating that smoking pot is less dangerous than drinking alcohol and states are legalizing pot possession, the United States is in the absurd situation of having hundreds of thousands of people in jail for doing something that is now perfectly legal in many states.

And prison policy is racist. African Americans are locked up at a rate five times higher than that of whites. Sentences for crack cocaine, a drug introduced into African American communities and heavily used in inner-city neighborhoods, were much harsher than those for the powder form, which was used more often by white people. The sentences were sometimes a hundred times longer for what is the same drug.

How confused I was when I went to Rikers Island, the giant prison complex in New York City, and found out that all the visitors were people of color. "Why don't you get put in prison in this country if you're white?" I wondered. Interesting.

There is a giant poster at the entrance to Rikers saying that you cannot wear extra-large pants and hoodies. Why? Perhaps because prison officials are ignorant enough to seed and spread the prejudice about that connection between hip-hop culture and crime.

If you need to know something about inequality, ask Howard Zinn. "The poorer you were the more likely you were to end up in jail. The rich did not have to commit crimes to get what they wanted; the laws were on their side. But when the rich did commit crimes, they often were not prosecuted, and if they were they could get out on bail, hire clever lawyers, get better treatment from judges. Somehow, the jails ended up full of poor black people" (*A People's History of the United States*). In the words of Eugene V. Debs, "As a rule only the poor go to prison. The rich control the courts and the poor populate the prisons."

Politicians long outdid each other being "tough on crime." Bill Clinton interrupted his 1992 presidential campaign to sign a death warrant for a mentally challenged man convicted of murder. The man, Ricky Ray Rector, had shot himself in the head after committing murder, effectively lobotomizing himself. He could barely function, yet he was executed. Rector asked for the guard to save the dessert from his last meal so he could eat it later.

Instead of realizing that the system wasn't working, the authorities just kept locking people up and found a mind-blowing solution for managing the increase: privatize! Private correctional facilities were started in the 1980s—locking people up to make a profit. By 2015, at the peak, 18 percent of federal prisoners were held in private prisons. In 2016, Obama's Justice Department announced it was phasing out private prisons. Of course, Trump reversed that policy. In anticipation, the day after the election, the stock price of the largest private prison company, now called CoreCivic, went up 43 percent.

Like education and health care, if the main goal is to make a profit, actually teaching people or healing people or rehabili-

tating people, in the case of prisons, is secondary. No one gives a shit at all. Private prisons exist to punish. Because they make money from people being incarcerated, the corporations lobby for harsher sentences and support politicians who are toughest on crime, as do the 400,000-plus prison guards.

Prison shouldn't be a profit center. The whole system costs $80 billion a year. Wouldn't most of that money be better spent on keeping people *out of* prison, not in it? On education and retraining, job creation, drug treatment, and so on?

We should support any efforts at reform. Even some Republicans, like Rand Paul, support criminal justice reform. Some 450,000 people sit in jail because they are denied or can't make bail, even when it's a few hundred dollars, and lawmakers including Paul are trying to change that in Congress.

The prison system does not help those who found themselves in trouble to return to society. It labels you an outcast and *prevents* you from being included. It's been this way forever. "Year after year the gates of prison hells return to the world an emaciated, deformed, will-less, ship-wrecked crew of humanity . . . their hopes crushed. With nothing but hunger and inhumanity to greet them, these victims soon sink back into crime as the only possibility of existence," says Emma Goldman in the essay "Prisons: A Social Crime and Failure" (1910).

As far as drugs are concerned, some places have come to their senses. Cities like Seattle and Ithaca, New York, are looking at drugs as a health care issue and not a criminal justice issue. Some even provide heroin users with places to safely use as part of a comprehensive drug policy. Opioid overdoses kill more than a hundred people a day—providing treatment can help people come off drugs without going to jail or dy-

ing. Switzerland went this route twenty years ago and has succeeded in reducing drug-related crime, HIV infections, and overdoses.

But there is not much enlightened thinking. Lock up drug users and make a buck if you can.

(!)

China is a good example of what can happen under a secretive government. There is very little information about incarceration in China. No one knows the real figure for executions—the low thousands probably. China's prisons are filling up with dissidents and democracy reformers opposed to President Xi Jinping. China has its own war on drugs and executes smugglers.

Chinese prisons are hellish. In pretrial detention centers, torture is common. Cells are overcrowded, and there are often no beds. Prisoners have to work long hours. In actual prison, inmates also work, but conditions might be better than in detention.

What we know is that we don't know what goes on in China. We know about the United States, but prison reform is not a political priority. There are more votes for being tough. In 2015, when President Obama visited a federal prison, he was the first president ever to do so. He looked in a nine-by-ten room that held three men and talked about overcrowding. He sounded sympathetic. But eighteen months later, when Obama left office, little had happened.

Under Obama, there was a movement against mandatory minimum sentences and the beginning of a national debate on drug policy. Funding for the "war on drugs" started to shift toward treatment, but under Trump, the government threatens

to double down on the failed policy. Trump's attorney general, Jeff Sessions, told federal prosecutors to seek the harshest punishments allowed under the law, which would send prison populations up again.

The appointment of General Mark Inch, who managed US detainees in Iraq and Afghanistan, to run the Bureau of Prisons jibes well with the general militarization of US police forces that has been going on for decades. As we have seen in countless tragic police shootings, there is no thought of deescalating a situation—go in hard, guns blazing, often in massed SWAT teams.

The 2016 documentary *Do Not Resist* detailed the rise of militarized SWAT responses by police forces. In the 1980s, there was an average of about 3,000 such deployments a year; now it's anywhere from 50,000 to 80,000. Since 9/11, the Department of Homeland Security has given police departments more than $34 billion to buy toys like Mine-Resistant Ambush Protected (MRAP) armored vehicles, Humvees, assault rifles, and so on. (Google "MRAP" and tell me if you think it makes sense to have these vehicles operating on US streets.) The Department of Defense has also given away billions of dollars in similar freebies.

It appears that the authorities are waging war on underprivileged sections of the US population with militarized policing and ultraharsh sentencing and prison conditions.

Why don't we discuss how to eliminate prison systems as we know them today and their torture, terrible conditions, cruel punishments, and murder? You're sending rockets to the outer cosmos, making clones of sheep, but you cannot reform a prison system? C'mon.

Eugene V. Debs knew how to do effective prison reform, and he wrote about it at the beginning of the twentieth century. It's known. It's doable. Here's what he suggests (*Walls and Bars*, 1927):

1. "First of all, it should be taken out of the hands of politicians and placed under the supervision and direction of a board of the humanest of men with vision and understanding. The board should have absolute control, including the power of pardon, parole and commutation."

2. "Prison inmates should be paid for their labor at the prevailing rate of wages."

3. "The prisoners themselves, at least 75 per cent of whom are dependable, as every honest warden will admit, should be organized upon the basis of self-government and have charge of the prison [and] . . . establish their own rules and regulate their own conduct under the supervision of the prison board."

4. "Feed prisoners decently and wholesomely, not extravagantly, but in a clean, plain and substantial manner to conserve their health instead of undermining and destroying it."

5. "At least 75 per cent of the inmates of every prison are not criminals but have simply been unfortunate, and every decent warden will admit that they would at once retrieve themselves if given their liberty and a fair chance to make good in the world."

Bottom line: Prisons should not be connected with creating profit. Prisons should not be run by army-like, secret organizations that can do whatever they please. Prison officials should be accountable for what they're doing. Prisoners should play a major role in their own management. There should be independent oversight boards to check how everything is going in prison. People will be interested in serving on such boards, because they understand that at some point, prisoners do go free, and rehabilitation is in society's best interests.

(!)

I was about six years old, walking with my father around Moscow. If a cop walked toward us, we'd cross the road. I clearly remember the poker-face trick my father taught me: if you walk near a cop, don't ever look at him, don't look into his eyes, don't draw his attention. I was six years old, and I was happy that cops didn't have anything on me. What could we be scared of? Nothing. We didn't rob banks or sell arms or drugs. There was just an irrational fear that something might happen.

As I got older, I began learning to communicate with cops, always bracing myself. But if I don't make myself confront them, the desire to cross the road, instilled in childhood, becomes so strong that it almost gives me hives.

If we want people to stop being afraid of cops, we should equalize our rights and give an average citizen the ability to jail the cop (for a reason) the same as he has the ability to jail you. A cop should feel the power of a common citizen above him. That's how we'll deal with that fear.

Deeds

Prison taught me a lot of lessons. One of them is about time, how time works. How vital it is to look forward and imagine alternative futures. I was living in barracks with a hundred other women. We had a shared bedroom. Each bed had a sign with the inmate's name, her photo, the number of her criminal article, and the beginning and end of her term: 2005–2019; 2012–2014; 2007–2022; 2012–2025. It's like a time machine when you're walking between those beds, being mesmerized by these years, fates, faces, crimes. You cannot escape thinking about time. As a prisoner you stay alive only by thinking about time. Imagining, dreaming: How will I build my life when I get out of here? **The future has never seemed so full of and rich in wonderful possibilities as when I was in a labor camp and had literally nothing but dreams.** Not only prison but also despair, grief, or on the contrary, inexplicable joy and unconditional love—basically any transgressive situation—opens in you this magic ability that is normally destroyed by adulthood: time when you can dare to dream and imagine.

Prison Riot

I was sent to a prison camp in Mordovia. Mordovia is a region of Russia renowned for the most terrible prisons and the puffiest pancakes. The mores in Mordovia are patriarchal and conservative. Women wear their hair long, often with a braid slung over their shoulder. They measure their life achievements in terms of the quality of their husbands and the number of their children.

Mordovia is a land of swamps and prison camps. Here they breed cows and prisoners. The cows give birth to calves and

produce milk, while the inmates sew uniforms. I encountered fourth- and fifth-generation guards. From the time they are knee high, the locals believe that a person's only purpose in life is to suppress another person's will.

The toughest discipline, the longest workdays, the most flagrant injustice. When people are sent off to Mordovia it's as if they're being sent off to be executed.

We worked sixteen to seventeen hours a day, from 7:30 a.m. to 12:30 a.m. We slept four hours a day. We had a day off once every month and a half.

I was welcomed to my dorm unit by a convict finishing up a nine-year sentence: "The pigs are scared to put the squeeze on you themselves. They want to have the inmates do it." Conditions at the prison are organized in such a way that the inmates in charge of the work shifts and dorm units are the ones tasked by the wardens with crushing the will of inmates, terrorizing them, and turning them into speechless slaves.

"If you weren't Tolokonnikova, you would have had the shit kicked out of you a long time ago," say fellow prisoners with close ties to the wardens. It's true: other prisoners are beaten up. For not being able to keep up. They hit them in the kidneys, in the face. Convicts themselves deliver these beatings, and not a single one happens without the approval and knowledge of the wardens.

Perpetually sleep deprived and exhausted by the endless pursuit of production quotas, the inmates are always on the verge of flying off the handle, screaming their heads off, and fighting. A young woman was struck in the head with scissors because she had delivered police trousers to the wrong place. Another woman tried to stab herself in the stomach with a hacksaw.

Thousands of HIV-positive women work with no rest, running down what is left of their immune systems. Near the end they would be taken to the camp hospital to die so their corpses would not spoil the penal colony's statistics. People were left behind bars alone with the understanding that they were goners, that they were broken, crucified, and doomed.

A woman died in the sewing factory one night. Her body was removed from the assembly line. The woman had been seriously ill. She should have been working no more than eight hours a day. But the camp wardens need thousands of suits. People fall asleep at their sewing machines. They sew their fingers together. They die.

If a needle pierces your fingernail and slices through your finger, your mind cannot process what is happening for the first five seconds. There is no pain, nothing. You just do not comprehend why you cannot pull your hand out of the sewing machine. After five seconds, a wave of pain washes over you. Wow, look, your finger is stuck on the needle.

That is why you cannot pull your hand out. It's simple. You can sit alone nursing your finger for five minutes but not for longer. You have to keep on sewing. You're hardly the first person to sew through her finger. What bandages are you talking about? You're in prison.

The mechanics tell me they don't have the spare parts to fix my sewing machine and will not be able to procure them. "There are no parts! When will they come in? How can you ask such questions and live in Russia?"

I mastered the mechanic's profession involuntarily on my own. I would attack my machine, screwdriver in hand, desperately hoping to fix it. Your hands are scratched and pierced by

needles, there is blood all over the table, but you try to sew anyway, because you are part of an assembly line and you must carry out your part of the job on a par with the experienced seamstresses. But the damned machine keeps breaking down.

Time and again, the needle in your sewing machine breaks, but there are no spare needles. You have to sew, but there are no needles. So you find old, blunt needles on the wooden floor and you sew. They do not punch through the fabric, and the thread gets tangled and breaks off. But you are sewing, and that's the main thing.

At night you have a good dream that makes you wake up with a smile on your face: you dream that you are presented with a set of needles. You wake up, look around, and realize that no, it was only a dream, a beautiful, rose-tinted dream. In reality, you will again sew the whole day with the blunt needles you scare up in the manufacturing zone.

"My imprisonment, my women's prison colony is lethargy, a dream," I wrote in a letter from the camp. "It is infinity, and it seems my whole life has passed here. At the same time, it is one frozen moment, a single day, which by the will of some evil genius must now last forever, must be repeated again and again till death do us part. My imprisonment is the reverse, material side of the Matrix, hundreds of bodies put into operation, weak, pale, dumb bodies, hundreds of physical existences enveloped in the slime of the eternal return, the slime of apathy and stagnation."

(!)

Forced prisoners' labor has been used in Mordovia since the late 1920s. The Mordovian camp complex was established during the "reforging of socially dangerous elements," as proclaimed

by Stalin. Before Stalin, political prisoners were able to hit the books, educate themselves, and write. Everything changed abruptly during Stalin's time. Forced labor was declared the primary method of reeducation. The goals of the planned Soviet economy were achieved at the cost of hundreds of thousands of lives of the people sent to the camps.

Even after Stalin's death in 1953, Mordovia remained a place where political prisoners were sentenced to hard labor. From 1961 to 1972, the Mordovian correctional labor camps were the only ones in the Soviet Union where inmates convicted on political charges (say, for distributing illegal literature) were sent.

My first impression of Mordovia came from the words uttered by my penal colony's deputy warden: "You should know that when it comes to politics, I am a Stalinist."

In Stalin's time, if a prisoner failed or refused to go to work three times, he was shot. In our time, he is just subjected to a good kicking and locked in an ice-cold solitary confinement cell, where he is supposed to freeze, get sick, and slowly die.

Sometimes you find a pig's tail in your prison gruel. Or the canned fish in the soup will be so rancid that you have diarrhea for three days. Convicts are always given stale bread, generously watered-down milk, exceptionally rancid millet, and rotten potatoes. In the summer, sacks of slimy, black potatoes were brought to the prison in bulk. And they were fed to us.

We sew on obsolete and worn-out machines. According to the Labor Code, when equipment does not comply with current industry standards, production quotas must be lowered vis-à-vis standard industry norms. But the quotas only increase, abruptly and without warning. "If you let them see you can deliver one hundred uniforms, they'll raise the minimum to one hundred

and twenty!" say veteran machine operators. And you cannot fail to deliver either, or else the whole unit will be punished, the entire shift. Punished, for instance, by everyone being forced to stand on the parade ground for hours. Without the right to go to the toilet. Without the right to take a sip of water.

There is a widely implemented system of unofficial punishments for maintaining discipline and obedience, such as forbidding prisoners from entering their barracks in the autumn and winter (I knew a woman who ended up so badly frostbitten after a day outside that her fingers and one of her feet had to be amputated) or forbidding prisoners from washing up or going to the toilet.

Dreaming only of sleep and a sip of tea, the exhausted, harassed, and dirty convict becomes obedient putty in the hands of the wardens, who see us solely as an unpaid workforce. In June 2013, my monthly wages came to 50 cents.

Sanitary conditions at the prison are calculated to make the prisoner feel like a disempowered, filthy animal. We get to do laundry once a week. The laundry is a small room with three faucets from which a thin trickle of cold water flows. We are allowed to wash our hair once a week. However, even this bathing day gets canceled. A pump will break or the plumbing will be stopped up. At times, my dorm unit has been unable to bathe for two or three weeks.

When the pipes are clogged, urine gushes out of the toilets and clumps of feces go flying. We've learned to unclog the pipes ourselves, but it doesn't last long: they soon get stopped up again. The prison does not have a plumber's snake for cleaning out the pipes.

The wardens force people to remain silent, stooping to the

lowest and cruelest methods to this end. Complaints simply do not leave the prison. The only chance is to complain through a lawyer or relatives. The administration, petty and vengeful, meanwhile uses all the means at its disposal for pressuring the convict until she understands that her complaints will not make anything better for anyone but will only make things worse.

What happens to different things when they are placed in boiling water? Soft things, like eggs, become hard. Hard things, like carrots, become soft. Coffee dissolves and permeates everything. The point of the parable is this: be like coffee. In prison, I am like that coffee.

(!)

There is little crying in here: everyone understands that it won't change anything. It's more like a deep sorrow that is not expressed in crying. Laughing isn't tolerated much here. If someone does laugh, she is approached and told, "What, you having fun?" Or, "What, you got nothing better to do?" But I laugh anyway.

It's possible to tolerate anything as long as it affects you alone. But the method of collective correction at the prison is something else. It means your unit, or even the entire prison, has to endure your punishment along with you. The most vile thing is that this includes people you've come to care about. One of my friends was reprimanded for drinking tea with me and was denied parole, which she had been working toward for seven years by diligently overfulfilling quotas in the manufacturing zone.

Disciplinary reports were filed on everyone who talked to me. It hurt me that people I cared about were forced to suffer. Laughing, Lieutenant Colonel Kupriyanov said to me, "You probably don't have any friends left!"

(!)

I continued to dream about starting a prison labor movement.

I had a small circle of people I could trust in my camp, and we would share plans of our upcoming labor war. When our endless conversations looked suspicious to prison wardens, we would pretend that we were all just flirting with each other, talking about flowers, and everything was just fine.

Our intention was to force the prison administration to register a labor union of inmates. I ordered law books for research. It was not easy to get through the censors and convince the prison administration that it was my basic right to *study books on Russian law in prison*. "Was I sent here because I broke the law?" I asked the administrators.

"Correct," they said.

"Do you want me to obey the law in the future?"

"Yes."

"Sweet. Then I have to get my books to learn the law." I got the books.

I studied the law that regulates a prisoner's life. I learned labor law too. I had to learn the basics by heart, because I was aware that my books would be confiscated the moment I started an open war with the administration about our labor conditions.

And conditions are truly horrible. If you think you live in a civilized world and we don't have slavery, you're wrong. Here's what life is like for an inmate in a Russian prison:

1. You have to work twice as long as allowed by the labor code (sixteen hours).
2. You work seven days a week with ancient, falling-apart, and thus really dangerous equipment.

3. Quotas are undoable and twice as high as regular work-shops outside the prison.
4. You get paid a ridiculously small amount of money; my salary varied from *50 cents to $10 . . . a month.*
5. You go through severe psychological and physical pressure if you don't fulfill your quota.

Unsurprisingly, our plan of creating a legal prison labor union was broken by the administration, which simply did not accept our papers. That's why we had to operate illegally.

We had a plan B. Plan B was me trying to *talk nicely* to the administration. I visited the head of my prison camp multiple times. Honestly I think he really enjoyed my attention, and he even asked me—more than once—to write a book about how horrible he was (you get two paragraphs, you're welcome). He liked to talk with me about Putin and democracy in Russia (his thought was that Russians love and accept only authoritarian rule). I assume it all made him think he was an important figure and not there just to steal money—like he was on an important special service mission, to break the will of the enemy of the state and make me obedient and therefore less annoying to the government. I have to admit that this prick had a serious talent for breaking people's will. He was born for it. He was—openly and proudly—a sadist.

Anyway, I tried to *talk nicely* to this person. I told him, if we work for eight hours a day instead of sixteen, I'll chill out. It did work, but it worked badly for me: I was severely punished, sent to dig trenches around the prison church, saw wood, and pull up concrete slabs all around the camp. My unit suffered too: the administration turned off the hot water in our barrack, and

worse than that, they forbade us from washing ourselves with the cold water. Don't even ask how we managed to survive. It was ugly.

That's how I learned that nice talks never work with those who have power over you.

That's how I learned that sometimes there is no other option than showing your teeth and going on the warpath.

In September of 2013 I started the most dangerous hunger strike I'd ever done. I handed a letter to the prison officials: "I will not remain silent, watching in resignation as my fellow prisoners collapse under slave-like conditions. I demand that human rights be observed at the prison. I demand that the law be obeyed in this Mordovian camp. I declare a hunger strike and refuse to be involved in the slave labor at the prison until the administration complies with the law and treats women convicts not like cattle banished from the legal realm for the needs of the garment industry, but like human beings."

THE DEMANDS I MADE DURING MY HUNGER STRIKE

1. Reduce the workday to eight hours.
2. Reduce the number of police uniforms we have to sew each day.
3. Introduce two days off each week.
4. Punish and dismiss the deputy warden, who threatened to kill me and other inmates critical of conditions in the colony.
5. Do not persecute or put pressure on inmates who file complaints against the colony.

"So you are a revolutionary?" my prison boss asked me. "Maybe legends will be spun about you, as they are now spun about revolutionaries, but right now you are here. With us. And don't you forget it. So keep your views to yourself while you are here. For your own good, you had better keep silent."

Prison is an island of legalized totalitarianism. The objective is to standardize the thoughts and actions of the people who end up on the island. If you dare to rebel in a totalitarian state, be prepared to be shot.

It was not an easy decision to rebel in a labor camp. But, you know, it is not enough to sacrifice lambs, calves, doves. Sometimes you have to sacrifice more.

"It was here, in Butyrka prison, that I gave some honest words to myself, some kind of word, that I embraced something," writes gulag survivor Varlam Shalamov. "What were these words? The main thing was matching word and deed. The capacity for self-sacrifice. The sacrifice was life. How it would be taken. And how it would be used."

Resistance gave me the strength to live. It gave me a feeling that life behind bars is not a waste of time.

It was my third hunger strike. The first one lasted for nine days, the second and third ones for five days. I finished my third hunger strike after the prison warden came to my bed with his mobile phone and asked me if I wanted to talk with the Presidential Council for Civil Society and Human Rights in Russia. A really high person in their hierarchy. Needless to say, prisoners are not supposed to use mobile phones, and wardens are positively not supposed to provide mobile phones to prisoners. But they decided to break all possible rules to deal with this situation. It was all uncomfortable to them: my hunger strike

and, of course, massive support from the outside—activists, with my comrade Peter Verzilov among them, were camping outside the prison, constantly rallying, chanting, and setting off fireworks. They were filing endless complaints and following the wardens everywhere, asking unpleasant questions about what's up with prison conditions and why on earth they treat human beings as slaves.

The Presidential Council guaranteed me that there would be an investigation of the human rights violations I'd mentioned in an open letter I wrote describing the reasons for my hunger strike. He told me that I'd even be invited to be on the public supervisory board when I got out. You learn one thing in prison: all officials recklessly lie all the time. You cannot trust anyone. But it still sounded like a good point to start negotiations.

As a result of my hunger strike, a major review of my penal colony happened. It was indeed initiated by that council. Most inmates were too intimidated to talk with the supervisory commission about violations, but the workday was reduced in my penitentiary to eight hours for some time. Food was better. The head of the penal colony lost his job.

Quite soon I was transported from Mordovia, which is located in central Russia, to Siberia. Feds in Moscow thought it would be easier to deal with me if I was far away. They hoped that activists, lawyers, and media wouldn't follow me to Siberia. Spoiler: they were wrong. Peter the Great Verzilov, a nightmare for prison officials, popped up in Siberia even before I was transported there. He immediately organized a local community of activists to help me, and when I finally—after one month in prison trains and transit jails—found myself in Siberia, there was already a camp outside my prison.

(!)

Hilarious situations arose after my hunger strike. I was still in prison, but guards totally changed their attitude to me. They treated me as an equal. I was shocked in the beginning, but then I just chilled and began to enjoy it. Christmas had come in the middle of summer. Sometimes it felt like officials were even slightly intimidated by my presence in their facility. I turned effectively from a prisoner into a member of a public supervisory commission in their eyes. I gained lots of symbolic power and weight. They were well aware of the trouble that prison wardens in my Mordovian camp had to face because of my open letter and protest. They did not want to lose their jobs too.

For a month they just hid me from everybody and switched me from one facility to another. My friends and relatives had no idea where I was or whether I was dead or alive. But I was celebrating the changes. When you jump in a van or a train for transporting prisoners, it's a dark and gloomy place, but it fills you with hope. Because you know it cannot get any worse than it is right now. Therefore, it has to become better.

When I arrived at my next facility, I could see the highest prison officials lining up, meeting me and checking how it's going. All of a sudden they started to care about following every single law.

I got back all the letters that censors in Mordovia had hidden from me for a year. I felt like I had just won the biggest lottery that has ever existed. Four giant, human-size sacks of letters in Russian, English, Chinese, French, Spanish, and more. Packages and packages of postcards that wonderful and truly alive people were sending from all over the world. Little knitted balaclavas. Rainbow balaclavas. I cried over these gifts and

cards: for a year in Mordovia when I was having literally the hardest time in my life, I had no idea how many passionate activists were following our story and were dedicated enough to write an actual note to a Russian prison camp located in the middle of nowhere.

I had established conversations in my mind with all those people, heard their voices, imagined details of their lives. Here is a sixteen-year-old girl from Arizona, and she's a fan of Kathleen Hanna; here is an old lady from Novosibirsk, and she likes classical music and German linguistics; here is a twentysomething guy from Amsterdam, and he's fighting climate change. I cried not out of self-pity, or not *just* because of that, but because I was speechless in the face of this symphony of people's efforts to break through barbed wire and prison walls and encourage two Russian girls to keep fighting. I was crying because I forgot that a prisoner may deserve love, and sympathy, and respect. And all those voices, in different ways and timbres, were strong enough to break through censorship, filling my cell with a beautiful activist choir. I proudly brought packages of those cards from one facility to another, though they were heavy. **When guards searched me and saw cards, they realized that I may be physically alone here in this prison, but I was part of a powerful community of like-minded people.** And this is a very important thought for a prison guard. You should plant this thought into your guard's head. You're not alone—you're an army.

I also got back all the books that had been stolen from me by Mordovian officials. They stole them because who wants a prisoner to be inspired to act? Definitely not prison guards.

These were memoirs of Soviet dissidents, Varlam Shalamov, Solzhenitsyn. I read the notes of Dina Kaminskaya, a

lawyer who courageously defended a good half of the dissidents in the USSR and therefore ended up being closely followed herself. I read about dissident and poet Yuri Galanskov, who died in 1972 in a Mordovian prison hospital where a large part of my struggle with prison administration took place. I read Vladimir Bukovsky, who managed to keep his spirit while being force-fed or made to undergo traumatic labor in camps. The memoirs of Natalya Gorbanevskaya, who was one of the dissidents who showed up in Red Square in 1968—right after the Soviet invasion of Czechoslovakia—with a banner reading "For our and your freedom" (participants in this action were sent to labor camps for up to three years or forced to go through treatment at psychiatric institutions). I was reading and wondering if there were any limits to the power of the human spirit and will.

Reading, in the super strict prison of Omsk, the memoirs of Russian revolutionary Vera Figner, I decided that she is my style icon forever, with her rigor and dedicated look, her tightly buttoned shirts, her unimaginable combo of being harsh, ascetic, mighty, and slightly coquettish at the same time; she was initiating prison protests while knowing that she was in jail for life. In my prison wagon—having not the slightest idea where I was heading to—I read a history of the Soviet dissident movement written by Lyudmila Alexeyeva, a veteran of the civil rights movement in my country who's still active nowadays in her nineties. In my Siberian prison hospital I read Victor Hugo's *Les Misérables* and *Ninety-Three* with its passages praising the sublime madness of the revolutionary spirit. And Osip Mandelstam's essay on a magnetic gangster, prisoner, blasphemer, and poet from the Middle Ages: François Villon.

What I learned from my hunger strike is that to protest is better than not to protest. Talking out loud about your values and goals is better than not saying anything. Before I learned this lesson, I was trying to be patient in Mordovia—for a year. I was telling myself that things could not be changed, because everything is too rotten. I'm too weak to change it, I thought. You can hardly find anything more typical than this kind of thought. They make us give up in advance. Without even trying. What we often don't realize is that trying may not bring you right away the bright future you're seeking, but it'll surely give you power, and strength, and muscles. Being a prisoner, I became much more powerful in my protest.

"We're with you, girl!"

"You rule!"

"You bent cops, sister!"

"Respect."

I'd hear this from old, weary prisoners covered with mind-blowing tattoos when I met them in transit jails or prison wagons. I mean, what can be better on earth than this kind of respect?

Because officials were slightly intimidated and confused by my presence now, I ended up in a carnival of prison surrealism. Like, they didn't give me real shitty prison food but bought food especially for me. That's how I got lamb ribs with mashed potato in the prison of Chelyabinsk. It happened *only* because I had mentioned Mordovian prison food in my open letter and it became known internationally for its misery.

In a prison of Abakan I was put in a cell with a young girl who was celebrating her birthday. She was so shocked by the new food that wardens started to give us after I was moved to her cell! It was real meat, real vegetables. She was asking

me about the difference between the North and South Poles, about Stalin and Madonna, when guards showed up in our cell, greeted my cellmate, and wished her a happy birthday. She could not believe what had just happened. Before they had been rude and the food was disgusting. Later I was invited to the prison boss's office, where he talked to me for four hours about his life story, about his friends and enemies, about his fears and hopes for the prison, about the prison economy and prison labor. The main idea was, we have a good established enterprise here, please don't interfere with your activism, okay?

At the end of my one-month journey I was transported to Krasnoyarsk, Siberia, and sent to the biggest and oldest Siberian prison. In fact I was happy to be sent to Siberia, 'cause it's my home. Siberians are simply great. Another exciting thing is that I had wanted to wind up in that prison since I was five. My grandmother's apartment, where I spent a lot of time in my childhood, is located right across the road. I remember being five or six years old and walking alongside those giant fences thinking, "How curious I am to take a look at what's there! I wonder if it's possible to escape? Can I use a ladder and take a look?" No doubt there is something witchy about me, because everything I passionately want inevitably happens.

My final destination was a prison hospital. It's probably one of the most prosperous prison facilities in the whole of Russia. The prison system didn't want to hear my complaints anymore. They let me write, read, and paint what I wanted. Instead of wearing the tight and extremely uncomfortable prison uniform, we wore pajamas. And finally, I got to participate in a prison rock band. It was called Free Breathe. Our band was mixed—four men and two women, including me. Every eve-

ning at 6:30, we were escorted to a prison theater, where our rehearsals took place. All of that was inconceivable before my hunger strike. I tried a couple of times to visit the prison theater in Mordovia, but I was only punished.

A sweet boy from my band, a kid who used to live by stealing cars, offered me a love letter exchange. It's a super big thing in prison, love letters. Often people wrote letters to people they had never seen in person. I knew that I'd never be good at that highly sentimental genre, and that's what I told him, so we ended up writing political rap texts to each other.

But the real fun started when we were touring with our band. We made a couple of concerts in our own facility, and then we went on tour. It's like a normal tour, but you travel in a prison van. You put guitars, pianos inside your cage and go. We came to a women's penal colony, and I was singing the songs of Zemfira, a Russian singer and songwriter, about sexual love between women (a topic and practice that's legally prohibited in any Russian camp): "I was dreaming about people desiring each other in a different way." After the concert officials took me on a private tour of their facility, showing me solitary confinement cells and barracks. We were fed special food, lots of chocolate and candies. This whole thing seemed *awkward as hell* to me.

In a couple of months I was released. I went back to Mordovia with food and medicine for my fellows in prison, and during that visit I was attacked twice by local thugs hired by the police. Prison officials did not let me visit the facility, of course, but our lawyer reported that since I was transported to Siberia, the workday had become sixteen hours again.

Prison officials, at least those currently taking those positions in Russia, can't be trusted. They have to be watched 24/7.

They have to be held accountable. Most of them don't have any good intentions, and if they tell you they do, they're lying.

It's really sad, though, if you start to think that the whole Russian political system is based on the same principle: there are certain people who have to be treated in a special way, and then there are the rest. We've visited a couple of male camps too, and we got that kind of vibe everywhere. As an activist I love to feel empowered, but an activist cannot be satisfied with personal privileges.

All this hypocrisy and showing off is not good. But this awkward behavior of officials definitely shows you how much muscle you gain by simply using your voice. My voice was amplified by the voices of all those who supported Pussy Riot. And it became a polyphony, a polyphony that made the whole Russian prison system feel weird. And when systems of all sorts feel weird, we're having fun, we're taking our fucking joy back.

(!)

May I finish with a short prison story?

Sometimes we don't see radically politicized people, but open your eyes—they're all around you. Look at that policeman who just arrested you. Look closely. Talk to him. What if he's even more pissed off at those who're in power than you are?

One of my prison guards was talking to me, leaning against the bars separating us.

"You know, civil war is not far off. Things are headed in that direction. Putin is clinging to power. He won't leave on his own. One day, we'll find ourselves on the same side."

"I wonder how that will happen if you're in uniform?"

"It's simple. I didn't swear an oath of allegiance to this government. I don't owe them a thing anymore. I'll take off my uniform and go with you."

"When?"

"When the revolt begins."

Heroes
MICHEL FOUCAULT

> Is it surprising that prisons resemble factories, schools, barracks, hospitals, which all resemble prisons?
>
> MICHEL FOUCAULT, *DISCIPLINE AND PUNISH*

Foucault is a poet of a high suspicion.

If you want to learn the trick of using history for your critical thinking, Michel Foucault is your man. He works with history like a fighting dog, bites it hard and doesn't let go easily. He spots a norm and digs into the history of it. Sexuality, madness, prison, surveillance, whatever. He's a gracious killer of norms.

When I first discovered Foucault at seventeen, I might not have understood *everything* he said, but what I got is that I don't have to take anything for granted. It was a relief, because the adult world expected me to believe and accept rather than investigate, doubt, and inquire, which was in my nature to do. Foucault elegantly reveals that there is always a power struggle that leads to a certain idea we have at our disposal, an idea that we're tempted to consider an accepted axiom.

Pussy Riot's basic, knee-jerk reaction in life is to refuse to obey *any* authority—prison, university, or record label. Pussy Riot and Foucault have the same demons to fight against—

rigid and restrictive thinking, normalization, classification, incarceration. When we hear something about "a norm" (or "it's normal, deal with it," "that's how it is," "you can't change it, just accept it"), we try to find someone who's a beneficiary of ours buying into this norm.

His debut book, *History of Madness,* was published in 1961, a year when the USSR sent the first human into space, East German authorities closed the border between East and West Berlin and construction of the Berlin Wall began, John F. Kennedy was inaugurated, and the CIA undertook an unsuccessful attempt to overthrow Castro that history remembers as the Bay of Pigs invasion. Foucault was thirty-five years old, and the book was a critique of modern approaches to madness that he had seen when working in a mental hospital in Paris and later in his own experience of psychiatric treatment.

Foucault's history of madness is a perfect example of someone gloriously questioning a norm before accepting it. The whole idea of mental illness is super new, claims Foucault, and it was created as an instrument of control.

Discipline and Punish, Foucault's book on prisons, normalization, and mass surveillance, published in 1975, was written under the motto "to punish less, perhaps; but certainly to punish better." Foucault describes how prison becomes the model for control of an entire society, with factories, hospitals, and schools modeled on the modern prison.

Foucault names three primary techniques of control: hierarchical observation, normalizing judgment, and examination. Control over people can be achieved merely by observing them, he says (thirty-eight years before Edward Snowden published his leaks about mass surveillance).

Think about how much disgusting stuff was—and is—legal. Slavery was legal. Segregation was legal in the United States as recently as 1964. It was not that long ago that the Civil Rights Act ended all state and local laws allowing segregation. "Propaganda of homosexuality"—talking about LGBTQ issues publicly—is still illegal in my country. On the other hand, wars are legal, and making profits from killing people is legal (General Electric, which makes your fridges and washing machines, and Boeing, whose planes you're flying in, are two of the biggest—and very legal—arms manufacturers and profiteers from war). **Outsourcing low-wage labor, using cheap labor from non-Western countries to make our computers and phones, making Asian children sew our pants is legal.** Destroying the planet via uncontrolled carbon dioxide emissions is legal, and very well-respected men are doing it. On the contrary, speaking truth to power, being a whistleblower can be illegal—in Russia, in the United States, anywhere.

Prison is an ideal architectural model of modern disciplinary power. There are surveillance cameras everywhere in prison, and inmates might be being watched at any time and all the time. But they can't be sure exactly when. As Foucault notes, since inmates never know whether they are being observed, they must act as if they are always objects of observation.

Prisons mirror the society around them. Unless we change both, we will all be trapped in a kind of prison.

Liberation Theology: A Conversation with Chris Hedges

Chris Hedges was Middle East bureau chief of the New York Times for seven years and has reported on wars in the Falklands, El Salvador and Nicaragua, and Bosnia. He was part of a Times team that won a Pulitzer Prize for reporting on terrorism in 2002. A prolific author, he has taught at Columbia, New York University, the University of Toronto, and Princeton—and increasingly in prisons. He was ordained as a minister in 2014.

NADYA: You work at Princeton, which is an Ivy League university. So you're teaching all those people who want to be 1 percent. Do you try to influence them?

CHRIS: You can't change their mind. Here, at places like Princeton, they're very hardworking. Many of them are very bright, but because these institutions are so difficult to get into, they have been conditioned to cater to authority. Large corporations like Goldman Sachs send people to this campus to recruit. The students too often define themselves by prestige, financial success, so they're easily seduced by Goldman Sachs. And that's sad. It's not that they're not good people, they are. And many of them have a conscience. I would just say they're weak . . . in that sense.

NADYA: I was this nerd. The best student in high school. I got a scholarship to Moscow State University (I didn't bribe anybody) and then I turned to politics. So it is possible. And how did it happen with you? Because it looks like you are a nerd too.

CHRIS: Yeah, definitely a nerd.

At the age of ten I went to a very elite boarding school for the uber-rich. And I was only one of sixteen kids on scholarship. My mother's family was working class, even lower-working class, in Maine.

I would look at the kids in the prep school, and many of them were very mediocre on many levels, including intelligence. And I realized that when you're rich you get chance after chance after chance. If you're poor, you—at best—get one chance. You may not even get that. And that kept me grounded.

So from a really young age I was always political. I was always fighting the institution, and luckily, I was a very good student, I was also a very good athlete, and I didn't drink, and I didn't take drugs so they couldn't get me. I started an underground newspaper in high school, and the administration banned it.

NADYA: Of course.

CHRIS: It was a serious paper. I wrote stuff I cared about that would normally never have been in a school paper. For instance, the people who worked in the kitchen, who were poor people of color, lived above the kitchen in terrible conditions. No students were allowed to go up there. I went up there and took pictures, and waited until the commencement issue so all the parents would be there and handed it out to embarrass the school, and the trustees were there.

Over the summer, the school renovated the kitchen, and when I came back, the kitchen staff had put up a little plaque in my honor.

NADYA: Wow.

CHRIS: Also my father was an activist; my father was a minister. He had been a veteran of World War II but he came back from the war virtually a pacifist. He was very involved in the anti-war movement in Vietnam, in the civil rights movement. We lived in an all-white farm town, where Martin Luther King was one of the most hated men in America.

He was very involved in the gay rights movement because his brother was gay, for which the church finally got rid of him. That was also important because I understood that you're not going to be rewarded for your activism. If you really, truly stand with the oppressed, you're going to be treated like the oppressed. And that was a lesson, because of my dad, I learned really young, and that saved me because I wasn't naive. I didn't think I was going to be exalted for doing the right thing. I knew the cost.

There was no gay and lesbian organization at my college, Colgate University. My father by then had a church in Syracuse, which was an hour away, and he brought gay speakers to my campus, and my father said, you have to go public, you have to come out. They were too frightened to go out of the closet. So one day my father said to me: you're going to have to start the gay and lesbian organization, which I did. I'm not gay, but I founded the gay and lesbian organization.

NADYA: Do you know if there are some priests who are still on the left side, who can be connected with us? I ended up in prison because I came to the church and I care about the church.

CHRIS: My favorite theologian is James Cone. The only theologian living in America worth reading. He's the father of black liberation theology. Cone called out the white church. He con-

demned the white church as the Antichrist. And he said, if you look at lynching, of black men and women and children in the South . . . what is that? It's the crucifixion. And the white church said nothing. As a matter of fact, the white church in the South supported it. Even when the physical manifestation of the crucifixion was in front of them, they were silent. And I asked him a year or so ago, so do you still think the white church is the Antichrist? And he said, well if you define the Antichrist as everything that Jesus fought against, I would have to say yes.

After the third century, with the rise of Constantine and apologists for power—Augustine, Aquinas, and others—they created a theology that I think was not only contrary to the fundamental message of the gospel, but was used to sanctify state power. And that's how you got a thousand years of church rule, with the inquisitions and the subjugation of the poor. There's a theologian named Paul Tillich who says every institution including the church is inherently demonic. And that's right.

And I was ordained, which you can watch online. James Cone preached the sermon, and Cornel West spoke, we had a blues band, we invited all the families of my students in prison to come in an inner-city church. When I did this ordination I was asked, "Will you obey the rules of the church?" And I said, "When the church is right."

Pope John Paul II did tremendous damage to the church. Because he had this phobia against communism. That gave the church a kind of right-wing tilt, and the church in essence embraced neoliberalism. It forgot about justice. It certainly forgot about the poor. And that's why it's largely irrelevant,

and I would say the last thing that made the church irrelevant in the United States was the rise of the Christian Right. They're not Christians. They're fascists.

Christian fascists are filling the ideological vacuum for Trump. Because Trump doesn't have an ideology other than his narcissism. And when you fuse the iconography and language of a religion with the state, it's fascist, and that's who they are.

NADYA: What do you think about identity politics? Do you think they may have been co-opted by liberalism?

CHRIS: It swiftly became co-opted. For instance, feminism. If you go back and read Andrea Dworkin and the real feminists, it is about empowering oppressed women, but feminism now became about a woman CEO, or in the case of Hillary Clinton, a woman president. Everything got twisted. An African American president who runs the empire. So as Cornel West says, Barack Obama is a black mascot for Wall Street. And the left just got seduced by it. It was just political immaturity. It was a willful severance with the poor because in marginal communities of poor people of color—they were not only losing all their jobs, getting evicted from their homes, being sent to the largest prison system in the world . . . but being shot, being gunned down right and left.

Their court trials are a joke. There's no habeas corpus, there's no due process, 94 percent are forced to plead out to things they didn't even do.

NADYA: Because they're scared.

CHRIS: The students I teach in the prisons with the longest sentences are the ones that went to trial because they didn't do it. And they have to make an example of them because if

everyone went to trial the system would crash. They'll stack you with twelve, fifteen charges, half of which they know you didn't do. And then they get to say: if you go to trial, look at that poor guy who went to trial. I taught a guy once who had life plus a hundred and fifty-four years, and he's never committed a violent crime. It's insane.

NADYA: What did he do?

CHRIS: It was drugs and weapons possession. But he was never charged with a violent crime. But see, this is the problem: because you deindustrialize the society, you create redundant or surplus labor, who are primarily black and brown, and you need a form of social control because you turn them into human refuse. What are the forms of social control? Mass incarceration and militarized police. If you go into Newark, or Camden, or any of these poor areas in New Jersey, they're mini police states, where you have no rights, where SWAT teams come and kick your door down in the middle of the night with long-barreled weapons, terrorizing, sometimes shooting everyone in sight, for a nonviolent drug warrant. It's really hell. And that is about what's going to get extended throughout the whole country.

We're seeing the ten thousand new police agents, the five thousand new border patrol, the 10 percent increase to the military, which they didn't even ask for. A complete militarization of the society.

NADYA: They didn't even ask for it! But yeah, take it.

CHRIS: And liberal elites are complicit because while this was happening to poor people of color, they were worrying about making sure they had their quota of LGBT people within their elite institutions.

Everybody talks about progress in gay rights—that's not true. It's progress for the elites, but if you're a gay man who only has a high school education, and you're pumping gas in rural Kansas, you're worse off. It's more dangerous with the rise of the Christian Right. And those gay elites in New York and San Francisco have turned their backs on the poor. . . . And it's not just the violence. It's the fact that because of the power of these Evangelical churches these poor kids believe they're impure, they're diseased, and that's why you have such a high rate of suicide among these kids.

All the way around, it's a class issue. And the neoliberal elites are complicit with the rest of the country in turning their backs on the poor, and especially poor people of color.

Richard Rorty said in *Achieving Our Country*, look, this is a dangerous game. He wrote in 1998. If you have a bankrupt liberal establishment that continues to speak in the language of liberal democracy but betrays those values to your working class and your poor, then eventually, you have not only a revolt against those elites, which is what we've seen with Trump, but you have a revolt against those values. And that's what's happened.

NADYA: How should we speak with them? Go deeper—analyze the economic situation that brought this disaster which you see right now, and Trump is just a symptom.

CHRIS: They don't want to hear it because they—just like all people in positions of privilege—don't want to hear anything that challenges their right to that privilege, so what's the reaction to the election? Russia did it! This is ridiculous. I'm no friend of Putin, but the idea that Russia swung the election, it just doesn't even make sense.

NADYA: I know that it is possible to change somebody's mind because I changed my own mind and I constantly change my mind every day.

CHRIS: I think that most people don't get their mind changed. I think that for me the most powerful way is to build relationships with the oppressed. I was in El Salvador, I was in Gaza, I was in Yugoslavia, or here I am in the prisons, or with the book I did, *Days of Destruction, Days of Revolt*, it was two years we spent literally in the poorest pockets of the United States.

NADYA: What do you answer to all those people who keep asking us, Okay but what is the alternative? You want to destroy things? But what do you want to put instead of that? And I'm telling them—look around, we have a lot of bright people and anybody can be better than Putin ...

CHRIS: Putin wouldn't have come down as hard on you as he did if he wasn't scared. Our job is to make them scared. Our job is to scare the shit out of them. Because that's the only way power reacts. Politics is a game of fear. Appealing to its better nature is a waste of time, it doesn't happen. So who was America's last liberal president? It was Richard Nixon. Not because he had a soul or a heart or a conscience. But because he was scared of movements. Mine Safety Act, Clean Water Act—all of that came from Nixon.

There's a scene in Kissinger's memoirs where tens of thousands of people have surrounded the White House in an anti-war demonstration and Nixon has put empty city buses all around the White House as barricades, and he looks out the window, and he goes, "Henry, they're going to break through the barricades and get us." Well, that's where people in power

have to be, all the time. I lived in France when Sarkozy was president. Sarkozy pissed in his pants every time the students came into Paris or the farmers brought their tractors into Paris.

NADYA: What should we ask for? What will be those words that can really bring us together?

CHRIS: I'm a socialist. I believe that most of the people at Goldman Sachs should go to prison, and Goldman Sachs should be shut down. Banks should be nationalized. Utilities should be nationalized; the fossil fuel industry should be nationalized. Yes, there are ways that you can have corruption with that as you do in Russia, but right now we're in a situation where those industries and corporations run the country and we're not going to break their back unless we take away their toys and their money.

I'm not telling you it's going to happen. I'm just telling you that the only hope we have is a revolution. A nonviolent revolution. Now, given the situation as it is in the United States and the weakness of the left and the lack of political consciousness, we're probably far more likely to have a protofascist right-wing backlash.

NADYA: Another question is, Can we develop a left version of globalization? Neoliberal globalization does not serve the people, but global mobility, on the other hand, is the thing that gave me everything I have. Otherwise, I would be sitting in my Siberian hometown working at the nickel factory.

CHRIS: Right. Well, there's corporate globalization, which is dangerous and evil. And then there's the globalization between movements because we're all fighting neoliberalism. We're all fighting corporate capital.

All revolutionary movements have fed off of each other throughout history. They come in waves. So you have the American revolution, and you have the French revolution, and then you have the Haitian independence movement.

I think that's right, that the only hope we have is by linking ourselves globally and not retreating into nationalism, which they want us to do.

CREATE ALTERNATIVES

In addition to resistance, create unorthodox, unconventional models, mores, institutions. Revitalize your ability to dream, to envision and create alternative futures. The inability to dream makes us shortsighted. The most radical act of rebellion today is to relearn how to dream and to fight for that dream.

You can listen to politicians, they'll lead you astray
You've gotta see the light and you've gotta see the way

COCKNEY REJECTS, "OI! OI! OI!"

Those of us who are outside and free, we're going to tell the truth. We're going to be honest. We're going to have a certain kind of moral and spiritual and intellectual integrity. And no matter how marginal that makes us, we're not in any way going to become well-adjusted to this injustice out here.

DR. CORNEL WEST, IN AN INTERVIEW WITH
DEMOCRACY NOW!, 2016

Words
STAY WEIRD

If Pussy Riot needed to define their job somehow, they'd say that their job is being ridiculous. **Being ridiculous is one of the best ways to tell the truth.** You don't pretend that you know. You're just asking, you're wondering and suggesting. You don't force others to build a brave new world.

People who behave weirdly might be called sick or disabled by some, but they just might be seeing something that others don't. Look at the Old Testament prophets, for example, who behaved like total weirdos.

When you are ridiculous, when you tell the truth, they will say you are insane.

Besides prisons, there are multiple other ways to turn you into an obedient domesticated pet. One of them is control through the medicalization of psychology, psychotherapy, and psychiatry.

Psychopharmaceuticals are overprescribed. The number of people with a diagnosis is rising exponentially, the diagnoses themselves are expanding. Anxiety, fear, and loneliness are plaguing us. Loneliness is the disease of our century—that's what I read when I was desperately googling "WHAT TO DO ASAP DYING FROM LONELINESS."

We don't really inquire about the reasons for this plague, though. We're isolated with our problems, which we perceive as minor, personal problems. Moreover, we start to feel guilty about our anxieties and fears because they make us less productive, and we end up taking performance-enhancing drugs. Why are so many people not feeling quite well? And why is the goal of treatment to conform patients to the norm rather than

to deal with the systemic issues that make millions of people feel miserable?

What if certain socioeconomic trends are leading to this explosion of illnesses? When competition and gaining success by any means have become our ideology, should we really be surprised by this overwhelming feeling of hopeless isolation? **Competitive solidarity does not exist; competitive love does not exist either.** Some things are just not supposed to be competitive, things like access to solidarity, love, health care, fresh air, and clean water. However, the most powerful forces today—privatization and deregulation—are based on making everything competitive. So, if so many people feel that they are fucked and fooled, maybe they are fucked and fooled. It looks like a duck, swims like a duck, and quacks.

The alleged scientific neutrality of modern medical treatments for insanity are in fact covers for controlling challenges to conventional bourgeois morality. That morality says that madness is mental illness, and it's presented as an objective, incontrovertible scientific discovery. But it's not neutral at all. **Labeling those who think differently as mentally ill, force-feeding them meds, and locking them up in hospitals are part of a mighty instrument of control.** As a matter of fact, it's the most dangerous form of control—one that appears to come with the approval of science. Scientific authority is designed to make you feel small and powerless. "Scientists know better"—that's what you're prescribed to assume. But may I tell you something? The next time you feel you can't argue with science, think about eugenics—eugenicists claimed their movement was a science while slaughtering millions of innocent people in its name. That's why I have problems with experts. I don't trust experts.

(!)

The antipsychiatry movement was big in the 1960s and '70s. What's the central idea of the antipsychiatry movement? That psychiatric treatment is often more damaging than helpful to patients. Classic examples: electroconvulsive therapy, insulin shock therapy, and lobotomy. The antipsychiatry movement has achieved a lot, methods have changed, but it certainly doesn't mean that civil society should just relax and stop checking what's going on in psychiatry. One of the most worrying things today is the significant increase in prescribing psychiatric drugs for children. Big pharma is a super powerful business, and we surely need to pay attention to the many cases when drugs are prescribed just because it's profitable for the company and doctors. Actually, it's really confusing how few questions we ask about the origins of and reasons for psychiatrists' labeling (which we clearly should ask).

"A happiness unthinkable in the normal state and unimaginable for anyone who hasn't experienced it . . . I am then in perfect harmony with myself and the entire universe." Dostoevsky thus described his epileptic seizures to a friend. In *The Idiot*, his character Prince Myshkin describes his epileptic episodes and the single second right before a seizure. "What matters though it be only disease, an abnormal tension of the brain, if when I recall and analyze the moment, it seems to have been one of harmony and beauty in the highest degree—an instant of deepest sensation, overflowing with unbounded joy and rapture, ecstatic devotion, and completest life?" Myshkin felt more alive than at any other moment: "I would give my whole life for this one instant," he said.

The goal of the power structures, though, is not to encour-

age revelation, joy, and ecstatic devotion. The goal of power is to make citizens measurable and governable. Michel Foucault reveals that it's a relatively new, nineteenth-century idea that those who behave strangely are merely sick, that they're invalids and have to be isolated from society.

Paul Verhaeghe, the Belgian professor of clinical psychology and psychoanalysis I referenced before, wrote a striking book on this explosion of psychopathologies in modern Western societies, *What About Me? The Struggle for Identity in a Market-Based Society* (2012). He writes about the psychiatric handbook, the *Diagnostic and Statistical Manual of Mental Disorders* (DSM), and how every edition brings more and more disorders: "180 in the second edition, 292 in the third, and 365 in the fourth, while the latest, *DSM-5*, gives a diagnosis for many normal human emotions and behaviours. Medically speaking, these labels have little significance, with most of the diagnoses being made on the basis of simple checklists. Official statistics show an exponential rise in the use of pharmaceuticals, and the aim of psychotherapy is rapidly shifting toward forcing patients to adapt to social norms—you might even say, disciplining them."

"Modern medicine is a negation of health. It isn't organized to serve human health, but only itself, as an institution. It makes more people sick than it heals," writes Ivan Illich, an Austrian-born Christian anarchist. Illich wrote the iconic book *Limits to Medicine: Medical Nemesis; The Expropriation of Health* (1976), and his main point is that "the medical establishment has become a major threat to health." He explains, "This process, which I shall call the 'medicalization of life,' deserves articulate political recognition." Drugs often have serious side effects that

are worse than the original condition, but because we get them from "professionals" who have (supposedly) access to the ultimate truth about our health, we believe them unconditionally. Which inevitably has consequences for us.

Thinking about economic inequality, it's clear that it indeed brings us lots of stress that doctors may describe as a diagnosis and make us take antipsychotics. Working-poor and many middle-income families suffer from constant financial stress, due to the increasing cost of homeownership and renting, rising prices, and stagnating salaries. A situation of chronic stress inevitably leads to a wide range of health-related issues.

Trying to conclude everything that has been said and everything else I've forgotten to say—it looks like we're living in a paradoxical situation:

1. Permanent financial instability and impoverishment are literally driving us nuts.
2. We pay an expensive doctor, get our diagnosis (one of millions—there is a diagnosis for everybody, for you too), and get a prescription.
3. We buy costly prescription drugs, get dependent on them, become junkies, and overpay pharmaceutical companies for legal drugs till the end of our lives (or the end of our money).

I guess an exit from this vicious cycle should be found.

(!)

What if sometimes, in order not to feel insane, or lonely, or sad, or fucked, you have no need to take a pill—you can find others

who are experiencing the same feelings, discuss your problems, organize, and solve the problem?

You have no money to pay back student loans—you have a right to feel sad, angry, fucked. You work all day long and have no money to pay your rent—you have a right to feel insane. But don't take a pill; it'll help you fall asleep but will not solve the issue.

Reach out to your people.

(!)

In May 2012, while we were sitting in a Moscow women's jail under investigation for our crime, psychiatry suddenly rose on the horizon. I have to admit, I was scared to death and started to panic. As someone who had spent her youth studying the antipsychiatry movement, I was well aware of punitive psychiatry's horrors. I think you've read *One Flew Over the Cuckoo's Nest* or seen the movie. So we underwent a forensic psychiatric examination in the Kashchenko psychiatric hospital, a facility that in the Soviet era was heavily involved in the political abuses of psychiatry. I was trying to appear as normal as I could possibly be. I found out that my doctor was honestly sympathetic to me and to our cause. He smiled warmly when I answered a question about priorities by naming freedom, sister/brotherhood, and equality.

However, all three of us were found to be suffering from a "mixed-personality disorder." What are the symptoms? "Proactive approach to life," "a drive for self-fulfillment," "stubbornly defending their opinion," "inclination to oppositional behavior," "propensity for protest reactions." All this was written in our psychiatric report. I actually didn't mind the descrip-

tion at all. **They defined it as an abnormal condition, but I think these are just characteristics of a human being who is still alive.**

The report used language very similar to the criteria used in the Soviet era when diagnosing dissenters. Punitive psychiatry was widely used in the USSR as an ideological weapon of control and repression. A Soviet citizen had to be unquestioning and submissive. Those who said anything against the oppression or showed any independence were regarded as suspicious troublemakers, a threat to everyday life.

ALL POWER TO THE Imagination

Here is what I heard in one Russian classroom:

KIDS: We're for justice.
PRINCIPAL: And what exactly is justice?
KIDS: It's what we don't have right now.

We have to learn how to be kids again, to use our imagination and start to think of alternatives that we're able to create with our own hands, think of possible futures that we could establish by restructuring our own lives, behavior, thinking, consumption of products, ideas, political concepts, news, social networks.

Too often we don't believe that another world is possible. This is what may be called the "there is no alternative" (TINA) disease, and it's a pure crisis of the imagination. "There is no alternative" was Margaret Thatcher's favorite slogan. In her case, it mostly meant the economy. Writing about Thatcher's TINA in the *Nation* (April 12, 2013), Laura Flanders said it meant that

"globalized capitalism, so called free-markets and free trade were the best ways to build wealth, distribute services and grow a society's economy. Deregulation's good, if not God."

The TINA disease is global. As activists we're so used to hearing this standard response from our fellow Russians: yes, our government is corrupt, courts exist only to protect the elites, the police do not work and only take bribes, Putin is a thief, but there is no alternative.

Official statistics claim that the overwhelming majority of Russians (80 percent) support Putin. Nah, they don't. A little investigation reveals that there are many citizens who are perfectly aware of how corrupt and greedy Putin is, how he's stripping Russians of their money and rights and monopolizing resources within the small group of his cronies. We're aware that we're living in a plutocracy, an oligarchy—for sure not a democracy. But here the TINA syndrome comes in. "But who will rule Russia, if not Putin?" is what I hear. "You!" is what I say. I can guarantee that you have more dignity, love of your country, and respect for your fellow citizens than Putin has. That's one hundred percent true. We can run things differently. There are enough good-hearted and smart people in our country to run our affairs better than Putin does.

The same is applicable to the United States. "The politics of inevitability is a self-induced intellectual coma," says Timothy Snyder, author of *On Tyranny: Twenty Lessons from the Twentieth Century*. "So long as there was a contest between communist and capitalist systems, and so long as the memory of fascism and Nazism was alive, Americans had to pay some attention to history and preserve the concepts that allowed them to imagine alternative futures. Yet once we accepted the politics of in-

evitability, we assumed that history was no longer relevant. If everything in the past is governed by a known tendency, then there is no need to learn the details."

TINA helps elites, it does not help us. We choose to fight for our dreams, we choose not to be powerless.

Deeds
ALTErnaTIVe: AnOTHer LaW EnForCemenT SysTem IS POSSIBLE

It's a mistake to put political activists in prison. It only makes them stronger and more convinced of their beliefs. If you consider becoming a president or an MP, please remember this lesson and don't try to silence activists by putting them in jail. It's simply not practical. They'll find a way to communicate from courtrooms and prison cells. They'll find a way to gain more power from their prison experience than they lose.

(!)

Putin and his team made a mistake when they locked us up. They had it coming. Now it won't be so easy for them to get us off their backs.

Authorities call Pussy Riot's performances controversial and offensive. All Pussy Riot's videos are labeled "extremist," and access to them has been prohibited in Russia by a court decision, and I can see why: we put their power in question.

But I believe it's my basic human right to kick my government's ass. And I put my whole self into everything I do.

(!)

When the authorities are so pissed at you that they have to lock you up, wear it as a badge of honor. Prison cannot make you weaker or break you unless you allow it to happen. **When they steal your freedom, the power still resides in your decisions and your will.** Nothing could be worse for those who locked you up than when you stand up proudly for your values even when you're behind bars. It's a cruel game: their goal is to publicly annihilate your spirit, but you look for sneaky ways to grow your courage and develop yourself instead of shrinking and dying (which is what is expected in this situation).

My prison time gave me the unbelievably sweet and paradoxical feeling of being a winner and a loser at the same time. We're in prison, but thanks to the court process we're taking part in branding the government as a mob of short-sighted, greedy, petty oligarchs and ex-KGB agents who are afraid of three women in bright dresses and funny hats.

"Here, in prison, I have acquired something very important—a sense of profound hatred for the modern state system and a class society," antifascist and anarchist Dmitry Buchenkov, a PhD in political science and a boxing coach, writes in a letter as he sits in prison, where he ended up because of an absurd politically motivated criminal case stemming from the 2012 protests in Russia. "It's very important for a revolutionary. I had this sense before, but understood it logically. Now it's a deep emotional distress. I want to thank the investigation committee and all case officers for my final emergence as a revolutionary. I was lacking this small detail—the prison, where I had a chance to meet absolutely different people who make up the Russian society, from junkies to businessmen. Nobody can make so many observations and political conclusions in such a brief period of time."

Dmitry Buchenkov ended up in prison because he was accused of participating in an illegal rally in Moscow on May 6, 2012. Dmitry was not in Moscow on that day, so he couldn't possibly have participated in any rally. But cops don't care—they seriously don't like the guy and want him locked up because he's a smart and effective community organizer.

<p style="text-align:center">(!)</p>

On the first day after our release in December 2013, we decided to found Zona Prava (Zone of Rights). A brilliant Russian lawyer, Pavel Chikov, who defended us while we were in a camp, is the head of Zona Prava.

The mission of our prison reform initiative is to overhaul the current law enforcement system, a vicious system that grinds people down and spits out coffins, to offer an alternative to a broken system. The acquittal rate in modern Russia is less than 1 percent. What does that mean practically? It means that once you find yourself in a police station, it's almost impossible to get out of there. Even those who work within the system are not happy about that. I know policemen for whom dignity and self-respect are important. We have ex-interrogators and ex-prosecutors working with us on protecting prisoners' rights.

People die in police custody every day. There are thousands of deaths in prison annually, half of them from tuberculosis, which given the current state of medicine should be impossible to die from, and from HIV, which is no longer necessarily a death sentence on the outside. We are reeducating prison camp staff and police officers, using the carrot and the stick to teach them to see detainees and convicts as human beings. We help prisoners draft complaints, petitions, and lawsuits. We are

involved in proceedings against prison wardens in the Russian courts and the European Court of Human Rights to help severely ill convicts obtain parole. Our doctors visit penal colonies and carry out independent exams of cancer patients and the HIV-infected.

In the year after Pussy Riot's release, Zona Prava was working on a few dozen cases across Russia, and more than ten are cases in the European Court of Human Rights.

We have started work in prison camps, and we're confident that if we can help convicts find legal ways to protest their enslavement, we can do a lot more for the many Russian citizens who want to express their dissatisfaction with the Putinist political system. We have compiled a book of complaints and suggestions, but so far citizens have no access to this book.

Most prisoners are locked up because of the war on drugs. Even possession of weed can lead to a prison sentence of up to eight years. The next biggest group of prisoners after those sentenced for drugs comprises the victims of domestic abuse, women who were beaten by their husbands or other family members, sometimes for decades, and who couldn't take it anymore. What could they do? I have a lot of acquaintances in that situation who would go to the police, and the police would tell them, "Hey, you haven't been killed yet! Come back once you're dead." Seriously. This is typical. It's almost like they get special instructions on how to answer when someone comes in with domestic abuse complaints.

We cannot change Russia's law enforcement system in a moment without the government's support. And our government, of course, is doing everything it can to prevent reform of prisons and law enforcement. What we can do is to provide

information, lawyers, and the safety margin afforded by public monitoring. We can help people imagine a different way of doing things, for the benefit of all.

ALTErnaTIVE: A DIFFErEnT MEDIA IS POSSIBLE

At the end of 2013, Putin was deeply displeased with revolutionary events in Ukraine. His logic was clear: if radical shifts can happen in a country that is our closest neighbor, his power in Russia is not as stable as he'd like it to be. It was a question of honor for Putin to provoke chaos in Ukraine and make sure that nobody in Russia saw a Ukrainian revolution as a positive example of changing elites through the people's power. Thus, Putin took three steps: (1) the annexation of Crimea, (2) a secret war in East Ukraine, and (3) an open media war against Ukraine and everybody in Russia who dared to say anything critical of the Russian invasion of Ukraine. Just when you think it can't get any worse, your president sends troops to a neighboring country and—wow!—says that *there are no troops,* though we have witnesses, we have photographic evidence. It's gaslighting at the next level.

Those who live in the United States had an unfortunate chance to feel the impact of the Russian media wars in 2016, during the presidential elections. But we Russians have lived with this reality for a while, since the beginning of Putin's first term as the president in 2000.

Any attempt to provide real information about what was going on in Russia's war with Ukraine in 2014 (not promoting a pro-Russian or pro-Ukrainian position but just honest reporting) put the person who made it available in jeopardy. Journalists and editors were fired and threatened, and investors and advertising

partners of media outlets who dared to provide real news were intimidated and *convinced* to stop working with *traitors*.

Troll factories had a lot of work too. There are giant government-paid networks of people whose one role in life is to seed distorted information on the internet. They're paid to "dislike" any video on YouTube that questions the power of Putin and his apparatus. Grown-up people are getting Russian taxpayers' money to "dislike," say, Pussy Riot's music video. Are you serious?

DoS (denial-of-service) attacks on websites that post anything critical of the government are another popular tool. DoS attacks bring down a website for a period of time, which is extremely annoying when you're a media agency and your duty is to provide news to the people ASAP. And here's another tool: courts and the government can block sites they don't like for all Russian users.

The year after our release was a tough one for the media; pieces of it were collapsing one after another under government pressure. In 2014, the Russian government's own media propaganda turned incredibly reckless. It was fake news par excellence. We had a unique chance to see how *bad* lies from the TV screens can be.

That's why we created an independent media outlet in 2014. (As you've probably noticed, we're not looking for easy ways to live a life.) It's called MediaZona.

The key point is our media offers an alternative information source that is completely free of censorship.

Citizens who are aware of what's going on aren't easily fooled. Our role is to be a trustworthy news service. We don't publish columns or op-eds because we believe that our readers

should come to *their own conclusions*. We trust our audience. It's up to them to decide what side they're on.

It's rewarding to see how big media resources—controlled by the Kremlin—refer to MediaZona's articles in their materials. Even those who are *literally working for the Kremlin* know that you can trust MediaZona. We're deadly serious about fact-checking. It's difficult to gain the trust of your audience, and you can ruin it with just one fake news story.

When we started, we mostly covered law enforcement issues: politics in Russia moved from Parliament to courtrooms and prisons, places where you eventually end up if you're politically engaged. We provide online reports from the courts, and we expose the absurdity, brutality, and injustice that dominate the modern Russian law enforcement system. Sometimes it's hysterically funny; sometimes it makes you cry. We publish stories of prisoners and ex-prisoners, giving voice to those the state prefers to stay silent.

MediaZona has existed for more than three years. We've been expanding, and now we're covering a broader spectrum of issues, making an encyclopedia of Russian life. Our main question is, What does a life in real Russia look like?

We're not interested in an official propaganda TV picture of Putin hugging kids or being sentimentally moved by bucolic church bells. We collect information on protests held outside big cities that usually remain unseen: strikes by miners or truck drivers, hunger strikes in prisons, rallies organized by angry schoolteachers. We talk to prosecutors, judges, policemen, prison wardens, those who work in the system right now as well as former officials. They give us leaks on how everything really works: the five steps of fabricating a criminal case, how

to torture a prisoner without leaving any evidence, the top ten ways to take a bribe, etc.

(!)

"Well. Are you ready to burn some police cars?" That was the first thing Sergey Smirnov said to me when we met for the first time at a gathering of leftist activists in 2008. Now he's an editor-in-chief of MediaZona. I'll let him tell you more about MediaZona:

> For a few years, we watched what was happening, and after a while—from my point of view—the most important events (for example, the case of [Putin critic Alexei] Navalny) went to the courts. Politics, real politics—it moved from the city squares to the courts. One case after another. And a huge number of new restrictive legislative measures have been introduced. It became obvious that court practices were the new form of communication between those in power and those in the opposition. And there was a moment when everyone knew exactly what was happening. But when everyone knows what's happening, one question remains—what do you do next? One possible reaction is to do nothing.
>
> We decided to cover it. We never had any illusions as to how interesting any of this would be for people. We never thought everyone would suddenly want to read about how policemen are killing people, or about how another two dozen people have been put behind bars for many years. . . . Of course, this isn't the most popular kind of information, but it's important.

Maybe this is a strange idea, but our mission is constantly changing. We have a lot of goals. One of them is to attract attention to court cases, courts, and to problems in this system. We do online broadcasting from courts, to show how the courts actually function.

I have another pretty strange idea about our mission, actually. I've written a couple of articles about the nineteenth century, and here's what I think. If in ten, or fifteen, or twenty years, our website could help a researcher understand this time period, we would be very happy. They could read our live online broadcasting archives from courtrooms to understand what really happened here, to get an idea of what kind of epoch this was.

Of course, we can only offer a small part of the picture. But capturing the current moment, what's happening right now—that's important. I'm convinced we can't even tell what is and what isn't important right now, and we don't know what will be important ten to fifteen years from now for someone studying Russia. In this context, I would like it if researchers would study some parts of our coverage. It's a strange thought. It's about understanding society.

I think one of the most serious problems is in the law and the system that puts people in prison in the first place. Consider, for example, Article Number 228 [of Russia's Criminal Code] on narcotics. It's a classic law that is used only for (a) launching criminal cases, (b) meeting quotas for the number of cases brought against suspects, and (c) issuing a certain number of criminal sentences in a given time period. No one actually thinks that the crimi-

nal code is there to punish crimes. The narcotics law is an enormous issue in itself, since about 30 to 40 percent of the people who are locked up in prison are there for drugs.

Maybe in 50 percent of cases, people are put in prison because investigators have to launch a case and bring it to court, so [prosecutors] use stories about drugs for their own statistics and quotas. It's a big problem. And there's no control over these agencies. They can write basically anything they want in the case files.

This is the main problem: people don't know how to work anymore. We can see this in the general level of work done in the courts. Investigators don't really know how to investigate anymore. They aren't taught, and they don't have any real opponents. It's a completely failed system. Even when young investigators come in, they see right away that, after they open a case, it doesn't matter at all what they write in the files. I've seen so much nonsense in protocols over the past year. When it comes down to it, when they actually have to search for someone in a real criminal case, they don't know how to do it. Because people have gotten used to working in a system where everything is scripted.

I've also seen a lot of judges, and so many of them are just so desperate. They know they can't declare anyone innocent; they know they can't make their own calls when sentencing. I have a feeling that when judges get any kind of freedom to make a decision, they get really happy and brighten up. Seriously.

(!)

If we didn't use our imagination, we would never have invented the lightbulb.

So allow your imagination to create alternatives. Imagine police officers as social workers rather than killers and armed robbers. Imagine free health care. Imagine art being made for art's sake, not just to be successfully sold. Imagine that instead of making us submissive, education encourages creativity and intuition.

Heroes
Aleksandra Kollontai

Aleksandra Kollontai was a feminist, activist, and Russia's first woman government minister and ambassador.

Kollontai was born in Saint Petersburg in 1872. Her mother had three children from a first marriage before she obtained a divorce, which was not easy, to marry the man who was to become Aleksandra's father. Aleksandra herself refused the arranged marriage that was set up for her and instead married a distant cousin, an apparently unsuitable man who was broke.

After the Russian Revolution, Kollontai wrote about gender relations and equality for women in a communist society like the one she thought was emerging. Women were not men's property, she wrote in "Sexual Relations and the Class Struggle" (1921). It should be easier for women to get divorced. Marriage should be based on freedom, equality, and friendship. Kollontai freaked out even her fellow Bolsheviks.

Kollontai's focus was on equality. Her writing reads as if it were very modern, not like something written a hundred years

ago. In "Sexual Relations," she writes about social hypocrisy. If a man marries a lowly cook, no one says anything, but if a woman doctor looks at a footman, she is scorned (even if he's good looking, she added).

Later, in the 1960s and '70s, came Kollontai's heirs, like the activist and visionary Shulamith Firestone (1945–2012). Firestone's ideas were a radical cocktail of feminism and critiques of Marxism and psychoanalysis. In *The Dialectic of Sex: The Case for Feminist Revolution* (1970), a bestseller written when she was twenty-five, Firestone advocated the complete elimination of gender as the only way to achieve equality. She wrote that to eliminate "sexual classes," children would be born through "artificial reproduction" and they would no longer be dependent on a single mother. "Genital differences between human beings would no longer matter culturally," she wrote, and labor wouldn't be divided by the sexes because labor itself would be eliminated too ("through cybernetics"). A promoter of celibacy, Firestone said that in an equal society, sex and reproduction would no longer be important.

In a piece in the *Atlantic* published after Firestone's death, Emily Chertoff wrote that "Firestone wanted to eliminate the following things: sex roles, procreative sex, gender, childhood, monogamy, mothering, the family unit, capitalism, the government, and especially the physiological phenomena of pregnancy and childbirth."

Under capitalism, Kollontai wrote, the woman was forced to work *and* bring up children, which was impossible. Women should be equal to men in the workplace and be defined by that work and not the domestic bondage they are forced to live under. In "Communism and the Family" (1920), she wrote that equality in the workplace would leave women with no time for cooking and cleaning and mending clothes, which were unproductive jobs in the new society. In fact there was now no need for families at all—workers would eat in communal kitchens, have their laundry done, and the state would bring up the children. It was a fantastic utopian glimpse of radical feminism written in the first quarter of the twentieth century. She managed to be a second-wave feminist five dozen years before the actual second wave, a kind of seeing that can only occur in highly sensitive and intuitive thinkers and artists who feel the air of an epoch before the epoch is born.

In *The Autobiography of a Sexually Emancipated Woman* (published in Russian in 1926), Kollontai wrote about her early disappointments in the attitude of the Bolshevik Party regarding her efforts to win over women workers. These battles started a long time before the revolution of 1917, dating back to 1906. Kollontai tried to set up a women's bureau, but her efforts were blocked. She wrote about that episode: "I realized for the first time how little our party concerned itself with the fate of women of the working class and how meager was its interest in women's liberation. . . . My party comrades accused me and those women comrades who shared my views of being 'feminists' and of placing too much emphasis on matters of concern to women only."

Kollontai was stubborn about the feminist question, and

she became influential in founding an All-Russian Women's Congress in December 1908. In the aftermath of that event she was forced to leave Russia for Germany, where she joined the Social Democratic Party. She hung out with leading European Social Democrats like Rosa Luxemburg, Karl Liebknecht, and Karl Kautsky. She roamed Europe for the cause, attending such events as a housewives' strike in Paris.

She knew Lenin and became a Bolshevik. She was made People's Commissar of Social Welfare in 1917, the first Russian woman to hold any government position. But women's rights were not as important to the Leninists as they were to Kollontai. We should admire Kollontai for pushing the Bolsheviks on women's rights, because Lenin, Trotsky, Stalin, and the others were men who didn't like a lot of pushing. But when conservative tendencies started to win in the party, Kollontai was forced out of Russia again. She was made Soviet ambassador to Norway in 1923, and she was the first woman to have that type of job too. She lived a long and eventful life and died in 1952.

"New concepts of the relationships between the sexes are already being outlined," she wrote one hundred years ago. "They will teach us to achieve relationships based on the unfamiliar ideas of complete freedom, equality and genuine friendship."

An ability to think beyond the confines of your own era is the greatest value of a creator.

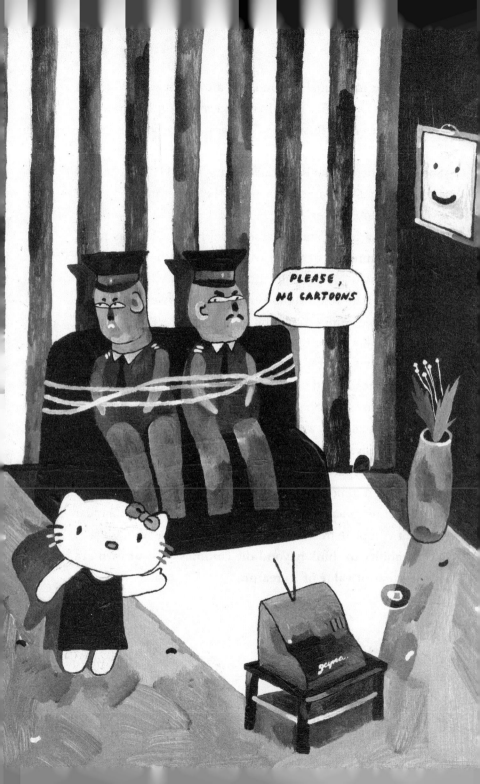

BE A (WO)MAN

Feminism is a liberating tool that can be used by male, female, transgender, transsexual, queer, agender, anybody. Feminism allows me to say: I behave how I like and how I feel, I deconstruct gender roles and play with them, I mix them up voluntarily. Gender roles are my palette, not my chains.

There is neither male nor female: for ye are all one in Christ Jesus.

PAUL THE APOSTLE, GALATIANS 3:28

No woman gets an orgasm from shining the kitchen floor.

BETTY FRIEDAN, *THE FEMININE MYSTIQUE*

The oppressed will always believe the worst about themselves.

FRANTZ FANON

Words
PROUD WITCH AND BITCH

"Russian feminism, of course, is not natural to Russia and has no basis," says archpriest Dmitry Smirnov, a popular spokes-

man for the Russian Orthodox Church, in one of his YouTube sermons. "Feminism aims to destroy Christian principles. Feminism tries to put a woman on the same level as man, depriving her of her advantages as a woman. Feminism lays waste to the family. Distinct rights for men, women, and children destroy the family. If we are baptized, we must regard feminism as a poison that makes people unhappy when it penetrates the minds of society and families."

I've always enjoyed watching Archpriest Smirnov's videos on YouTube. He was one of the inspirations for Pussy Riot. We fell off our chairs when we watched his sermons, and as we fell we came up with the idea of starting a feminist punk band.

Archpriest Smirnov talks about women's advantages that are being destroyed by feminism. A well-known trick; the same old story. Sexists are famous for claiming that they're actually helping women by putting them on a super special pedestal. But, of course, there on that pedestal, you'll not see any creative work or career or any self-fulfillment. This pedestal is all about being a servant or a beautiful thing among other things. **And it's easier to look up someone's skirt when they're standing on a pedestal.**

"School," Smirnov said in a deep voice, "must be a crutch for the child to prepare him for adult family life. Alas, twenty-five years ago, our schools, under the influence of winds blowing from the West, rejected education and limited themselves to pumping knowledge into children. There is another problem: *Ninety-nine point nine percent of our teachers are women. In terms of their psychophysical capacities, they . . . Teachers should be men.*"

"Feminism encourages women to leave their husbands, kill their children, practice witchcraft, destroy capitalism and be-

come lesbians," said Pat Robertson—a conservative Christian, televangelist, and another media mogul from the United States who apparently is out of his mind—in a fund-raising letter quoted in the *New York Times* in 1992.

"Feminism was established to allow unattractive women easier access to the mainstream," wrote Rush Limbaugh in the *Sacramento Union* in 1988. Limbaugh is known for popularizing the term "feminazi" and dismissing consent in sexual relations.

Donald Trump has casually boasted of sexually assaulting young women. In an interview in *Esquire* in May 1991, he dismissed getting bad press. "It doesn't really matter what they write as long as you've got a young and beautiful piece of ass," he said.

"A real man should always try, and a real woman should resist," says Russia's leader, Vladimir Putin, as quoted by *Komsomolskaya Pravda*.

In Russia, women make up only 10 percent of the cabinet. We Russians come out ahead of only the poorest African countries and the Arab world, where there are legal and religious restrictions on the involvement of women in politics and public life. And yet polls show that a quarter of Russian citizens believe women have no place in politics or the number of women in politics should be reduced. Instead of protecting women from domestic violence, my government has recently passed a law that *legalizes domestic violence.*

Sexists live among us, not just in parliaments and on TV. A statement from the father of Kat, one of the incarcerated Pussy Riot activists, was used in our trial: "He knows that Tolokonnikova drew his daughter into the so-called feminist movement. In this connection, he has repeatedly and strongly condemned

the very idea of feminism in Russia, because he believes the movement does not conform to Russian civilization, which differs from western civilization." This chthonic statement was quoted in the verdict in the Pussy Riot trial, and it was used by the court to prove that my "correction" was not possible without isolating me from society.

"Feminism and feminists are cusswords, indecent words," said the guard at Christ the Savior Cathedral, one of the "injured parties" named during the Pussy Riot trial. If that is how it is, swear as much as possible. Cuss. Be indecent.

"Feminism has achieved everything already! What else do you need?" How often do you hear this question? I feel like each day starts with it. Having in mind everything that's listed above, it does not look like feminism can celebrate victory and peacefully retire.

<div align="center">(!)</div>

Pussy Riot considers ourselves to be part of the third wave of feminism. The third wave deconstructs the very concept of gender duality. If gender is a spectrum, then discrimination on the basis of gender becomes absurd. We reject the bipolar "man/woman" model itself. We think of gender differently: there are innumerable genders that do not follow the line between "male" and "female" poles.

I don't have a stable sexual identity, I refer to myself as a queer person. I see no reason to say "I'll never ever do this or that" about anything.

There is no use hoping that previous generations have settled everything for you and gender roles have been obligingly spelled out for you. **Don't think that your job is just being**

born with a certain kind of wee-wee, and then supposedly everything is clear: the boys step to the right, wearing army uniforms and brandishing pistols, while the girls step to the left, wearing lace and brandishing eyebrow tweezers.

Gender roles are site, time, context specific. All that crazy talk about historically neutral, eternal male and female roles will always remain irresponsible baby talk. There are different notions of genders and different sets of roles prescribed for those genders in every decade of human history, in every social class, at every workplace, for every age and race. **You can talk about that feminine mystique crap as much as you please, but I know for a fact that low-class women who were living under slavery in nineteenth-century Russia were tough and strong as fuck, and those ladies would beat any modern male New Yorker in arm wrestling.** There were and are "traditional" societies where it's a norm to have, say, three genders and four types of sexuality. Just two centuries ago all European aristocratic cis men wore heavy makeup and wigs.

This whole thing about "a weak fragile woman" or "a weak sex" is merely a fetish. This fetish had a certain place in our history, but there was a specific time and culture in which it was born, and there is a time when it dies. Disappears like a face drawn on the sand.

What is feminism about to me? **Feminism is about getting rid of excessive expectations that are projected on people according to a gender and sexual role that they are expected to perform.** Feminism is about understanding the genealogy and history of every gender role that's prescribed for you. Feminism is about freedom of choice and having informed options.

I don't have enough time on Earth to play at being a weak

sex. My life is finite. I have a very limited amount of years indeed, and I want to learn, try, achieve, change, feel, dare, lose, win a lot. I have no time for old-school games. You know, some people are unwilling to live straight from the shoulder. What if you're living only once, for the last time? I cannot simply assume that I have another thousand years left.

I have been an activist and a feminist since I was seven or eight. The first time I discovered what feminism was, I was eight years old. I immediately decided that I was a feminist, because it just makes sense. You go to school and you see that all the authors and all the scientists you're studying are men. So you're asking yourself, "Why? What happened in history?" And so I claimed I was a feminist, and one day my mate from preschool came to me, and he was really sorry for me, he was really sad, and he told me, "It's okay, don't worry, everybody at eight years old can call themselves a feminist, but it's okay, you'll change your mind, you'll begin to love men. Maybe when you're around fourteen."

He spoke with me like I had some kind of disease, but he was trying to encourage me and tell me that I would get over it.

I was a nerd from a very early age. Once my physics teacher was embarrassing me in front of the whole class by saying that "Nadya is such a good girl! She gets just the best marks all the time." She continued with the thought that I'd probably become a very successful person in life and marry a president. I was ten years old, but I remember I understood enough to be furious. I thought, *Why can't I be president myself?* **Is it really the greatest achievement of a girl to become somebody's wife?**

I became a feminist because Russian men refuse to give me a hand. Russian men don't shake hands with women. It both-

ered me. A guy from my art collective liked to proclaim that women are not capable of making art. "The only one who actually made real art was Leni Riefenstahl," he would add. That bothered me even more.

I came across Simone de Beauvoir when I was eighteen. "One is not born, but, rather, becomes a woman," she said. She actually gave me some hope. I also was blessed to discover queer theory and gender as acting—with Judith Butler's help. **At eighteen I realized what the main question of my life was: How can we effectively redefine the norm?** What makes you a pirate, a nomad, or a rebel?

<p align="center">(!)</p>

Misogyny stinks in big cities, but it starts to stink even more when you find yourself in a small and nearly closed society like a village, a tiny industrial town or prison. I learned that in prison you are obliged to compete in beauty contests. If you don't compete, you won't be paroled. Not competing in the "Miss Charming" contests means they will write "does not have a proactive stance" in your personal dossier. I boycotted the contest, so the prison decided I did not have a proactive stance. Because I did not compete in the beauty contest, the court refused to grant me parole.

The colony also decided that my friend who preferred to look androgynous was not ready to be paroled because she kept performing at prison concerts in low-heeled shoes. The way the colony saw it, performing onstage in low-heeled shoes was too masculine. A woman should wear high heels. My friend was granted parole only after she performed in high heels and thus proved her loyalty to the feminine regimen.

"You could be stuck in prison for the next seven years," my guards told me. And they would taunt me. "You're a beautiful young woman, but when you get out you'll be old, twenty-nine, nobody will want to fuck you."

(!)

At its core, the word "bitch" is about power. It is said with awe, with rage, and it is said about women who have looked at the world and decided to get what they want. That is too often considered a bad thing. Women are taught to put others first. So we are taking the word back.

I'm a proud whore and cunt. Throughout history, the women we labeled bad were powerful, strong women. Look at witchcraft, look at witch hunting.

A bunch of people I've met, heterosexual men mostly, claim that they don't support feminism. But they barely ask themselves, "What is feminism?" Their rejection is rooted in either fear or fantasy. Well, let me give you another definition: "Feminism is a movement to end sexism, sexist exploitation, and oppression." I love this description given by bell hooks.

Feminism is beneficial to men too. Feminism is beneficial to transgender people. Feminism is beneficial.

Let me explain. If you're *a real man* and you're too tough to cry, to grieve, or to love, you're the one who loses. Feminism would help you make peace with your feelings. It's okay to feel. It's called "life," to feel things.

Imagine: You're a man, you live in Russia, and at eighteen, you have to go into the army. They say that *a real man* has to shoot and fight. It's obligatory for men but not for women. When you were a kid, girls were your equals on the playground.

Institutions like the army deepen a gender gap in your mind; the moment you come back after one year of service, you've been successfully brainwashed and you don't see women as your comrades, mates, buddies, collaborators. As *a real man* you treat women as another species, people who should be either (a) worshipped and protected, or (b) oppressed and beaten. If you're an eighteen-year-old man who has to join the army, wouldn't you rather join forces with women and together demand that service be voluntary and you're not a slave of the state?

But it's not just *real men* who need to be challenged. A lot of women (mostly heterosexual) still believe that feminism is not needed. For thousands of years our survival was based on our subordinated, masochistic connection with a dominant culture, so it's perfectly understandable why it can be hard to break these bonds. Women feel uneasy, and that's why you have women who vote for misogynist douchebags like Putin and Trump. That's why you have women who are longing for *a strong hand*. Sometimes it can be challenging to get rid of shackles, but it's worth it. **It's a good idea to bite the hand that feeds you. Once you're truly equal, you don't need that hand anymore. No domination. You eat together. You simply share food.**

I know some women (mostly heterosexual) who still believe that our primary task is to compete with each other over a partner. That we should fight for a dick and not our rights. It's so comforting for a dominant culture! As long as we continue to think our survival depends on men's validation, it's so easy to use us. It's the old story: force a group to lose their collective consciousness and sense of solidarity, and then toy with them,

use them, manipulate them. The belief that our vital energy is based on men's approval has its roots in history. Indeed, there were times when women were totally dependent economically on men. Those who were not were branded outcasts and witches, and had to be burned. Time has changed a little bit.

(!)

The patriarch of the Russian Orthodox Church wants to prohibit abortions. Stalin banned abortions in 1936 to increase the birth rate, a prohibition that remained until 1955. The USSR's experience showed that banning abortion increased not the birth rate but two other indicators: the death rate of mothers from illegal abortions and the number of infanticides.

Anna Kuznetsova, famous for supporting Putin and the telegony theory (a belief that offspring can inherit characteristics from every sexual partner a woman has had), was made Children's Rights Commissioner in 2016. Children have so many feelings and emotions, and they are shy, bashful, and unable to ask the right questions. They need a better advocate than someone who believes vaginas have memories. Sexuality is a powerful source of vigor and inspiration. Why suppress it, when you can teach people to use it?

Female sexuality is about to be discovered and unchained. My case studies have proved to me that there are a lot of men out there who still have no clue what to do with a clitoris. If you want to fuck me and don't know the power of the clitoris, you suck. If I find out that someone is too phallocentric in bed, I get up, put on my clothes, and leave. Sometimes I recite a lecture on the false consciousness of phallotheologocentrism while I'm puttin' my clothes on.

Female individuals who explore their sexuality are stigmatized. Whore, slut, hooker. You know what I'm talking about. I was convinced for a long time that my ideas had priority and everything carnal was sinful. I had to work hard to restore the connection between the body and the consciousness. I keep on working. The quality of life improves considerably after this connection is finally established.

(!)

A group of female rap artists in France recorded a song about licking the clitoris. French YouTube banned the video. Male rappers from all over the world ask us to suck their cocks, but *this* video contains pornography? Why is the clitoris considered pornography and the penis is not?

THE MONSTER OF OBLIGATORY PERFECTION

When I was a teenager I realized the style of behavior I liked was far from what passed for "feminine." I tried to wear high heels. For six months I tried, but like clockwork they wore down at a slant to the middle, then fell off. I could not sit still and cultivate a smooth bearing, as befits a young woman. I sang loudly in the hallways at school and waddled like a goose.

I frankly couldn't understand why I should emulate the behavior expected of a young woman. I couldn't understand what the benefits were. And if there were no benefits, then why force myself? Because it was obvious how dull it was to wiggle decorously along on high heels clutching a handbag.

Every time I see a woman in high heels, I am filled with sympathy and want to ask her whether she wants a piggyback ride. I admire men who wear high heels, though. Despite the

fact that tradition doesn't oblige them to do it, they still wear heels. They are my heroes. I like to imagine they do it just to honor all the oppressed women in our history.

<div align="center">(!)</div>

There is power in imperfection. Don't try to be perfect all the time—it's actually boring.

This monster of obligatory perfection is a very real thing. It is not just art that is overproduced; human beings are overproduced too. Groomed. Tamed. If you want to know my feelings on that, overproduced people don't move me.

When we got out of prison, we understood quite fast that the power of normalization is not a joke. The more active and vocal you become, the greater this normalizing force gets. Don't wear white tights under a black skirt (or vice versa). Make your hair darker. You need to lose a few pounds. Work on your voice, it's too nasal. Don't say "fuck" when you're onstage with Bill Clinton. Be more social. Why do you Russians never smile? You can't wear sneakers, wear heels. It scared the hell out of me. I bought the lipstick, heels, hair straightener. But I still felt that I wasn't perfect enough. Honestly, I felt like shit. I tried not to say "fuck" at Clinton's event, but five minutes into my speech, I surely did it.

But I wasn't brought up in the woods to be scared by owls. The moment of truth happened when they were applying the fifth layer of makeup on me in the CNN studio. I thought that I don't really need to look like a corpse or a mannequin to talk about politics. I asked them to clean my face.

I actually enjoy makeup. Sometimes. I would love to see more men wearing it.

I don't mind being called beautiful or even being beautiful. But I don't want to be too busy being beautiful. It's not my thing.

I'm writing this book in English, and it's humbling as hell. There are times when I feel like a dog: I know something, but I can find no human words to express it. It's a failure, but a good one. I could have a translator, or I could have a nice person to write this book instead of me. Probably it would be a better book then. Sorry to say, but I stick to the DIY principle. If I know that I can (theoretically) do something by myself, I'll do it. It makes my life path full of challenges, it's true. But that's the way to not alienate your own life from yourself.

I find perfection in attempts, in moving forward, taking risks, and yep, in failing. **I would never have learned as much about my government, my country, and the amazing people who're living in it, and I would never have the voice I have today, without the biggest apparent failure of my life, my prison term.**

(!)

When I was released from prison, I was confused.

I had to learn a lot of basic things again. How to cross the road. How to use money. How to buy shampoo and not be distracted by the millions of bottles on the shelves.

I met many people besides just new friends. I met those who offered me $1,000 for an erotic photo shoot with Pussy Riot. The people trying to hustle us assumed that a person who had just got out of prison *must* be going through financial troubles. I was followed by political cops *fucking everywhere*, my private phone conversations were leaked to YouTube, and I was ca-

sually beaten by Cossacks and state vigilantes every couple of weeks.

I also had to learn to maintain the clarity of thinking I had found in prison.

I had discovered a previously unknown, strange and simple beauty in living among outcasts and being an outcast myself. I had learned to see clarity and honesty in being at the bottom of society but still having the courage to smile. I realized that there is life in the darkest circles of hell, circles that are normally and shamefully hidden from the average citizen.

Nothing could be more breathtaking than seeing a gorgeous, blooming creature growing proudly from rotten prison soil. It's a pure manifestation of the unstoppable life force. Women who refused to be broken, women who chose joy, love, and laughter. I adored the grace with which they undertook their everyday struggle with the misery, despair, and death in a prison life.

The most precious thing you can have in prison is self-respect. That's pretty much everything you can allow yourself to own. You cannot own clothes, food, or money. You cannot have knives, shields, or guns to protect yourself. Your safety and happiness can be provided only by self-respect. It's dangerous to lose your self-respect, and if you lose it once, you may never be able to pick it up off the floor. You have to take care of your self-respect 24/7. Consistency in your beliefs, behavior, and character is greatly appreciated. You cannot afford to panic, to be indecisive. Your deeds should follow your words; otherwise it'll become known that you're a cheap little liar, you're weak and can be easily attacked and hustled.

We had to go through normalization and sanitization when we came out. We were expected to say one thing and not say another. Sometimes I would feel like my newborn freedom was dissolving into the air.

In our everyday lives, we often expect that something from the outside world, a magic pill or a new pair of shoes, can make us feel happier or safer. Usually it's an illusion. The key to happiness for me is the dignity and self-respect I find in my work, whether I'm a prisoner sewing my uniform quota or a free woman making art. It was hardly possible to explain ideas about simplicity and clarity of life to most of the people who surrounded us after our release.

(!)

If you're honest with yourself, you don't forsake the revelations that you have found.

When Pussy Riot was speaking at Harvard, police arrested one man from the audience for speaking his mind. His position was that Harvard should not host public figures who openly supported Vladimir Putin, which Harvard had done before.

We were supposed to go along with it. Instead, we canceled our upcoming events, and rather than going to a fancy dinner, we went to the police station and stayed there until the man was freed. The looks on their faces! But how could they expect us to do anything different? The dissonance seemed lost on them, their disappointment coupled with the fact that they would never have cared about having dinner with us in the first place if it were the fancy dinners we had chosen in the past.

Deeds
REVOLUTION IS MY GIRLFRIEND

Prison is sweet to me and no drudgery.

I don't send letters to my husband on the outside.

He will never ever find out I love Maruska Belova.

<div align="right">DINA VIERNY, "LESBIAN WEDDING SONG"</div>

To be fair, the time when you are in love in prison should not count as part of your sentence, because prison stops being punishment. Everybody knows this, so many prisoners look for someone to fall in love with.

Inspiration does not just happen, but you can pack your things in a bundle and set out on your way in the hope of making discoveries, having adventures, and finding treasures. If inspiration has come, give yourself up to it. Live in such a way that your life could be a movie plot.

<div align="center">(!)</div>

Natasha is telling me excitedly about Nina, the number one dyke in our camp. "So Nina comes up to me and she's, like, 'Wanna tumble?'"

I sit sewing opposite Natasha, who is talkative, svelte, and fast. She is the quickest seamstress on the line. Everyone likes going with Natasha to the baths, because she is thin but has large breasts, like in a painting. Everyone stares in amazement.

"'Tumble'?"

"Tumble, tumble. What, you don't know what it means? She was inviting me to the tool shack to have a fuck."

"Ah, that Nina of yours is cool. But what, you turned her down?"

"I did."

"What the fuck?" I said.

(!)

Nina takes two cigarettes from the pack, clamps both between her lips, and lights them. She proffers one of the lighted cigarettes, keeping the second for herself. She is wearing a gray down shawl. Because of her big nose, she looks like a fledgling eagle when she wears it. The shawl is a gift from one of the women in love with Nina.

Nina has been incarcerated for nine years. She was young when she was sent down. In the camp, she became a boy. Talent, disposition, and an education on the streets made her a tomboy, someone who climbs in and out windows. She has black hair, a smoker's husky voice, and long eyelashes. She has legs, gracefulness, height, and a figure. And she completely lacks feminine affectation. Instead, she has boyish, aggressive desire and the ability to take what she wants.

Nina has a deliberately burly, wading gait, her head held high, her legs spread wide as she walks. She wears her kerchief in the underworld manner, tying the ends not in front, like little Alyonka on the famous Russian chocolate bar wrapper, but in the back, like Jack Sparrow or something.

Nina douses herself heavily with a simple men's cologne. Perfume and cologne are forbidden in prison because they contain alcohol, but you can get hold of them for a large amount of money and by going through trustworthy channels. It is harder than buying drugs on the outside.

It is nine in the evening. Night has fallen in the villages of Mordovia. The cows have stopped mooing, and the horse-

drawn carts loaded with sauerkraut have stopped running.

Opposite us are the lit windows of the machine shop. Female prisoners are sent there when they are severely lacking in physical intimacy. "It's time for you to go to the machine shop," they say. Four dudes work in the machine shop, all four of them alcoholics. For some women, a trip to the machine shop has ended with their giving birth in the Mordovian prison camp hospital in Barashevo.

It is deserted outside the sewing shops; there is not a soul in sight. It is a time when you are not supposed to leave the shops. We have left. We are strolling and smoking.

"Why do you open the door for me?" I dig into Nina when we exit the shop into a wet March blizzard. "When did you first decide you would open the door for women?"

"I don't remember," she shrugs.

The outcome of my discussions about gender with Nina are as paltry as if you asked a man on the first date why the fuck he has brought you flowers. He brought them just because. He could have not brought them. Traditions are inexplicable.

Nina comes to life alongside me. Seducing women and falling in love with them is the life she has found during her nine years in prison. And I am thrilled and grateful to be learning her means of overcoming death and boredom.

Beyond the colony's flimsy, rotten wood fence are dark woods and swamp. Nine years. Nine years behind a rotten fence.

But at that moment I am not bored behind this fence.

(!)

We are drinking instant coffee, the strongest instant coffee I have ever drunk, coffee as potent as absinthe. I would later learn to drink such coffee in the camp every morning. Nina treats me to chocolate bars, while I pull a Snickers from my sock. I snuck it through the frisk at the gate to the manufacturing zone.

"You learn quickly," laughs Nina. She is bashful about her chipped teeth and wants them replaced when she gets out. But I think the chipped teeth contribute to her brassiness, and that is a good thing.

I speak very little: I am afraid of my own words. For conversing with Nina, my words are excessively even and regular; they are educated words. My language is like dead Latin compared with her temperamental Italian. When she listens to me, Nina is ashamed of her own language, which she imagines is simple and obscene. But I think there is much more life in Nina's language than in mine, more nuances and shades of meaning. The decisive element is intonation. The same word spoken with a different intonation can mean different things.

Vera, from the shop floor next door, comes to visit Nina. Vera is young and feminine. She has thick, long brown hair, girlish manners, a slim figure, and D-cup breasts. Vera sits down with a plastic cup of coffee and gazes at Nina for hours. Vera will later tell me she has not actually fallen in love with anyone during her six years in the colony, but this is not true.

Nina doesn't like dainty girls like Vera. She likes the kind of girls you can get into trouble with. Nina sometimes has fast and furious sex with Liza, a seasoned prisoner from another shop

floor. Liza has curly blond hair burned to red, a gruff voice, and one of the most brazen gazes in the colony. When rumors of these encounters reach Nina's steady girlfriend, Katya, the head prisoner of my residential unit, there is an explosion. Dishes, benches, and flowerpots go flying.

<div align="center">(!)</div>

I have been summoned to the prison colony's security department.

"You got magazines in the mail, but I am not handing them over."

"Why not?"

"They *promote homosexualism*," the female security officer snaps. She scratches the word "faggots" on the rainbow-colored cover of my magazine. "Tolokonnikova, are you aware that not only the theory but also the practice of homosexualism has been banned in the colony?"

That's how it all ended. For having a connection with me, Nina was placed in a solitary confinement cell for two weeks. When she got out of there, we did not speak anymore.

The dialectic of theory and practice.

Heroes
BELL HOOKS

bell hooks is the godmother of postcolonial feminism. She started her first book at nineteen when studying at Stanford on a scholarship from her segregated Kentucky hometown. She has taught at the University of California, Santa Cruz; Yale;

Oberlin; and the City College of New York and has written more than twenty books.

A pioneer of intersectional feminism, she started to use this term in the 1980s, a long time before it became popular. In 1984, she dropped a bomb, a book named *feminist theory: from margin to center*, in 1989 another: *talking back: thinking feminist, thinking black*. bell hooks is one of the first to point out that the focus of feminism should not be sex only, but rather the intersectionality of race, economics, and gender.

In *feminism is for everybody* (2000) she writes, "Imagine living in a world where we can all be who we are, a world of peace and possibility. Feminist revolution alone will not create such a world; we need to end racism, class elitism, imperialism." In her 1985 *feminist theory* she writes, "Most women active in feminist movement do not have radical political perspectives and are unwilling to face these realities, especially when they, as individuals, gain economic self-sufficiency within the existing structure."

I always thought that to be a decent artist you should master the fine art of giving a name. Eloquent, precise, it should have the potential to become commonplace without being commonplace. By giving names you learn about economy of words.

hooks was born Gloria Watkins, and her pseudonym is a tribute to her great-grandmother. She decided not to capitalize her name because she wanted to focus on her work rather than her name, on her ideas rather than her personality. hooks's name is a perfect representation of her writings: nonhierarchical, poetic, and explosive. **Inclusiveness wins over elitism; all letters are equal.**

Look at the titles of hooks's books. Aren't they perfect poetry?

ain't I a woman? black women and feminism (1981)
breaking bread: insurgent black intellectual life (1991, cowritten with brother Cornel West)
feminism is for everybody: passionate politics (2000)
where we stand: class matters (2001)
we real cool: black men and masculinity (2004)
soul sister: women, friendship, and fulfillment (2007)

In 2000 hooks released *all about love: new visions,* and it's fucking striking. It somehow manages to combine class analysis, anthemic calls for solidarity and compassion, psychotherapy, postcolonial feminism, the high pleasure of serving others, and cries for sister- and brotherhood. Praise of communal spirit goes hand in hand with longing for individual freedoms.

Love is love without sexual interest. hooks uses psychiatrist M. Scott Peck's definition of love from his book *The Road Less Traveled* (1978). Aware his definition might be inadequate, Peck says love is "the will to extend one's self for the purpose of nurturing one's own or another's spiritual growth."

The personal is political, so hooks effortlessly jumps from questions of sexual pleasure to analyzing the mechanism of radical political change. Indeed, there are no successful mass people's movements without sincere, dangerous commitment to loving those around you and, thereby, a readiness to sacrifice yourself for their sakes. Remember how Nina Simone eulogized Martin Luther King Jr. in her song on his death? *"King of love* is dead," she says.

THE CLOSING STATEMENT
HOPE COMES FROM THE HOPELESS

At this stage of History, either one of two things is possible:
either the general population will take control of its own
destiny and will concern itself with community interests,
guided by values of solidarity and sympathy and concern
for others; or, alternatively, there will be no destiny for
anyone to control.

NOAM CHOMSKY, *MANUFACTURING CONSENT*

You cannot buy the revolution. You cannot make the
revolution. You can only be the revolution. It is in your
spirit, or it is nowhere.

URSULA K. LE GUIN, *THE DISPOSSESSED*

The stakes are as high as they could be. We may destroy ourselves and destroy the planet. So we need thinking that goes beyond existing boundaries. We need to question the status quo. We need political imagination.

You can't know the answer before you ask the question. And we should make a collective effort to find the answer. As a matter of fact, nobody can expect to have full knowledge about

anything when you enter the international waters of piracy. There can't be unchangeable sets of rules when you're entering the unknown. What there should be is an active and alive mind, a heart that's in the right place, and good intentions.

I made a vow to be open and understanding even to those who condemn me, I promised myself to always give the benefit of the doubt before judging. **I don't judge quickly because I know from experience what it means to be a witch who has to be burned at the stake.** I know how it feels when you're used as a scapegoat. It's scary. There is no dialogue when you're an outcast. You're dispossessed of your right to talk, to think, to have joy or pain . . . to live. You're dehumanized, you're portrayed as an enemy, you're an object among other objects.

I choose to be the Idiot, Dostoevsky's character, who promised himself that no matter what the circumstances he'd remain open, sympathetic, kind to people around him. We're all searching, always asking, and we can never be perfect, we climb and we fall, we're going through pain and sometimes causing pain too. I may say, write, or do stupid things, not knowing that it can hurt somebody. And I am sorry for that.

It's okay with me if I sound childish. I prefer to try, to risk, and to burn. I choose to live like a kid; kids are not afraid to admit that they don't know some things, and they have endless curiosity and willingness to learn. When my daughter does something that hurts me, she comes to me and says, "Give me a hug."

Many of those who wanted to beat me or destroy me really just needed a hug. I faced a mercenary who was hired by my government to physically hurt me, and he did burn my eyes. I stood in front of him and kindly asked, "Why did you

choose to do that? It's painful. It hurts. You hurt my eyes. Why?" And then I saw a human behind his eyes, but he was confused and did not have any coherent, human answer to the question.

All human beings want to believe they have dignity. If you answer dehumanization with more dehumanization, it'll be easy for your opponent to ignore your words and feelings, stigmatize you, put you in prison, take your life away.

It's physically painful to see the hurricane of hatred, lies, and hypocrisy that is politics right now. It's normalized to deceive, to be insincere and nontransparent. As long as you're not caught, it's fine. And more often, they don't care if they are caught.

I'm tired of doublethink. They're petty liars, all those people who sit in the White House and quote the Bible but never follow Christian virtues of not judging, of simplicity and honesty.

We're tired of lies. Truth really does have some kind of ontological, existential superiority. That's why so many people support Bernie Sanders, who is making *a moral political revolution by simply being a politician who refused to sell his dignity*, whose deeds follow his words and who indeed serves the people, not corporations, friends, and his own pocket. He does what a politician should do. Isn't it pathological that a politician who's honestly and consistently doing his/her work is an exception?

We need a miracle to get out of here. And miracles are real; they have happened to me before. Unconditional love, for example, or solidarity, or courageous collective action. Miracles always happen at the right moment in the lives of those with a childlike faith in the triumph of truth over falsehood, of those who believe in mutual aid and live in keeping with the gift economy. You cannot buy the revolution, you can only be the revolution.

Any corrupted power structure is built on lies. To quote Václav Havel, "It works only as long as people are willing to live within the lie." It's a choice that has to be made: do not live within the lie.

(!)

I'd like to leave you with some things that I may (or may not) have learned from doing political artistic actions.

- **I have learned: A combination of Zen, willpower, calmness, and persistence.**
 Martial artists know everything about the power of this elixir. When you're fighting, you don't want to be trapped by fear or rage, hiding and escaping instead of calmly playing chess in the ring. You want to win with your wits.

- **I have learned: To feel good about others being mad at me.**
 You can hardly imagine how many people I irritate. Overall, it's a good sign for a (wo)man of political action when they call you a criminal or an outcast.
 It's not just opponents who'll be mad at you. When you knock on doors and ask people to participate, some of them will tell you to go fuck yourself. That's fine. So go fuck yourself—it helps to relax and to get your thoughts together and keep going.

- **I have learned: To be grateful, to throw out those greedy expectations about life and people around me.**
 Working with volunteers helps to develop an extremely

useful attitude: don't expect that anybody has to do a favor for you or your cause. But if they do, you're *genuinely* happy. I'm amazed and thankful every single time somebody decides to help with the cause I'm working on. It means that they trust me and get inspiration from working with me. In itself, it's the biggest reward you can get. Sometimes you lose a battle, or an action that you've been preparing for weeks is stopped, prevented by police listening to your phones. Under those circumstances it's hard not to be angry or frustrated. But, hey, you met so many incredible generous and loving humans while you were working on the action.

- **I have learned: To give myself fully to the action I do.**

 Those who own the power and who use this power to screw us up are watching us: they're not going to give us even an inch if we don't show persistence.

- **I have learned: I'm not ashamed of who I am.**

 If I seriously cared what everybody thinks about me, I would have accomplished nothing. Today, you'll be called a horny piece of hysterical vagina. Tomorrow, they'll devote to you a glossy ten-pound magazine, where they say, "She dealt with body and sexuality issues." And then you will know that both things are equally dull.

 I was told: don't march in the rally under feminist banners—you'll be hated for that, because our country is not ready to understand feminism, Russians think feminists are angry ladies who have not been fucked for years and want to kill all men, blah, blah, blah. They said to Bernie

Sanders: don't call yourself a socialist, rural America is allergic to this word. But still, after generations of Cold War propaganda against commies, Americans were about to vote for a socialist. You keep doing what you do, and you let the world change its opinion of you.

If you are not proud of who you are, nobody will be.

- **I have learned: I'm not trapped in thinking nobody cares about what I do.**

 Get rid of the messiah complex. You cannot solve the world's problems alone. If you think so, you are Trump. Your activist effort is a unique and important part of a global chain reaction and, ergo, it has to be done. Or: think globally, act locally.

- **I have learned: To reject political gaslighting.**

 Experts, economics magazines, think tanks, Ivy League colleges, parliamentarians, Putin—they all politically gaslight us, try to manipulate our thinking and persuade us we are wrong. They say that everything is fine and we're creating problems out of nothing. They want you to feel that you're not educated, you're not aware enough to have an opinion and act on it. Who knows the quality of people's lives better than the people themselves?

- **I have learned: To be dumb.**

 Like Bernie Sanders says, if I were not dumb, I would have stopped my political activity a long time ago. Because "there is no point, you will never change it," as they say. But I'm dumb, so I act.

(!)

All rules, including those on these pages, may be (and possibly should be) thrown away. These rules should be treated as just another Pussy Riot punk prayer, which I have performed to open myself up to a miracle, a (failed) attempt at being a revolution. **A rigid interpretation of any rule or advice kills the spirit of freedom, and it's the last thing that should happen.**

I believe we should follow what Ludwig Wittgenstein wrote at the end of *Tractatus Logico-Philosophicus*:

> *6.54. My propositions serve as elucidations in the following way: anyone who understands me eventually recognizes them as nonsensical, when he has used them—as steps—to climb beyond them. (He must, so to speak, throw away the ladder after he has climbed up it.) He must transcend these propositions, and then he will see the world aright.* '

Wittgenstein conceded that his own propositions are at some level incorrect, but they could still be useful. I would endorse this idea about any set of rules.

No matter how you perform your acts of civil disobedience—rallying, occupying, painting, making music, or stealing and freeing animals from the zoo—**go do it, tear the fabric of submission to pieces.**

And know this: if everyone who tweeted against Trump showed up on the street and refused to leave until he left, Trump would be out of office in a week. The powerless *do have power.*

Answer for pages 54 and 55:
Your body is a battleground, **Barbara Kruger**
I shop therefore I am, **Barbara Kruger**
Music is my hot hot sex, **CSS**

AFTERWORD
BY KIM GORDON

We are lucky to know you, Nadya. We should bond with you in order to absorb through osmosis your experience living with a greedy, power-hungry, authoritarian, narcissist type. Show us the lessons you have learned growing up in your oppressive political climate so that we may learn how to deal with ours, which every day becomes scarier and more challenging in its potential. As you describe in the book, there is a mirroring effect between our two nationalistic cultures. Trump wants to be Putin. Putin wants to be more Putinesque. Your book is a combination Girl Scout (this organization we have here in America to breed nationalism and crafts, but also DIY) and how-to manual on revolutionary actions. It is serious but has the playful feel of a *Mission: Impossible* show, where the mission is heard on a tape recorder. The voice says, "Should you choose to accept this mission . . . This tape will self-destruct in five seconds." As you say at the end of the book, essentially, don't follow my rules—they are a way in or a way out. The action is not an absolute; it is a beginning forward. And you quote Wittgenstein:

6.54. My propositions serve as elucidations in the following way: anyone who understands me eventually recognizes them as nonsensical, when he has used them—as steps—to climb beyond them. (He must, so to speak, throw away the ladder after he has climbed up it.) He must transcend these propositions, and then he will see the world aright.

Everyone is looking for the next cultural revolution. Hand in hand with situationalism came punk, but one was born of hippie culture, the other anti-hippie. People are always looking to music for this—music of the '60s, punk, Nirvana (from the underbelly of indie)—but only if it is taken up as a populist motion. Noise and experimental fringe music, which are truly about freedom of expression, are not ever going to be mainstream—or are they? It becomes a problem of art for art's sake, or is it an action against programmed songwriting? The point of your book seems like, Stop waiting for something and make it happen. Stop romanticizing about the past—it's in the action, no matter how awkward it is. Like sex, it sometimes feels awkward, but only if you think about it that way.

AFTERWORD
BY OLIVIA WILDE

When I was asked to play Julia in the stage adaptation of George Orwell's *1984*, I struggled with how to flesh out a character who had always seemed to me a frivolous floozy without any *real* commitment to revolution. She wanted to fuck, drink coffee, and eat chocolate all the time, which I naively misunderstood to mean she wasn't as brave as Orwell's tragically self-sacrificial Winston. Of course, once I dived deeper into the material and appreciated the depth of Julia's rebellion, I realized how wrong I was. I also realized who would be my main inspiration for my performance: Nadya Tolokonnikova. Just like that, Julia cracked open for me like an egg.

Nadya embodies the true rebel spirit with every fiber of her being. Revolution is not an action. It's a state of being. For 141 minutes a night, eight times a week, I tapped into that way of existing. To know that it was possible to live with such fierce independence is exhilarating. It's simply a choice. What would happen if we all chose that path?

Pussy Riot, as a living, breathing piece of revolutionary art, exemplifies a complete rejection of control. They have breathed

life, humor, color, and joy into the struggle for freedom. As Arundhati Roy put it in *War Talk*, "Our strategy should be not only to confront empire, but to lay siege to it. To deprive it of oxygen. To shame it. To mock it. With our art, our music, our literature, our stubbornness, our joy, our brilliance, our sheer relentlessness—and our ability to tell our own stories. Stories that are different from the ones we're being brainwashed to believe." We forget our own ability to craft our reality. Just as Orwell prophesized, by handing over control of our consciousness, we have allowed ourselves to become our own oppressors.

Perhaps the most powerful thing we can do is to *exist*. To not let ourselves be defeated, unpersoned, by surrendering to apathy or misery. Of course Howard Zinn put it best when he wrote in "The Optimism of Uncertainty," "What we choose to emphasize in this complex history will determine our lives. If we see only the worst, it destroys our capacity to do something. . . . The future is an infinite succession of presents, and to live now as we think human beings should live, in defiance of all that is bad around us, is itself a marvelous victory." Defiance as an act of optimism. We must not give up on our own power to craft the narrative, no matter what they do to us.

After six months of playing Julia on Broadway, I finally got to meet Nadya when she came to see the show. That night, I felt her presence in the audience, and it energized me to the point of tears. I felt my Julia was suddenly not alone, particularly when I said the line, "I'm alive, I'm real, I exist, right now. We defeat the Party with tiny, secret acts of disobedience. Secret *happiness*." I knew Nadya understood. I knew I finally did too.

A PUSSY RIOT READING LIST

Alexander, Samuel, Ted Trainer, and Simon Ussher. *The Simpler Way.* Simplicity Institute Report, 2012.

Alinsky, Saul. *Reveille for Radicals.* New York: Random House, 1969.

———. *Rules for Radicals: A Practical Primer for Realistic Radicals.* New York: Random House, 1971.

Ball, Hugo. "Dada Manifesto." July 14, 1916. Available at https://www.wired.com/beyond-the-beyond/2016/07/hugo-balls-dada-manifesto-july-2016/.

Barber, Stephen, ed. *Pasolini: The Massacre Game: Terminal Film, Text, Words, 1974–75.* Sun Vision Press, 2013.

Barthes, Roland. *Mythologies.* New York: Hill and Wang, 2012.

Berrigan, Daniel. *The Nightmare of God: The Book of Revelation.* Eugene, OR: Wipf and Stock, 2009.

Black, Bob. *The Abolition of Work and Other Essays.* Port Townsend, WA: Loompanics, 1986.

Breton, André. *Manifestoes of Surrealism.* Ann Arbor: University of Michigan Press, 1969.

Bujak, Zbigniew. Quoted in the introduction to "Václav Havel: The Power of the Powerless," http://vaclavhavel.cz/showtrans.php?cat=clanky&val=72_aj_clanky.html&typ=HTML.

Bukovsky, Vladimir. *To Build a Castle: My Life as a Dissenter.* New York: Viking, 1979.

Butler, Judith. *Gender Trouble: Feminism and the Subversion of Identity.* New York: Routledge, 1990.

———. *On the Discursive Limits of "Sex."* New York: Routledge, 1993.

———. *Precarious Life: The Powers of Mourning and Violence.* New York: Verso, 2004.

Chomsky, Noam. "Americanism." Available at https://www.youtube.com/watch?v=8basvBeZEL0.

———. *The Essential Chomsky.* Edited by Anthony Arnove. New York: New Press, 2008.

———. *Language and Politics.* New York: Black Rose Books, 1988.

Cone, James H. *Black Theology and Black Power.* New York: Harper & Row, 1969.

———. *A Black Theology of Liberation.* Philadelphia: J. B. Lippincott, 1970.

———. *The Cross and the Lynching Tree.* Maryknoll, NY: Orbis Books, 2011.

———. *God of the Oppressed.* Maryknoll, NY: Orbis Books, 1997.

Davis, Angela Y. *Are Prisons Obsolete?* New York: Seven Stories Press, 2003.

———. *An Autobiography.* New York: Random House, 1974.

———. *Freedom Is a Constant Struggle.* Chicago: Haymarket Books, 2016.

———. *Women, Race & Class.* New York: Random House, 1981.

Debs, Eugene V. *Labor and Freedom.* St. Louis: Phil Wagner, 1916.

———. *Walls and Bars.* Chicago: Socialist Party of America, 1927.

De Kooning, Elaine. *The Spirit of Abstract Expressionism: Selected Writings.* New York: George Braziller, 1994.

Dickerman, Leah. *Dada.* Washington, DC: National Gallery of Art, 2005.

Diogenes Laërtius. *Lives of Eminent Philosophers: Books 1–5.* Loeb Classical Library No. 184. Translated by R. D. Hicks. Cambridge, MA: Harvard University Press, 1925.

Dostoevsky, Fyodor. *The Idiot.* Translated by Richard Pevear and Larissa Volokhonsky. New York: Alfred A. Knopf, 2002.

———. *Letters and Reminiscences.* New York: Alfred A. Knopf, 1923.

———. *Notes from a Dead House.* Translated by Richard Pevear and Larissa Volokhonsky. New York: Alfred A. Knopf, 2015.

Dworkin, Andrea. *Heartbreak: The Political Memoir of a Feminist Militant.* New York: Basic Books, 2002.

———. *Intercourse.* New York Basic Books, 2002.

———. *Life and Death.* New York: Free Press, 1997.

Einstein, Albert. *Ideas and Opinions.* New York: Crown, 1954.

Fanon, Frantz. *Black Skin, White Masks.* Rev. ed. New York: Grove Press, 2008.

———. *The Wretched of the Earth*. New York: Grove Press, 1963.

Figner, Vera. *Memoires of a Revolutionist*. DeKalb: Northern Illinois University Press, 1991.

Firestone, Shulamith. *The Dialectic of Sex: The Case for Feminist Revolution*. New York: William Morrow, 1970.

Foucault, Michel. *Discipline and Punish: The Birth of the Prison*. New York: Pantheon Books, 1978.

———. *History of Madness*. Edited by Jean Khalfa. New York: Routledge, 2006.

———. *Madness and Civilization: A History of Insanity in the Age of Reason*. New York: Random House, 1965.

Friedan, Betty. *The Feminine Mystique*. New York: W. W. Norton, 1963.

———. *The Second Stage*. New York: Simon and Schuster, 1981.

Fromm, Erich. *The Art of Being*. New York: Continuum, 1993.

———. *The Art of Loving*. New York: Continuum, 2000.

———. *The Sane Society*. New York: Holt, Reinhart & Winston, 1955.

Gorbanevskaya, Natalya. *Red Square at Noon*. New York: Holt, Reinhart & Winston, 1971.

Goldman, Emma. *Anarchism and Other Essays*. New York: Mother Earth, 1910.

———. *Prisons: A Social Crime and Failure*. Alexandria: Library of Alexandria, 2009. Kindle.

Goodman, Amy, and Denis Moynihan. "How the Media Iced Out Bernie Sanders & Helped Donald Trump Win." *Democracy Now*, December 1, 2016, available at https://www.democracynow.org/2016/12/1/how _the_media_iced_out_bernie.

Havel, Václav. *Open Letters: Selected Writings, 1965–1990*. New York: Alfred A. Knopf, 1991.

———. *The Power of the Powerless: Citizens Against the State in Eastern Europe*. Edited by John Keane. New York: M. E. Sharpe, 1985.

Hedges, Chris. *American Fascists: The Christian Right and the War on America*. New York: Free Press, 2006.

———. *Empire of Illusion: The End of Literacy and the Triumph of Spectacle*. New York: Nation Books, 2009.

———. *Wages of Rebellion*. New York: Nation Books, 2015.

———. *War Is a Force That Gives Us Meaning*. New York: PublicAffairs, 2002.

Hedges, Chris, and Joe Sacco. *Days of Destruction, Days of Revolt*. New York: Nation Books, 2012.

hooks, bell. *ain't i a woman: black women and feminism*. Boston: South End Press, 1981.

———. *all about love: new visions*. New York: William Morrow, 2000.

———. *feminism is for everybody*. Boston: South End Press, 2000.

———. *feminist theory: from margin to center*. Boston: South End Press, 1984.

———. *soul sister: women, friendship, and fulfillment*. Boston: South End Press, 2006.

———. *talking back: thinking feminist, thinking black*. Boston: South End Press, 1989.

———. *we real cool: black men and masculinity*. New York: Routledge, 2004.

———. *where we stand: class matters*. New York: Routledge, 2000.

hooks, bell, and Cornel West. *Breaking Bread: Insurgent Black Intellectual Life*. Boston: South End Press, 1991.

Hugo, Victor. *Les Misérables*. Translated by Julie Rose. New York: Modern Library, 2008.

———. *Ninety-Three*. New Jersey: Paper Tiger, 2002.

Illich, Ivan. *Limits to Medicine: Medical Nemesis, The Expropriation of Health*. London: Marion Boyars, 1976.

Kaminskaya, Dina. *Final Judgement: My Life as a Soviet Defense Attorney*. New York: Simon & Schuster, 1982.

Kant, Immanuel. *Anthropology from a Pragmatic Point of View*. New York: Cambridge University Press, 2006.

Kesey, Ken: *One Flew over the Cuckoo's Nest*. New York: Viking, 1962.

King, Martin Luther, Jr. *The Autobiography of Martin Luther King Jr*. New York: Warner Books, 1998.

Knabb, Ken, trans. "The Beginning of an Era," *Internationale Situationniste* 12 (September 1969).

Kollontai, Aleksandra. *The Autobiography of a Sexually Emancipated Woman*. Translated by Salvator Attanasio. London: Orbach & Chambers Ltd., 1972.

———. *Selected Writings*. New York: Norton, 1980.

Kropotkin, Peter. *Kropotkin's Revolutionary Pamphlets*. New York: Vanguard Press, 1927.

Laing, R. D. *The Divided Self.* New York: Pantheon Books, 1962.

————. *Knots*. New York: Pantheon Books. 1971.

————. *The Politics of Experience*. New York: Pantheon Books, 1968.

LeGuin, Ursula. *The Dispossessed: An Ambiguous Utopia*. New York: Harper & Row, 1974.

Lucian. *Selected Dialogues*. Translated by C. D. N. Costa. Oxford: Oxford University Press, 2009.

Marcuse, Herbert. *The Aesthetic Dimension: Toward a Critique of Marxist Aesthetics*. Boston: Beacon Press, 1978.

Mandelstam, Nadezhda. *Hope Abandoned*. New York: Atheneum, 1974.

————. *Hope Against Hope*. New York: Atheneum, 1970.

Mayakovsky, Vladimir. *The Bedbug and Selected Poetry*. Bloomington: Indiana University Press, 1975.

Miller, Henry. *The World of Sex*. London: Penguin, 2015.

Orwell, George. *Animal Farm*. London: Secker and Warburg, 1945.

————. *1984*. New York: Harcourt Brace, 1949.

Paine, Thomas. *Rights of Man*. Mineola, NY: Dover, 1999.

Pankhurst, Emmeline. *My Own Story*. New York: Hearst International Library, 1914.

Plutarch. *Plutarch's Lives*. Vols. 1 and 2. New York: Modern Library, 2001.

Proudhon, P. J. *General Idea of the Revolution in the Nineteenth Century*. Honolulu: University Press of the Pacific, 2004.

Richter, Hans. *Dada: Art and Anti-Art*. 2nd ed. New York: Thames & Hudson, 2016.

Rorty, Richard. *Achieving Our Country: Leftist Thought in Twentieth-Century America*. Cambridge, MA: Harvard University Press, 1998.

————. *Contingency, Irony and Solidarity*. New York: Cambridge University Press, 1989.

————. *Philosophy and the Mirror of Nature*. Princeton, NJ: Princeton University Press, 1989.

Sanders, Bernie. *Bernie Sanders Guide to Political Revolution*. New York: Henry Holt, 2017.

————. *Our Revolution*. New York: Thomas Dunne, 2016.

Shalamov, Varlam. *Kolyma Tales*. New York: Penguin Classics, 1995.

Sloterdijk, Peter. *Critique of Cynical Reason*. Minneapolis: University of Minnesota Press, 1988.

Snyder, Timothy. *On Tyranny: Twenty Lessons from the Twentieth Century*. New York: Tim Duggan, 2017.

Solzhenitsyn, Aleksandr. *The Gulag Archipelago 1918–1956: An Experiment in Literary Investigation I–II*. New York: Harper & Row, 1973.

———. *The Gulag Archipelago 1918–1956: An Experiment in Literary Investigation III–IV*. New York: Harper & Row, 1975.

Stiglitz, Joseph E. *The Price of Inequality: How Today's Divided Society Endangers Our Future*. New York: W. W. Norton, 2012.

Streeck, Wolfgang. *How Will Capitalism End? Essays on a Failing System*. New York: Verso, 2016.

Tillich, Paul. *The Courage to Be*. 3rd ed. New Haven, CT: Yale University Press, 2014.

———. *Dynamics of Faith*. New York: Harper & Row, 1957.

———. *The Shaking of the Foundations*. New York: Charles Scribner's Sons, 1948.

Tzara, Tristan. *On Feeble Love and Bitter Love: Dada Manifesto*. San Francisco: Molotov Editions, 2017.

———. *Seven Dada Manifestos and Lampisteries*. Richmond, Surrey: Alma Books, 2013.

Verhaeghe, Paul. *What About Me? The Struggle for Identity in a Market-Based Society*. Melbourne: Scribe, 2014.

Villon, François. *The Poems of François Villon*. Translated by Galway Kinnell. Hanover, NH: University Press of New England, 1965.

West, Cornel. *The Cornel West Reader*. New York: Basic Books, 1999.

———. *Democracy Matters*. New York: Penguin, 2004.

———. *Race Matters*. Boston: Beacon, 1993.

Wilde, Oscar. *The Ballad of Reading Gaol*. Leonard Smithers, 1898.

Wittgenstein, Ludwig. *Tractatus Logico-Philosophicus*. New York: Harcourt Brace, 1922.

Zinn, Howard. *A People's History of the United States*. New York: Harper & Row, 1980.

———. *You Can't Be Neutral on a Moving Train: A Personal History of Our Times*. Boston: Beacon Press, 1994.